MAKING AND USING WORKING DRAWINGS
FOR REALISTIC MODEL ANIMALS

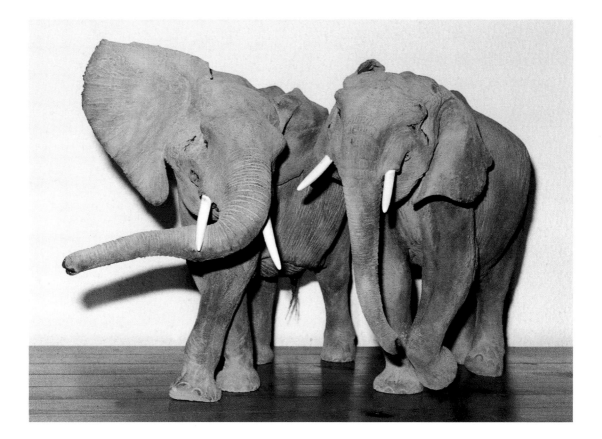

MAKING AND USING WORKING DRAWINGS FOR REALISTIC MODEL ANIMALS

Basil F. Fordham

With a Foreword by Dr G. Plodowski
Forschungsinstitut und Naturmuseum Senckenberg
Frankfurt/Main, Germany

Guild of Master Craftsman Publications Ltd

First published 2000 by
Guild of Master Craftsman Publications Ltd
Castle Place, 166 High Street,
Lewes, East Sussex BN7 1XU

Photographs by Basil F. Fordham except where otherwise stated

ISBN 1 86108 120 0

A catalogue record for this book is available from the British Library.

Edited by Stephen Haynes
Designed by Christopher Halls at Mind's Eye Design, Lewes
Cover design by Rob Wheele at Wheelhouse Design, Brighton

Set in Lapidary

Colour origination by Viscan Graphics (Singapore)
Printed in China by Sun Fung Offset Binding Co Ltd

ACKNOWLEDGEMENTS

I would like to express my gratitude to Stephen Gaze, Dr G. Plodowski, Jane Snelling, and all the members of the publishing team who took part in the production of this book; and especially to my wife Jillian for her forbearance.

SAFETY NOTICE

For safety reasons, note that none of the models described in this book is suitable to be used as a plaything, especially by children.

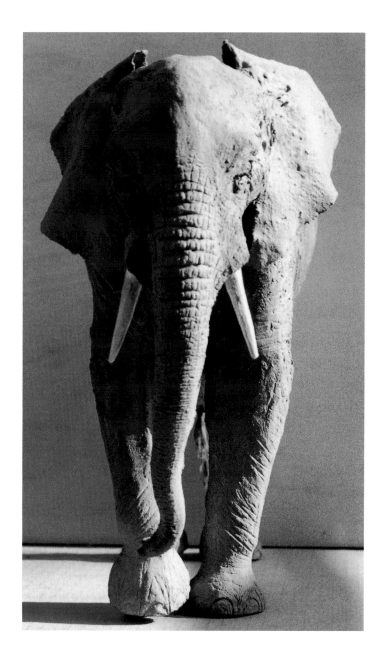

CONTENTS

Foreword ix

1 Introduction 1

2 Getting to know your subject 3

3 Collecting and organizing information 37

4 Making drawings 49

5 Using your working drawings to make the model 78

6 Glossarial section 117

Further reading 124

About the author 126

Index 127

This book is dedicated to the memory of my father, Frederick W. Fordham, who taught me that small things make perfection but perfection is no small thing.

FOREWORD

Humans, as visually responsive beings, have long made drawings of the animals around them. A powerful imagination is needed to visualize the three-dimensional object on the basis of the two-dimensional drawing. Physical representations such as sculpture, which is known to us from the Stone Age, did not have such a disadvantage, and one could literally 'grasp' which animal was represented, through touch. Moreover, the anatomical correctness of the representation was not important. Mere recognition sufficed, the power of the symbol and the magical meaning being more significant. Often the proportions of an animal were deliberately altered to give prominence to a particular feature: for example, the primitive strength of the bull or the delicate elegance of the gazelle – the animal as allegory.

Models of animals and reconstructions of fossilized animals for natural history museums must, however, be anatomically and proportionally correct. Working drawings, such as those described in this book, are essential prerequisites for their production. They guarantee the observance of the correct proportions even in exaggerated poses.

Exact working drawings are particularly important in the reconstruction of fossilized animals, because no living or stuffed animals are available as models, and usually only a partial skeleton exists. In these cases it is possible to reconstruct the animal's appearance and behaviour on the basis of a working drawing in which the interconnections and workings of the existing bones are established beyond doubt.

Although the building of animal models from drawings ensures that the proportions are not distorted for dramatic effect, and the model-builder's artistic freedom is therefore limited, this should not mean that the model appears stiff and wooden. This is shown by the very lifelike and yet anatomically correct models of Basil F. Fordham. He combines the precise methods of an engineer with an artist's feel for form and movement – skills developed particularly through the long and intensive observations of animals made during his stay in Africa.

Dr G. Plodowski
Forschungsinstitut und Naturmuseum Senckenberg
Frankfurt/Main, 1999

INTRODUCTION

Drawings have been used for many thousands of years by all sorts of people. They are just as much a form of language as is the written word, and they have a vast part to play in providing the right type of information just when and where it is wanted. Drawings form a permanent record which can be read by anyone at any time. They can be just a few lines on an odd piece of paper to convey or record something simple, or they can be extremely detailed and take up many sheets; it all depends on the message they are intended to hold. A modeller's drawings should follow this rule: only draw as much as you need to set down for your purpose.

This book has been arranged in accordance with my own method of working, so that as you read through it you will see how the making of drawings fits into the model-builder's world. Once a model is envisaged, the first task is gathering information; then comes the process of sorting out this material, establishing vital parameters, using the information to produce a clear and thorough description of the animal concerned. Next follows the making of a maquette, which is manipulated until the desired pose is displayed. The model itself can then be built.

The worth of drawings in model-making is sometimes questioned; those who are 'good with their hands' just want to get hold of the materials and tools and do the job. If you are capable enough, and satisfied with the results, this book is not for you. It is for the modeller who wants to know just what is wanted here, just how much to take off there, and exactly how this part relates to that part. It is for those who want to be able to make efficient working drawings and use them competently to make a realistic model of any proposed animal. Remember that paintings and photographs show the subject in two dimensions only, so viewers have the opportunity to examine the subject from only one point of view.

With modelling, the third dimension comes into play and the viewer has an infinite number of viewpoints to choose from.

It is important to be familiar with the animal which is being modelled. Your knowledge of the subject will show in the model. The character of the animal will show, its body language will be correct, the attitude of the whole body will be realistic, the facial expression will be right – the animal will 'live'.

Although anatomy and physiology form part of the subject matter of this book, I have included only those aspects with which model-makers are concerned: how animals are put together, what shapes they are and how they move. I have tried to minimize the use of technical terms; however, for the sake of making my meaning clear I have used some, and these are explained in the Glossarial Section at the back of the book. I have not quoted references for information which is common knowledge and which I believe to be true. Bear in mind that all the illustrations have been produced for the benefit of the model-maker rather than the student of anatomy, and the skeleton and muscle drawings have therefore been simplified where appropriate.

The process described in this book is finished when the basic shape of the animal has been established. There is not space here to go into the details of hides, coats, feathers, colours, etc. Nor do I discuss in detail how to make the model itself, except in so far as the use of the drawings comes into the process. This book is essentially about making and using drawings.

Any drawing where measurements or comparisons are of interest has been drawn on a graticule (grid). Animals of the same species vary in size and shape according to such factors as sex, age and physical fitness. The graticule sizes given in this book are for

average adult males. Where sizes are given in centimetres and inches, please note that I give no direct comparison between these two measuring systems, simply because animals vary so much in size that very precise measurements would be misleading.

In the illustrations which show the bones of the limbs, each major bone or group of bones has its own distinctive colour throughout the book, so that the reader can readily identify a particular bone, and the differences in the placement of these bones in various animals will be clearer. Fig 2.7 is the key illustration of this system. (Figs 2.2, 2.13, 2.19–21, 2.23–5, 4.13–14 and 5.19 have their own colour schemes.)

Chapter 4 shows how to modify the basic drawing to accommodate particular poses and special frameworks. I have presented some of my own working drawings in Chapter 5; these show various short cuts to save time and space. The making and use of maquettes, armatures, gauges, datums and callipers is described in some detail, to give the modeller closer guidance in the use of drawings during the manufacturing process of model-making.

The making of models follows one of two main methods of construction. Method one is to work inwards by carving or sculpting. Method two is to work outwards by manipulating a mass of soft material or by using frameworks of formers and armatures. Fig 1.1 summarizes the various routes which can be taken when making a model.

The book covers all the classes of **tetrapods** (four-footed or four-limbed animals): amphibians, reptiles, birds and mammals (in scientific terminology, **Amphibia**, **Reptilia**, **Aves** and **Mammalia**). It ranges from the comparatively simple shape of the tortoise to the more complex shape of the elephant. Many woodcarvers have no hesitation in referring to the woods they use by both their English and Latin names. I use a similar terminology to refer to the main animals I work with in this book: the amphibian *Rana temporaria* (common frog), the reptile *Testudo graeca* (spur-thighed tortoise), the bird *Columba livia* (domestic pigeon), the mammals *Felis catus* (domestic cat) and *Loxodonta africana* (African elephant). These names are worth knowing because they are used internationally, and they each refer unambiguously to one particular species of animal.

For safety reasons, I would remind you that none of the models described in this book is suitable to be used as a plaything, especially by children.

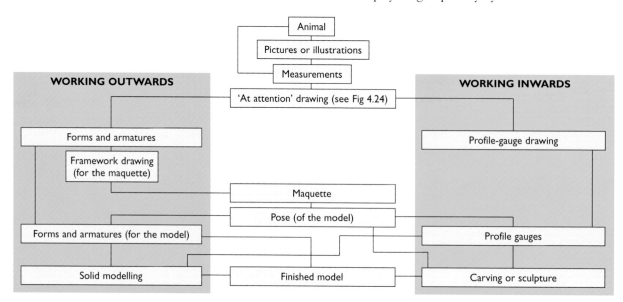

Fig 1.1 The routes which can be taken in making a model animal

GETTING TO KNOW YOUR SUBJECT

Animal anatomy and physiology is a vast subject, and there is not space here to cover it exhaustively. The information given here will be limited to what model-makers need to know about the subject. As mentioned in the Introduction, the animals covered here will be **tetrapods** (four-footed or four-limbed animals), either existing (such as elephants) or extinct (such as dinosaurs). Later we will consider in more detail a frog, a tortoise, a pigeon, a cat and an elephant (see pages 87–108). Tetrapods have an enormous number of common features in their body make-up. In one sense you could say that they are all *the same basic beast*.

If we now have a look at some of these features we will become familiar with many of the ground rules which will underlie the build of our models. A most helpful feature about tetrapods, or four-footed animals, is that they have a left side and a right side which are virtually mirror images of one another. The plane of symmetry joining these two halves – the centre line, as it were – is technically known as the **sagittal plane**. This plane is the most important feature when making the drawings of the animal.

Before we go any further, let us look at the terms we use when referring to the different views of the animal. Fig 2.1 shows the everyday terms, while Fig 6.1 on page 117 shows the scientific terminology. It is worth familiarizing yourself with the technical terms, as you may eventually want to refer to scientific literature for further information.

Fig 2.1 Describing an animal: names of the different views, in everyday terminology (refer to Fig 6.1 on page 117 for the scientific terms)

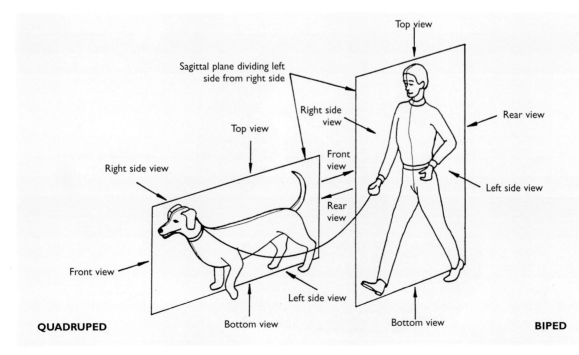

BASIC COMPONENTS OF FOUR-FOOTED ANIMALS

In this section we will look at what the model-maker needs to know about the basic anatomy and physiology of these animals. Considering each part in turn, we will look at how each piece has developed, and how it varies in different animals; we will consider what it does, but more particularly what shape it is and how it goes together with all the other pieces.

THE HEAD

The head contributes enormously to the character of the animal. It contains the brain for control, the eyes, ears, nose, mouth, and some of the sense organs for touch. It contains the mouth and jaws for biting, chewing, tasting, swallowing, breathing and making noises. It contains the olfactory organs for smelling, air-cleaning and breathing, and the nostrils. The whole of the head is used for body language by varying its attitude, expression and movement. It can also be used as a weapon in conflict. All of this makes it a complex entity. All tetrapod heads carry all the equipment mentioned above, and in much the same sort of arrangement.

The head carries a plane of symmetry, the sagittal plane: there is a left side and a right side. The jaw, mouth, nose and brain lie on the sagittal plane; the eyes and ears lie one on each side of it. The normal attitude of the component parts of the head remains pretty well constant in all tetrapods, both quadrupeds and bipeds:

- The nose and mouth opening are at the front.

- The jaw is on the underside.

- The mouth lies just above the jaw.

- The olfactory passages lie over the mouth.

- The eyes lie over and to the rear of the olfactory passages.

- The ears lie just behind the eyes.

- The brain lies behind the eyes and between the ears.

This basic arrangement is shown schematically in Fig 2.2.

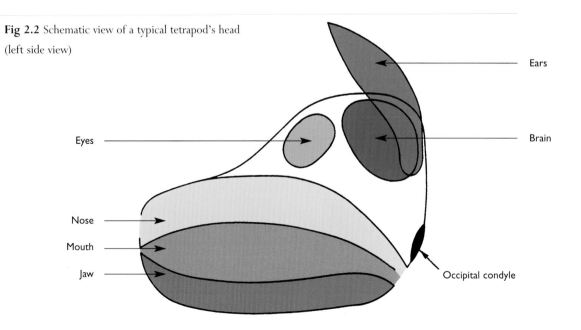

Fig 2.2 Schematic view of a typical tetrapod's head (left side view)

Ears

Brain

Eyes

Nose

Mouth

Jaw

Occipital condyle

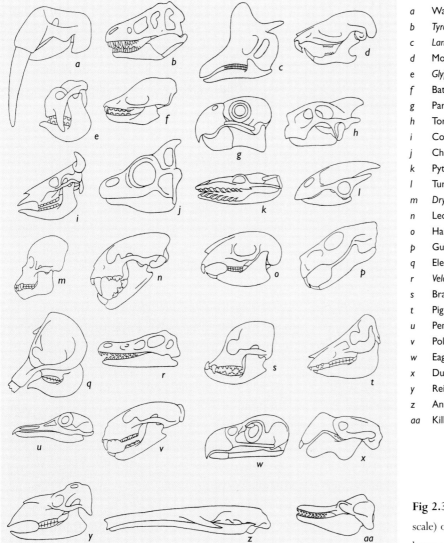

a	Walrus
b	*Tyrannosaurus*
c	*Lambeosaurus*
d	Mouse
e	*Glyptotherium*
f	Bat
g	Parrot
h	Tortoise
i	Cow
j	Chameleon
k	Python
l	Turtle
m	*Dryopithecus*
n	Leopard
o	Hare
p	Guinea pig
q	Elephant
r	*Velociraptor*
s	Brachycephalic dog
t	Pig
u	Penguin
v	Polar bear
w	Eagle
x	Dugong
y	Reindeer
z	Anteater
aa	Killer whale

Fig 2.3 Some examples (not to scale) of the variation in skull shape between one animal and another

The **skull** encompasses all of these components and carries at its rear end (or bottom end, in the case of bipeds) a joint, known as the **occipital condyle**, which couples with the spine. This joint, together with the first two vertebrae, the **atlas** and the **axis**, allows the head a large degree of movement on the neck.

Despite the underlying similarity in structure, however, there is an enormous amount of variation in heads from one kind of animal to another, because of the different ways in which heads and sense organs are used. The head of a seal, for example, is streamlined for efficient swimming. The head of a crocodile has a large mouth which gives it an enormous bite. The head of a bushbaby has large, forward-facing **orbits** (eye sockets) to carry the large, sensitive eyes. Herbivores have eyes on each side of the head; carnivores and climbers have eyes on the front of the head, giving them binocular vision, which enables them to judge distances more accurately. Many tetrapods have sensitive hairs or whiskers (**vibrissae**) on the nose which help them to feel obstacles.

These are just a few of the many special adaptations which account for differences between one head and another. Fig 2.3 shows some of these variations (and see also Fig 4.15). Note that in this illustration the different heads are not shown to a common scale.

THE NECK, TRUNK AND TAIL

The **neck** increased in length as animals evolved and moved from the water to the land. Mobility of the head enables land animals to search for food, look out for predators, and so on, without having to move their bodies about too much; whereas in water the body could move sideways much more easily to the food source.

One of the main variations to be seen in necks is in the musculature to establish control of the head. The heavy-headed quadrupeds – elephants, rhinos, hippos, and the tyrannosaurs – all have enormously powerful muscles in the neck, especially at the back to hold the head up. On the other hand, animals such as flamingos and swans, with lightweight heads, need much less powerful muscles.

The **trunk** is the largest part of the animal. It contains most of the **axial skeleton** – that is, the **vertebrae**, the **sacrum** and the **ribcage** (see Fig 2.6 on page 9) – and the **viscera**. The trunk provides a mounting for the limbs. The ribcage supports and shapes the trunk between and just aft of the front limbs, and provides part of the means to expand the lungs for inhalation of air.

The **tail** first evolved as a means of propelling the body through the water, then as animals moved onto the land it developed a great variety of uses. In some cases its main use is as a balancing organ (as in many dinosaurs, and in the modern kangaroo), and as animals' bodies got shorter the tail tended to shorten as well. When some animals, such as the whales, returned to the water, the tail again came to be used as a swimming aid. Others, such as crocodiles, have always used it in this way. Birds have developed the **pygostyle** as a means of mounting their tail, which is made of feathers.

Tails have been retained for many other uses, including swatting insects, covering rear vents, and body language. They may be used as a warning sign, as in the case of rabbits and deer; as a gripping agent, as with monkeys; or for defence, as with the dinosaur *Diplodocus* (which may have used its long tail as a whip), or the club-tailed dinosaur *Euoplocephalus*.

THE LIMBS

The limbs evolved to help with locomotion, which enhanced the animal's prospects of survival. Since then they have undergone massive changes to suit a wide variety of uses. They have been, and still are, used for innumerable different jobs by different animals at all stages of evolution. As their function has changed, so has their shape; but the basic underlying structure – the **appendicular skeleton** – remains much the same in all tetrapods.

The limbs are mainly used for walking or running. However, various species use the front legs for other activities, such as gripping or flying. As animals evolved, the stance changed as different demands were made on the limbs, especially affecting the **distal** ends of the limbs (fingers and toes). This had far-reaching effects on the overall posture of the animal, and so the **plantigrade**, **digitigrade** and **unguligrade** stances came into being, as we shall see later when we come to consider the structure of the skeleton (pages 7–15).

JOINTS, MUSCLES AND MOVEMENT

To allow for the various movements which an animal needs to make in the course of its daily life, evolution has provided joints in the bony system, which enable one part to move relative to the other parts. The many different types of joint provide for different types and ranges of movement, as we shall see on pages 15–20.

Ligaments are bands or membranes of strong tissue (which is pliable, but with varying degrees of elasticity) which join bone to bone; they serve to hold joints together while still allowing movement, and they also help support long necks and tails. Animals with long necks – such as the dinosaur *Diplodocus*, giraffes and chickens – all need strong ligaments in the back of their necks for support – indeed, *Diplodocus* needed massive ligaments all along its spine.

Muscles are for pulling; they can only pull. Wherever movement is required, there is muscular effort to provide the pull.

The skeletal muscles are the prime movers in body movement and they are found pretty well everywhere in the surface areas of the body. They have evolved into various shapes and sizes. Their shape greatly influences the external shape of the body, and they are therefore of particular interest to the model-maker.

Tendons are cords or bands of strong tissue which attach muscles to bone wherever the muscular effort is needed.

INTERNAL ORGANS AND FAT

These are of interest to the modeller only where they help to define the outside shape of the body; this applies mainly to the abdominal area and to the **ventral** side (the front or lower side) of the neck.

WHAT YOU SEE ON THE OUTSIDE

The other important external features are the eyes, ears, mouth, nose, and the general covering of the body. They are all mounted on the general framework of the body and help to give the animal its final 'presence'.

THE SKELETON (BONE AND CARTILAGE)

The whole skeleton is made up of two major assemblies: the **axial skeleton** – the skull, spine and ribcage – and the **appendicular skeleton** – the skeleton of the limbs.

THE AXIAL SKELETON

THE SKULL
The cranial cavity of the skull fits closely around the brain, and so follows its shape. The shape of the rest of the skull is also determined by its function. There has to be something to carry the upper teeth, conforming to the structure of the teeth and their layout, and there has to be a structure to carry the **mandible** (the movable lower jaw). The evolution of the nasal passages forms sometimes quite a large snout over the mouth; this accommodates the turbinal bone structures, over which the air passes for smelling and moistening. The bones surrounding the **orbits** (eye sockets) generally form eye-sized recesses. However, some animals, such as the walrus (Fig 2.3*a*), have no regular orbits at all.

The outside of the skull is formed so as to provide attachment points for the many muscles which are necessary for operating the jaw, ears and nose, and for the various muscles which control the movement of the head on the neck.

The rest of the axial skeleton is made up of two assemblies – the vertebral column and the ribcage – which together provide the framework on which the body is built.

THE SPINE OR VERTEBRAL COLUMN
The vertebral column is made up of three sections: the **vertebrae** in front of the sacrum, the **sacrum**, and the tail vertebrae.

The animals considered here, the tetrapods, are all **vertebrates** – that is, the body is built around a column of bones which are assembled in a row to form a rod or spine. This spine was the first part of our skeleton to evolve; indeed, it has had more than 500 million years to develop.

As time has gone on, this spine has developed along different lines, modifying into several versions according to the type of body it supports. It is used mainly as a girder in quadrupeds, but in bipeds it serves as a column. This variety of function has been one of the major reasons for the variation in the shape of the spine. Large, heavy-headed quadrupeds, for example, have to have a lot of muscle attached to the spine to support the head, while to balance the body when standing some animals have to have long tails. Animals with long bodies need a stronger spine to carry the weight of the body to the legs. All of this requires muscles running along the back so that the body can be controlled.

With bipeds the loads on the spine are quite different, and so the spine has developed in a different way, as a column. However, all spines have some features in common, and one of these is the **vertebra**. This is the basic building block of the spine. Fig 2.4 shows the general features of a vertebra. Each individual feature of the vertebra varies according to its purpose, but the general structure is the same.

Mobility of the spine is allowed by the flexible disc of cartilage between each pair of vertebrae. The discs and vertebrae are pulled tightly together by ligaments and muscles. The pull of muscles on the processes (projections) on the vertebrae flexes the spine, and the discs allow this flexing to occur (Fig 2.5).

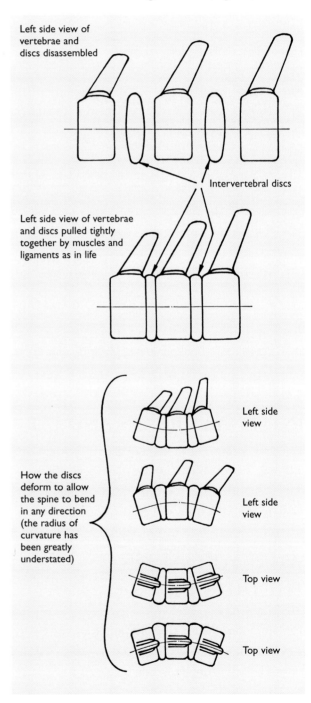

Fig 2.5 Schematic views of vertebrae showing how they are strung together

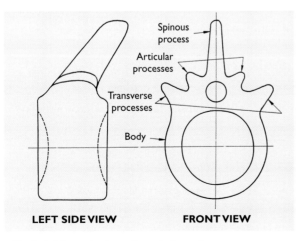

Fig 2.4 Schematic view of a typical vertebra

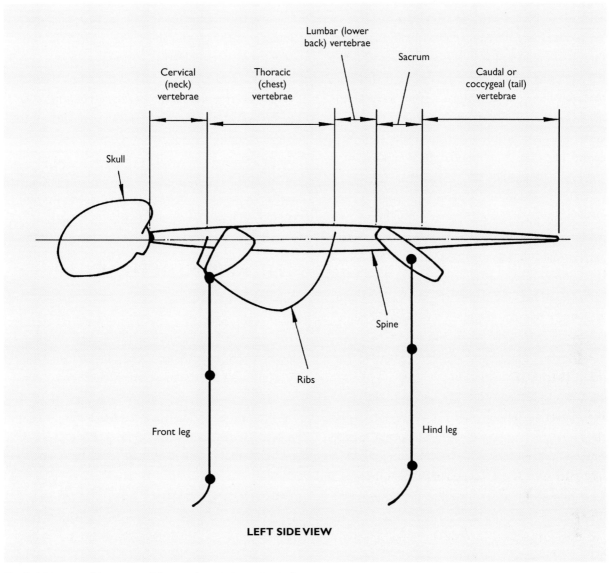

Fig 2.6 Names and locations of the vertebrae (schematic view)

Starting at the skull and moving away towards the tail, the various groups of vertebrae have their own specialized jobs to do (Fig 2.6).

The **cervical** (neck) **vertebrae** support the head and anchor some of the muscles which steady the head and control its position; they also anchor muscles from the **scapulae** (shoulder blades) and major back muscles.

The **thoracic** (chest) **vertebrae** provide a mounting for the ribs, and carry the forward part of the body in quadrupeds. They mount muscles from

the head, neck and scapulae, muscles running all along the spine, the major back muscles, and muscles to the ribcage.

The **lumbar** (lower back) **vertebrae** mount muscles to the ribs and the pelvis, muscles running along the spine, and major back muscles. These vertebrae are large; they hold the front half of the body to the back half, and they carry the middle part of the body in quadrupeds.

The **sacrum** is a fused set of vertebrae which forms part of the pelvis.

The **tail** varies considerably from species to species. With dinosaurs, where the tail was long and heavy, the vertebrae had processes (see Fig 2.4) which were quite large; these presumably carried muscles to control movement. Humans, who discarded the use of the tail, have virtually lost it; our 'tail' is a small mass of four fused vertebrae. The skeletal part of the bird's tail is the **pygostyle**, composed of several small **caudal** (tail) **vertebrae**. This group still allows the bird to swing its tail.

All the muscles attached to the tail extend along it and the tail can wag in any direction. Modellers should note that some tail centre lines do not match up with lumbar centre lines (Fig 4.9 on page 60 shows an example); if you do not allow for this you will get the tail in the wrong place.

THE RIBCAGE

The ribcage is made up of two sections: the ribs and the sternum or breastbone. The ribcage strengthens the body wall and provides attachment for muscles.

The **ribs** are mounted on the thoracic vertebrae and their movement causes breathing to take place. Their inner end is made of cartilage, and most ribs are attached at this end to the sternum, in such a way as to allow a lot of movement. In turtles and tortoises the ribs unite with the **carapace** (the upper part of the body shell); in birds the ribs unite with an enlarged sternum.

In quadrupeds the ribs also help to transfer the weight of the front part of the body to the front legs, by means of a muscular hammock. This hammock is formed by muscles which attach the scapula to the ribcage, the sternum and the spine, as we shall see when we come to consider the muscles (pages 20–7). In tetrapods that leave their bodies on the ground for much of the time, such as crocodiles, the ribs carry the whole of the trunk weight to the ground, and so are much larger.

The **sternum** varies quite a lot in tetrapods; many animals, especially the ancient ones, did not have one. It lies along the front part of the chest and helps to secure the front end of the trunk together. In animals that have well-developed clavicles (collarbones), the sternum provides attachment for their inner ends. Birds have well-developed sternums: these are extended ventrally so as to provide attachment for the wing muscles, as we shall see when we come to examine the pigeon in more detail (see pages 93–9 and Figs 5.18–19).

THE APPENDICULAR SKELETON

The appendicular skeleton is the skeleton of the limbs. There are two assemblies: one for the front limb and one for the hind limb. The front limb skeleton is composed of the **pectoral girdle** and the limb itself; the rear limb skeleton comprises the **pelvic girdle** and the limb itself. The girdles are the mounting pieces for fixing the limbs to the body.

VARIATION IN LIMBS

Fig 2.7 shows a front and a rear limb, with the names of the bones labelled. These are my schematic or 'standard' limbs: the drawing is stylized so as not to resemble any particular animal. The bones have been coloured, and this colour scheme is used throughout the book for the sake of comparison. This drawing can be said to represent the basic arrangement of all tetrapod limbs. (Note, however, that some animals, notably reptiles and birds, have an additional bone in the pectoral girdle, the **coracoid**; see Figs 5.18 and 5.19 on pages 93 and 94.)

The basic limb evolved out of swimming fins, and really retains very much the same basic elements of structure; however, the limbs of individual animals vary greatly in shape.

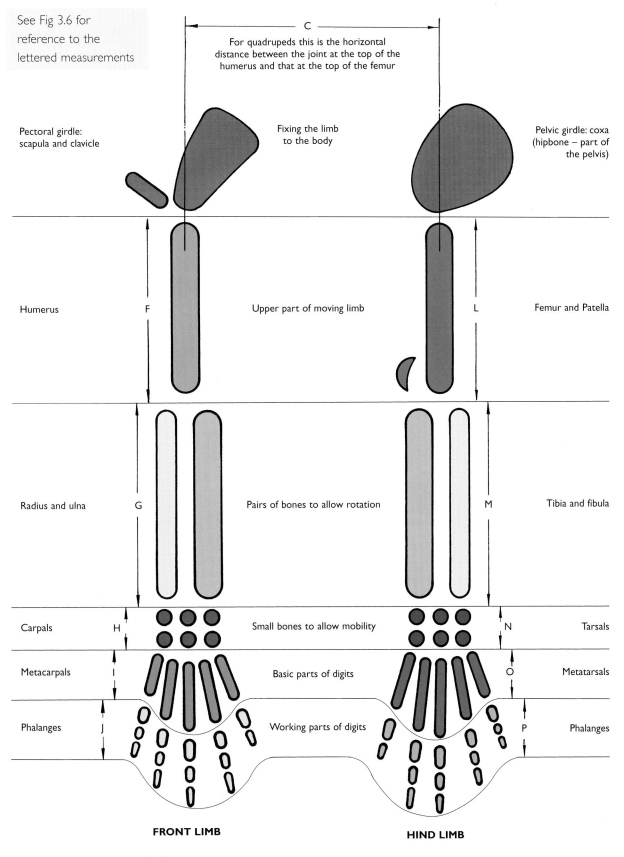

See Fig 3.6 for reference to the lettered measurements

C

For quadrupeds this is the horizontal distance between the joint at the top of the humerus and that at the top of the femur

Pectoral girdle: scapula and clavicle

Fixing the limb to the body

Pelvic girdle: coxa (hipbone – part of the pelvis)

Humerus

F

Upper part of moving limb

L

Femur and Patella

Radius and ulna

G

Pairs of bones to allow rotation

M

Tibia and fibula

Carpals

H

Small bones to allow mobility

N

Tarsals

Metacarpals

I

Basic parts of digits

O

Metatarsals

Phalanges

J

Working parts of digits

P

Phalanges

FRONT LIMB

HIND LIMB

Fig 2.7 Schematic 'standard' limbs

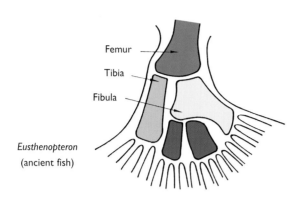

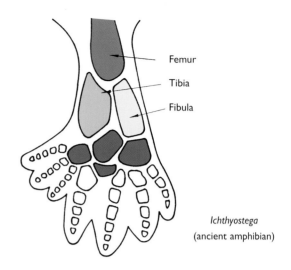

Femur

Tibia

Fibula

Eusthenopteron
(ancient fish)

Femur

Tibia

Fibula

Ichthyostega
(ancient amphibian)

Fig 2.8 The origin of limbs: schematic views of the rear limbs of an early fish and an early terrestrial animal

The first variance came about as the limbs were used more and more for terrestrial movement. At first they retained the fin shape, but were used on the bottom of the water to propel the fish over the sea or river bed; then it is thought that the fins evolved into limbs to propel the tetrapod through groups of water plants in swamps (Fig 2.8). Eventually they came to be used on land, and then they had much more work to do: they had to move and support a body which had no buoyancy from water, and the weight of the body offered much more resistance to movement. The limbs became much more powerful and longer, and later developed from a *flat* to a *squat* shape. The **carpus** and **tarsus** bones became smaller, which allowed more wrist and ankle movement.

As time went by, the limbs of terrestrial animals developed from a *squat* shape to a more *upright* stance (Fig 2.9); this made them much more efficient at weight-bearing and allowed faster locomotion. As animals became specialized as quadrupeds (the horses and other four-footed animals with which we are familiar), the bones of the lower ends of the limbs were simplified. Most of the weight was now carried on the **radius** and **tibia**, while the **ulna** and **fibula** became less important and gradually reduced in size. (It is important to realize that in summarizing the development of the limbs we have passed through about 400 million years of development in the last two paragraphs.)

Fig 2.9 Squat and upright limbs

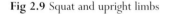

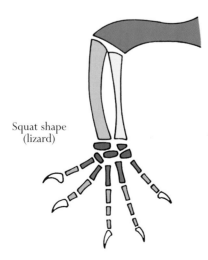

Squat shape
(lizard)

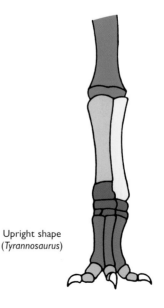

Upright shape
(*Tyrannosaurus*)

In due course the limbs of various species developed into different shapes to suit the duties they had to carry out. Figs 2.10 and 2.11 show some of the variations which evolution has produced in these limbs. These variations mainly reflect the use required of the limb. The horse is a running animal, and its limbs have developed in a way which makes running easier. They are modified to such an extent that the horse now stands on only one digit of each limb. The limbs of the bat are modified to allow flight to take place; the greatly extended fingers of the front limb provide support for the wings. The

a	Tyrannosaurus
b	Horse
c	Rabbit
d	Diplodocus
e	Gorilla
f	Crocodile
g	Tortoise
h	Whale
i	Bird
j	Bat

Fig 2.10 Some representative examples (not to scale) of tetrapod front limbs

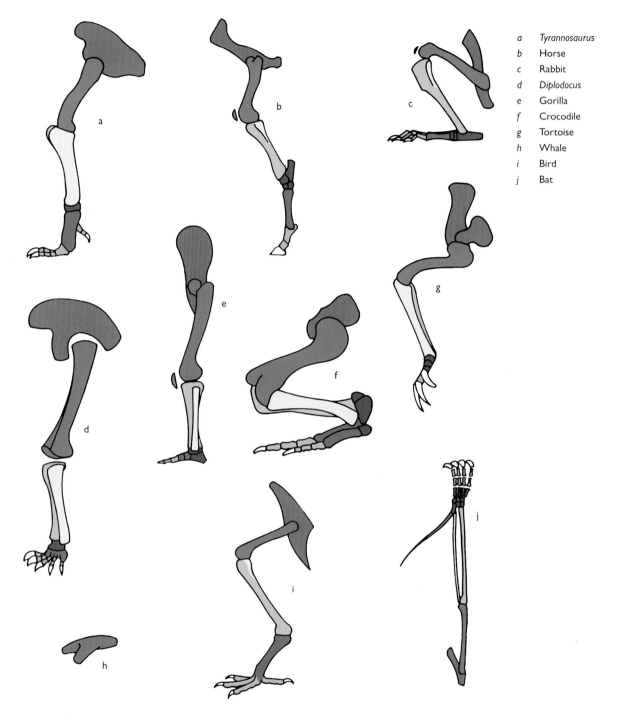

a	Tyrannosaurus
b	Horse
c	Rabbit
d	Diplodocus
e	Gorilla
f	Crocodile
g	Tortoise
h	Whale
i	Bird
j	Bat

Fig 2.11 The rear limbs of the same animals (not to scale)

rear limbs of the whales were no longer required when they returned to the water, and they are disappearing. Today there are just the remnants of the pelvic bones in some whales, while in others the limb has gone altogether. The humerus and femur of the tortoise have become curved to allow the limbs to move whilst projecting through the holes in the shell. The bird's rear limb still retains features of its reptilian ancestry, while its front limb has modified extensively to allow the bird to fly; the 'hand' now has only three fingers and the whole limb is arranged as a feather-carrier.

Fig 2.12 shows how tetrapods are classified according to the way they use their feet.

JOINTS AND LIGAMENTS

We are concerned here with those parts of the skeleton which allow movement. As a model-maker you will want to know where the joints are, what kinds of movement they permit, and how they affect the body shape at any one time.

When the muscles work around a joint, the parts of the body on either side of the joint move in relation to one another. Joints are held strongly together by **ligaments**, which are flat ribbons of tough tissue joining bone to bone. Some joints have little or no movement, and are of little interest to the model-maker. Those allowing large amounts of movement are provided with a lubricating fluid: these are known as **synovial joints**. Fig 2.13 shows a section of such a joint; they are typical of the appendicular skeleton.

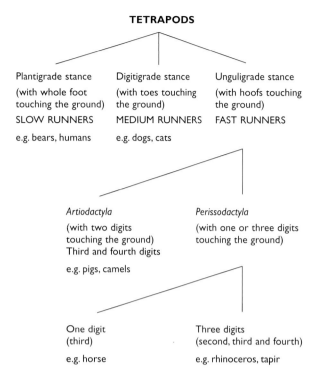

TETRAPODS

| Plantigrade stance (with whole foot touching the ground) SLOW RUNNERS | Digitigrade stance (with toes touching the ground) MEDIUM RUNNERS | Unguligrade stance (with hoofs touching the ground) FAST RUNNERS |

e.g. bears, humans e.g. dogs, cats

Artiodactyla (with two digits touching the ground) Third and fourth digits

e.g. pigs, camels

Perissodactyla (with one or three digits touching the ground)

One digit (third)

e.g. horse

Three digits (second, third and fourth)

e.g. rhinoceros, tapir

The digits are numbered from 1 (the thumb) to 5 (the little finger)

Fig 2.12 Classification of tetrapods according to their stance

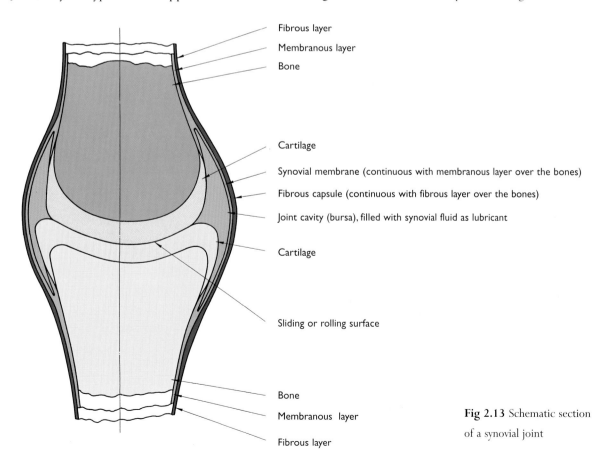

Fibrous layer
Membranous layer
Bone

Cartilage

Synovial membrane (continuous with membranous layer over the bones)

Fibrous capsule (continuous with fibrous layer over the bones)

Joint cavity (bursa), filled with synovial fluid as lubricant

Cartilage

Sliding or rolling surface

Bone
Membranous layer
Fibrous layer

Fig 2.13 Schematic section of a synovial joint

If you want to be able to model exactly and in detail, the precise movement of one bone relative to the other must be studied. A ball-and-socket joint produces a sliding movement; in other types of joint there may be either sliding or rolling movement. These types of movement vary the positions of the bones relative to one another in a complex fashion when the joint is used. In a ball-and-socket joint the centre of movement stays at the centre of the ball. However, with other joints the nature of the movement must be examined in more detail in order to establish the bones' positions for the particular pose you wish to model.

The type of synovial joint used determines the type of movement which is possible. We shall go through the six types one by one.

THE TYPES OF SYNOVIAL JOINT

PLANE OR FLAT
Move your ribcage relative to your pelvis; the movement of your vertebrae is an example of how the flat joints work.

HINGE
Move your elbow or knee; they work just like a hinge. The hinge joint allows movement in one plane through a large angle.

BALL-AND-SOCKET
Move your hip joint; the ball-and-socket joint allows movement in almost any direction.

PIVOT
A pivot joint in the neck works when you move your head to say 'no'.

SADDLE
When you wiggle your thumb around, the saddle joint at its base works like two hinges arranged at 90° to one another, allowing movement in many directions.

ELLIPSOID
When you wiggle your fingers around, the ellipsoid joints at their bases work like a saddle joint but with restricted sideways movement.

Now we shall consider the various joints around the body which the model-maker needs to know.

HEAD
The only joints on the head of interest to modellers are those between the skull and the jaw (**mandibular condyle**), and between the skull and the spine (**occipital condyle**). The great degree of freedom the head has on the neck is mostly due to the joints provided by the **atlas** and the **axis**. These are the two vertebrae on the spine next to the skull. The skull–jaw joint allows the jaw to make biting movements, and in many animals the jaw can move a little from side to side, which allows chewing.

NECK, TRUNK AND TAIL
The relatively long neck of most tetrapods, combined with the mobility of the head itself, allows the animal to put its head in almost any position. The position of the head is extremely important in many aspects of life: most of the sense organs are on the head, and it needs careful and rapid positioning. Model-makers should be aware that the position of the head is of great importance in body language.

The degree of development of the neck is quite marked as you go through from amphibians and reptiles to birds and mammals; the neck has generally (with some exceptions) tended to become longer and more flexible.

The remainder of the spine has only the limited movement allowed by the joints between the vertebrae. The amount of movement available at any one joint is quite small. However, in some animals the tail is long and is quite flexible and mobile; this

is because the vertebrae are short and there are a great number of them working together.

Some highly specialized tails have existed; for instance, the dinosaur *Deinonychus* had tail vertebrae with long bony fingers on them which stretched along the tail. This arrangement probably gave the dinosaur at will either a slightly flexible tail or a rigid one, resulting in an extremely sensitive balancing organ. The tails of lizards and kangaroos today tend to follow a similar construction.

FRONT LIMB

The joint between the **scapula** and the **humerus** – the shoulder joint – is a ball-and-socket joint with great mobility, especially in the monkeys and apes, where the limb assembly allows **brachiation**. The brachiating animal moves by swinging from one handhold to the other, rather like bipedal walking except that the animal is hanging from the support rather than standing on it, and the arms are used instead of the legs. This form of locomotion requires great flexibility in the shoulders. The brachiating animals usually have large **clavicles** allowing the shoulder joints great freedom. In birds and bats the **coracoid** has evolved to couple the proximal end of the humerus to the sternum. In this way the lifting action of the wings is carried straight to the body of the bird (see further Figs 5.18 and 5.19 on pages 93 and 94). In quadrupeds, by contrast, the movement of the **proximal** (shoulder) end of the humerus is restricted to front and rear.

The joint between the humerus and the **radius** and **ulna** – the elbow joint – is a hinge joint which allows a lot of movement in one plane only, usually allowing the 'hand' part of the limb to move forward as the elbow is bent. An elephant's elbows go past straight when it puts its weight on the front limb, but in most animals the elbow joint comes to the end of its travel as the limb is straightened.

The joint between the radius and the ulna should be mentioned here because, although it is not a synovial joint, it does play a part in determining the shape of the animal. You may have noticed, as a cat is walking towards you, how the front paw as it moves forward turns palm-inward. You can see this on film, too, with lions and bears. This is caused by the radius and ulna twisting around one another. They twist in this way because they are attached one to the other by fibrous tissue (Fig 2.14). This does not occur with the *Perissodactyla* (odd-toed ungulates), where there is no palm as such and the ulna has virtually evolved out of existence.

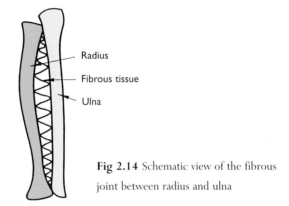

Radius

Fibrous tissue

Ulna

Fig 2.14 Schematic view of the fibrous joint between radius and ulna

The **carpals** (see Fig 2.7 on page 11) are small, irregularly shaped bones, massed together with ligaments, which collectively form a universal joint between arm and hand. The ligaments pull them together so that the whole assemblage is a flexible, bony mass. For modelling purposes you must take it as being just that. The amount of freedom in the joint varies from animal to animal; in the hoofed mammals (unguligrades), for example, the available movement is fore and aft only, but in the plantigrades and digitigrades there is more sideways and rotational freedom.

The function and shape of the parts of the lower limbs vary considerably, and you will need to study the particular animal you are modelling to identify its distinctive features. By way of example, several varieties of front and rear feet are presented on the following pages.

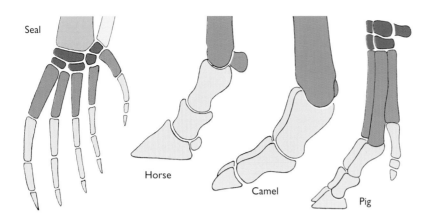

Fig 2.15 Some examples of front feet

The distal end of the front limb is diversified into hands, feet or paws with fingers or toes (Fig 2.15). All of these finger or toe bones are basically cylindrical, becoming progressively shorter as they approach the end of the limb. All of them have a joint at each end, except the last phalange which is at the extreme end of the limb. Most of the joints are hinge joints allowing movement in one plane only. All allow quite a lot of movement in the direction of the plane of the joint. Mostly the planes of the joints are in line with one another.

REAR LIMB

The hip joint between the **coxa** (hipbone) and the **femur** (see Fig 2.7 on page 11) is a ball-and-socket joint, and the amount of freedom is considerable. This joint provides fore-and-aft movement for locomotion.

The knee joint, between the femur and the **fibula** and **tibia**, is regarded as a loose hinge joint; there is a little spare sideways movement all round. Fig 2.16 shows how similar some of the joints are from one

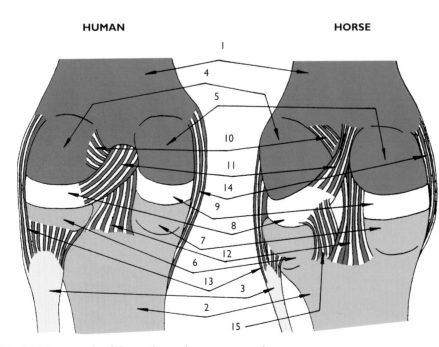

Fig 2.16 An example of the similarities between tetrapod joints: a human knee and the knee or 'stifle' of a horse, seen from behind. The outer layers of ligaments, bursae and tendons are not shown

HUMAN **HORSE**

BONES
1 Femur
2 Tibia
3 Fibula

COMPONENT PARTS OF BONES
4 Lateral condyle of femur
5 Medial condyle of femur
6 Lateral condyle of tibia
7 Medial condyle of tibia

MENISCUSES
8 Lateral meniscus
9 Medial meniscus

LIGAMENTS
10 Anterior cruciate ligament
11 Femoral ligament of lateral meniscus
12 Posterior cruciate ligament
13 Lateral collateral ligament
14 Medial collateral ligament
15 Posterior ligament of lateral meniscus

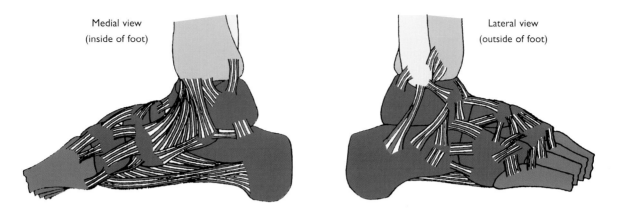

Medial view
(inside of foot)

Lateral view
(outside of foot)

Fig 2.17 The ligaments which control the freedom of movement of a human ankle joint

tetrapod to another. The knee joint sometimes entails the use of a **patella** (kneecap), which directs the ligamental effort to straighten the knee. There is freedom for the lower part of the limb to come to a straight condition in the forward movement, and quite a lot of freedom for it to bend backwards.

The **tarsals** (see Fig 2.7) are, like the carpals of the front limb, small, irregularly shaped bones, bound together with ligaments to form a universal joint between leg and foot; from the modeller's point of view they comprise a flexible, bony mass. In the unguligrades they are free to move fore and aft only,

but in plantigrades and digitigrades there is more sideways and rotational freedom. The drawing of a human ankle in Fig 2.17 gives an example of the number of ligaments involved.

The distal end of the rear limb is diversified into feet or paws with toes (see Fig 2.18). As in the front foot, all the toe bones are basically cylindrical, and progressively shorter towards the end of the limb. All have a joint at each end, except the last phalange at the extreme end of the limb. Most are connected by hinge joints, allowing quite a lot of movement in the direction of the plane of the joint only. Mostly the planes of the joints are in line.

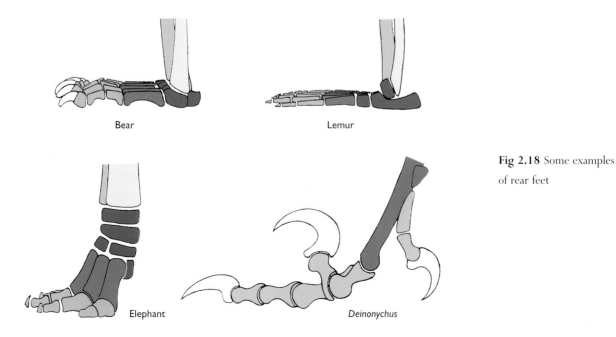

Bear

Lemur

Fig 2.18 Some examples of rear feet

Elephant

Deinonychus

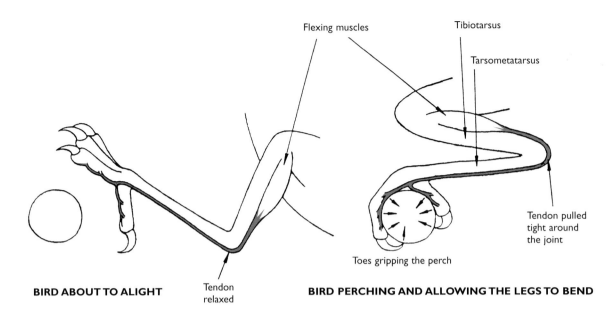

Fig 2.19 Schematic view of the perch-gripping mechanism used by perching birds (tendons shown in red)

Perching birds have long tendons running from the muscles which flex the toes to the underside of the phalanges. These tendons run from the distal part of the muscle, over the rear of the joint between the **tibiotarsus** and **tarsometatarsus** bones (Fig 2.19), to the phalanges. This mechanical arrangement means that as the bird settles its body downwards to rest, bending the legs, the tendons are stretched by the joint, pulling the toes inwards. The perch is gripped without effort by the flexing muscles and so the bird can roost comfortably for long periods without tiring. Incidentally, almost half the species of birds are **passerines** (perching birds).

MUSCLES AND TENDONS

Having considered those parts of the body which *allow* movement, we now move on to those which *produce* movement, and contribute to the final body shape: the skeletal muscles and their tendons. (Skeletal muscles are those which move the skeleton.) Muscles other than the skeletal muscles, apart from those in the face, are of no relevance to the model-maker, who needs to know only how muscles and tendons make the body move and how they provide external shape.

The **striated** (striped) **muscles** cover most of the surface areas of the body and play an important part in determining the form of the animal. They are called 'striated' simply because the muscle fibres when packed together to form a muscle give a striped appearance. The working part of each muscle is composed of bundles of **contractile** fibres covered by a sheath of connective tissue. Each fibre contracts as it is energized. Muscles can only pull; they contract (shorten) when energized, and generally swell as they do so.

As muscles have evolved they have taken up various shapes. Fig 2.20 gives an indication of the most common forms. Note that in the muscle illustrations in this book, the muscle fibres are shown in red and the connective tissue and tendons are left white.

Fig 2.21 shows the general assembly and action of muscles. On the right of the figure the muscles are shown mounted to operate a joint; this part of the illustration also shows how the muscles are mounted on the skeleton. The muscle is quite closely attached to its **origin** – that is, the part of the skeleton which is not moved (or is moved least). The other end of the muscle is usually attached to a tendon,

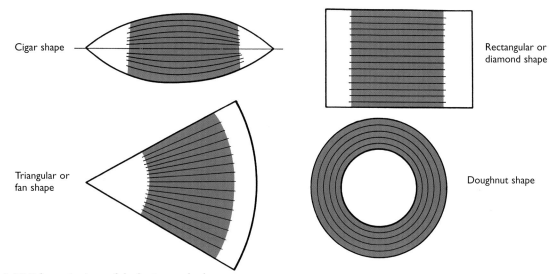

Fig 2.20 Schematic views of the basic muscle shapes

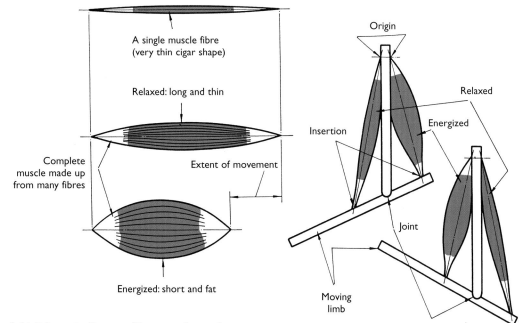

Fig 2.21 Schematic diagram of how muscles work

which then transfers the muscle effort to where it is needed; this part is called the **insertion**. However, some small muscles, particularly in the face, are attached only to the skin.

The tendons, which vary in sectional shape, are made of extremely tough tissue and extend like smooth hawsers or ribbons to transfer the muscular effort. Very often they move in lubricated sheaths or canals, which reduce wear and ensure that the tendon does not move over other parts of the body without guidance. The whole system is arranged so that the action is smooth and can act in an almost frictionless way. Very often there may be several layers of separate muscles lying in a bunch. In this case there will be thin sheets of connective tissue between the muscles which allow them to work independently with smooth motion.

Some muscles work on more than one point, in which case the end of the muscle is bifurcated and each bifurcation has its own tendon to transfer its effort. Some muscles work as a team, two or three operating on the same joint.

Musculature is a somewhat complicated subject once you start to look at it in detail, and both muscles and tendons have long, academic names. Fortunately, close study is necessary only for the model-maker who is going in for serious museum reconstructions and similar work, and is beyond the scope of this book. All we need concern ourselves with here, so that the finished model looks realistic, is those parts of the body where muscles and tendons tend to make up the outer shape (Fig 2.22).

Fig 2.22 Muscles can have a considerable effect on body shape

We have seen before that in many respects all tetrapods are really the same basic beast. This is so as far as muscles and tendons are concerned as well: the same basic muscles are there in each animal, though they are modified to suit their job in a particular body. Let us compare some examples.

Figs 2.23, 2.24 and 2.25 show the superficial musculature of, respectively, a human, a cat and a horse; Table 2.1 gives the names of the individual muscles shown in all three figures. The selection of muscles shown in these illustrations is designed to give a first glimpse of the relationships which obtain between the musculature of the various tetrapods. The human has been put in a quadrupedal stance for comparison with the others. Additionally, the human limbs have been shown in various postures: the left foot is in digitigrade stance to match the cat, the right foot is in the plantigrade stance typical of humans, bears and armadillos, and the hands are in the unguligrade stance for comparison with the horse. Most animals which adopt the unguligrade posture have evolved hoofs from their claws, and their feet have evolved so as to have fewer digits touching the ground; the fewer digits used, the faster they can run.

We will now go through the body to have a look at the various muscles with which the model-maker needs to be concerned.

HEAD AND NECK

The head is mounted on the end of the spine and has muscles running from it to the neck, shoulders and spine to control its movements relative to the body. Because the head carries the organs of sight, hearing and smell, and also houses the mouth, jaw, tongue and teeth, the speed and precision of its movement are of paramount importance to the animal. The muscle arrangements in the more modern species reflect this, while those, say, of the frog – where the neck is short – are much less apparent.

HALF TOP VIEW

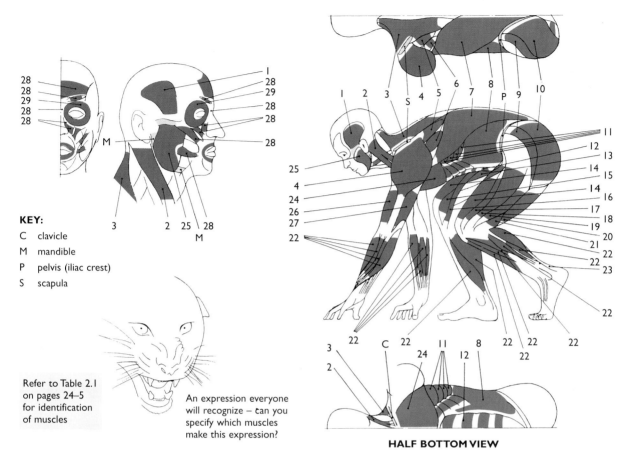

KEY:

C clavicle
M mandible
P pelvis (iliac crest)
S scapula

Refer to Table 2.1
on pages 24–5
for identification
of muscles

An expression everyone
will recognize – can you
specify which muscles
make this expression?

HALF BOTTOM VIEW

Fig 2.23 General view of superficial musculature: man

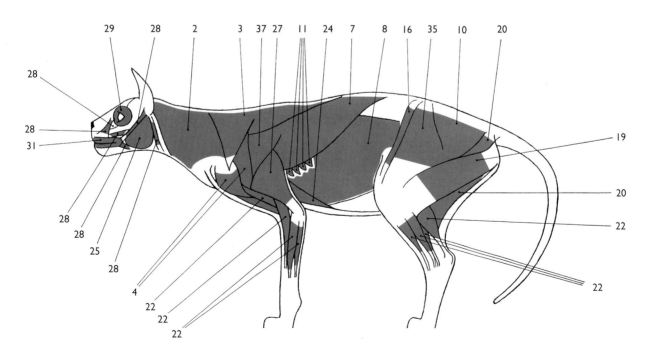

Fig 2.24 General view of superficial musculature: cat

Refer to Table 2.1 for identification of muscles

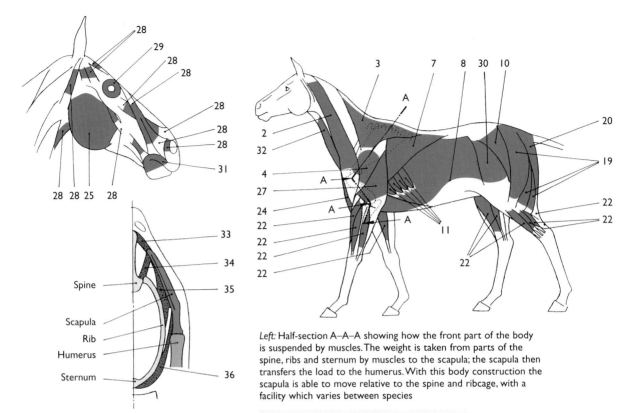

Left: Half-section A–A–A showing how the front part of the body is suspended by muscles. The weight is taken from parts of the spine, ribs and sternum by muscles to the scapula; the scapula then transfers the load to the humerus. With this body construction the scapula is able to move relative to the spine and ribcage, with a facility which varies between species

Refer to Table 2.1 for identification of muscles

Fig 2.25 General view of superficial musculature: horse

Number	Shape	Main use(s)	Origin	Insertion	Scientific name
1	Flat	Closes the mouth	Skull	Mandible	Temporalis
2	Cigar	Controls movement of head	Clavicle and sternum	Skull	Sternocleidomastoideus
3	Triangular	Moves the scapula	Back of skull and spine	Scapula and clavicle	Trapezius
4	Hollow half-sphere	Moves the humerus	Scapula and clavicle	Humerus	Deltoideus
5	Cigar	Moves the humerus	Scapula	Humerus	Teres minor
6	Cigar	Moves the humerus	Scapula	Humerus	Teres major
7	Flat	Moves the humerus	Spine and pelvis	Humerus	Latissimus dorsi
8	Flat	Bends the spine Holds in the abdomen	Ribs	Pelvis and stomach sheath	Obliquus abdominis externus
9	Flat	Moves the femur	Pelvis	Femur	Gluteus medius
10	Flat	Moves the femur	Pelvis and spine	Femur	Gluteus maximus
11	Flat	Moves the scapula Extends the ribs	Ribs	Scapula	Serratus anterior
12	Flat	Moves the spine Holds in the abdomen	Pelvis	Ribs and sternum	Rectus abdominis

Number	Shape	Main use(s)	Origin	Insertion	Scientific name
13	Cigar	Moves the femur	Pelvis	Femur	Adductor femoris
14	Cigar	Straightens the rear leg	Pelvis	Patella	Rectus femoris
15	Cigar	Straightens the rear leg	Femur	Patella	Vastus internus
16	Flat	Flexes the rear leg	Pelvis	Tibia	Sartorius
17	Cigar	Straightens the rear leg	Femur	Patella	Vastus lateralis
18	Flat	Moves the thigh	Hip tensor (tensor fasciae latae - no. 30)	Tibia and fibula	Iliotibial tract
19	Cigar	Extends the rear leg	Pelvis and femur	Fibula	Biceps femoris
20	Cigar	Stabilizes the rear leg	Pelvis	Tibia	Semitendinosus
21	Cigar	Stabilizes the rear leg	Pelvis	Tibia	Semimembranosus
22	Various extensors and flexors of the distal parts of the limb. Full details of these muscles and their names are beyond the scope of this book.				
23	Ribbon	Extends foot			Achilles tendon
24	Flat	Moves humerus	Sternum and clavicle	Humerus	Pectoralis major
25	Flat	Raises mandible	Skull (zygomatic arch)	Mandible	Masseter
26	Cigar	Flexes radius and ulna	Scapula	Radius	Biceps brachii
27	Cigar	Extends radius and ulna	Scapula and humerus	Ulna	Triceps brachii
28	Various muscles controlling facial expression. Full details of these muscles and their names are beyond the scope of this book.				
29	Flat	Closes the eye	Tissues around the eye		Orbicularis oculi
30	Triangular	Flexes the hip	Pelvis	Tibia	Tensor faciae latae
31	Doughnut	Closes the lips	Tissues around the mouth		Orbicularis oris
32	Flat	Flexes the head	Sternum	Mandible	Sternocephalicus
33	Flat	Supports front end of body	Spine	Scapula	Rhomboideus
34	Flat	Supports front end of body	Spine	Scapula	Serratus cervicus
35	Flat	Supports front end of body	Ribs	Scapula	Serratus thoracis
36	Flat	Supports front end of body	Sternum	Scapula	Pars scapularis
37	Flat	Flexes the shoulder	Scapula	Humerus	Infraspinatus

Table 2.1 Identification of the superficial muscles shown in Figs 2.23–2.25

The head has evolved into many different shapes, and this has affected the size and direction of the muscles controlling the jaw and the rest of the face, including those responsible for facial expression. Most are quite small, but if you are modelling something where the face is a major feature, and is quite large, it would be well to study the actions of these muscles.

BODY AND TAIL

The body and tail have many long muscles running along the spine, and on the body there are broad, flat muscles covering most areas. On the back there are wide muscles to the scapula and pelvis, and wide muscles covering the belly and the ribs.

Tails vary from practically nothing on humans to massive, powerful ones on the whales. The tail muscles (abductores caudae) travel along the spine.

FRONT LIMB

There are muscles attached to the scapulae and to the body. The scapulae are mounted on either side of the ribcage in a hammock of muscles, and in quadrupeds it is this hammock which carries the weight of the forward part of the body to the front legs (see the cross section of the horse in Fig 2.25). In monkeys, and other animals which hang by their hands from some support, it is these muscles which carry the weight of the whole body.

In quadrupeds, most of the limb movement is forwards and backwards, and the muscular arrangement can be quite simple; the clavicle may disappear altogether, or sometimes only a vestige of it may remain, as in the domestic cat (see Fig 4.21 on page 71). However, in the animals which can brachiate, the mobility of the scapula is retained and a well-developed clavicle is also retained.

In quadrupeds the scapula does not have much freedom to move forwards or backwards, and this provides a firm basis for the locomotive effort of the front limb. Since the scapula is mounted on the body by muscles and the clavicle alone, the top end of the front limb can change position, and model-makers should be aware of this. You should note which animals have a comparatively large degree of scapula movement, and which do not. Watch a lion in side view walking, or rather slinking, along: see how much the scapulae move, and notice how much the top of the scapula modifies the line of the back. Watch an elephant's back to see how its shape is altered by the upper end of the scapula.

Any tenseness in a front limb arises from the action of the muscles; the limb has no other method of holding any pose (except hanging down). All of the

muscles the model-maker is concerned with run along the limb, and they are generally long and thin. In the running quadrupeds (digitigrades and unguligrades), the muscles which pull the limb backwards are well developed and can exert powerful efforts.

The muscles which control the 'hand' are mostly in the area between elbow and wrist. They are usually long and thin, and lie in the direction of the limb; the muscle effort is transferred to the 'fingers' by tendons. To identify the flexors and extensors in your own arms, put out your left arm horizontally in front of you with the hand palm-downwards. Put the fingers of your right hand on the top of your left arm between the wrist and the elbow (slightly nearer the elbow). Now lift your left-hand fingers upwards strongly, without bending the wrist. Feel the **extensors** working under your right-hand fingers. Now put the fingers of your right hand on the underside of your left arm and make a powerful clawing or gripping motion with your left hand. You will feel the **flexors** working under your right-hand fingers.

The **intrinsic** muscles in the hand or foot themselves are very small, and their details are beyond the scope of this book.

REAR LIMB

The rear limbs of quadrupeds carry the weight of the rear end of the body and of the tail. In bipeds, of course, they carry all of the body weight.

The top end of the hind leg cannot move relative to the body as does the top end of the front limb. The upper end of the femur is connected by a ball-and-socket joint to the pelvic bones, and so has practically no relative movement where it joins the body; its position is fixed. Since it is used mainly for locomotion, the rear limb has been involved in far less evolutionary change or modification of use than the front limb.

Most of the musculature at the top of the rear limb provides effort to move the limb forwards and backwards; the muscles which draw the limb backwards are the most powerful, especially in the running quadrupeds (the digitigrades and unguligrades). There is very little muscular effort to produce any sideways motion, except in animals which climb.

As with the front limb, any tenseness of the rear limb arises from the action of the muscles. The limb has no other method of holding any pose (other than hanging down). All the muscles of interest to the model-maker run along the limb and are generally long and thin. One should note how the **patella** (kneecap) directs the ligamental effort to increase leverage.

The calf muscle, with its tendon (Achilles tendon or tendo Achillis) running to the back end of the heel (known as the 'hock' in horses), is important for the model-maker because it contributes so much to the shape of the rear part of the hind limb.

In the foot, the principal muscles are in the area from knee to ankle, and the muscle effort is transferred to the toes by tendons. The intrinsic muscles in the foot are small, and their details are beyond the scope of this book.

INTERNAL ORGANS AND FAT

The modeller need not be concerned with the internal organs of the body except where they help to form the outside shape of the animal. They do this mainly on the ventral surface, particularly in the stomach area, where they shape the belly. The base of the tongue helps to shape the underside of the jaw line; the larynx (Adam's apple) and oesophagus (gullet) work alongside the neck muscles to help shape the ventral surface of the throat. Cows' udders and the mammary glands of sows and

bitches play their part in body shaping, as do genital organs. If enough depth of detail is required on the model, these features should be studied. Birds' crops also help to shape the ventral surface of the body.

When animals eat more than their body needs, they tend to store some of the excess as fat. Hibernating animals are particularly good at this; bears, for instance, put on a lot of weight ready for the winter. We all know how much humans vary in this respect; animals do too.

EXTERNAL FEATURES

Finally, we must consider those details on the outside of the animal which complete its identity. When you are looking at and feeling a cat, say, the message you receive may be something like this: a large, male, seal-pointed Siamese cat which is lying down relaxed and purring, moving its front feet forwards and backwards with the claws half-out, its eyes half-closed. You have observed the species of animal as well as some of its individual characteristics, you have some body language and you have some posture detail. If you are making a model of this particular cat, your model will start to look realistic when you have depicted all these features. Even the purring should be suggested by the way the body is arranged.

THE EYES, EARS, MOUTH AND NOSE

EYES
The eyes must be right. The message bears repeating: *the eyes must be right*, because they are the most expressive part of the animal. You must ensure they are exactly in the right place, and that they match so that when you look at the model you do not find one eye higher or lower, or more forward or backward than the other.

The eyes of tetrapods work together. Your model must show this feature, especially if it is an animal with forward-facing eyes – you don't want a majestic tiger with a squint, for example. (Though such animals do tend to squint when focusing on a nearby object, because each eye looks directly at the object.) Even with an animal which has its eyes on the sides of its head, if you look at it directly from the front you can see both eyes: they face forward just a little. Also, when one of these creatures moves, say, the right eye to the front, then the left eye will move to the rear. In other words, their eyes work together just like ours. (Of course there always has to be the exception: the chameleons move each eye independently.) Eye movement is reduced in some species, such as snakes and owls.

The size of the eyes must also be right: there is a vast difference in size between elephants and humans, for example, but an elephant's eye is about the same size as a human eye. The eyes of a tarsier are enormous in proportion to the size of its body, especially when compared with, say, those of a blue whale.

When modelling eyes, look to the expression of the eye, the shape of the exposed part of the eyeball, the expression given by the eyelids. Is it a wide-eyed stare? Is it a half-asleep look? Are the eyes alert, looking carefully to spot danger?

Take care with the pupil: some eyes have distinctive pupil shapes, and these may change with the light. Some examples are shown in Fig 2.26. In humans the white of the eye shows. This is unusual: in most animals only the iris shows.

If your animal model is big enough, you may have to include eyelashes, and these need a little study. An elephant's eyelashes go in all directions; a giraffe has particularly elegant ones.

The upper eyelid usually moves much more than the lower one. Many animals – owls are an example – also have what is called a **nictitating membrane** in each eye; this is the so-called 'third eyelid', which moves sideways across the eye, beneath the eyelids proper (see Fig 2.26). Maybe your model should show this.

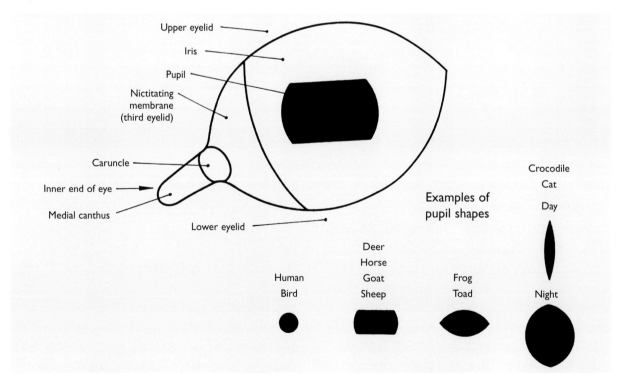

Fig 2.26 Schematic view of the external parts of the eye

The **medial canthus** (see Fig 2.26) extends away from the eye towards the front end of the top lip by different amounts. In humans it is short, but in some animals, such as deer or lions, it extends quite a long way.

EARS

Model-makers need only be concerned with the outer part of the ear. The part which sticks out from the head is called the **pinna**, and only mammals have this. It has effectively evolved from nothing: amphibians and reptiles have only an ear opening on the side of the head or a disc-shaped drum level with the surface. Usually the pinna is funnel-shaped, and each ear can be moved to face any direction the animal wishes. Humans have lost this facility – though if you think carefully and try to move your ears you may just feel those old muscles trying to move.

The ear functions as a sound funnel. We humans can tell easily enough which direction a sound is coming from, even though our ears are fixed in one direction relative to the head, but in animals with rotating sound detectors (pinnas) the hearing mechanism gives a quicker response, which improves their chances of survival.

For the efficient collection of sound energy, evolution has produced some particularly elaborate ears – especially those of some bats, who establish the geography of the masses around them by sending out sound waves which bounce off solid objects in the vicinity. The waves come back, the ears pick them up and the bat 'sees' its environment by sound.

Some animals use their ears in more ways than hearing. For instance, the elephant uses its ears, which have large blood vessels in them, as a cooling mechanism: it extends its ears and waves them to cool its blood. The elephant will also extend its ears and then clap them together as a warning device.

For the modeller the position of the ears on the skull is very important: they must be in the right place. In mammals their direction and degree of erectness are significant, because they are organs which give off a lot of body language. For example, if your model is of an animal which is listening hard for the suspected predator, or trying to sense prey, then the ears must be wide apart, extended in a funnel shape and directed towards the place the animal is interested in. The animal may then turn its head to point in that direction, so that the ears may return to their forward-facing position and not be twisted sideways.

MOUTH

For the modeller the jaw is a pretty inexpressive object – it is either open or closed – but the lips give some animation. Monkeys, in particular, move their mouths around as part of their body language. The snarl is quite a common expression, of course. Therefore the shape of the lips has a place in the body language of mammals. Amphibians, reptiles and birds have no lips.

The mouth, if open, shows the tongue and the teeth. The tongue is usually of a 'standard' shape, except in some lizards and snakes, where it is forked. The teeth vary according to species; you will need to study the teeth of your animal if the mouth is to be open. Some teeth are exposed even when the mouth is closed: elephant and walrus tusks, crocodile and some dinosaur teeth are always on show.

NOSE

The external part of the nasal system varies a lot in shape and size. Its duty is to control air input and output to and from the body. It usually comprises two nostrils, though some animals – some whales for instance – have only one nostril. The surround for these nostrils varies from simple openings in the face, as in tortoises, to elaborate structures like the elephant's trunk.

Some animals use their nose for other purposes; the pig, for example, uses it for digging. Some animals' noses have protective features about them, like the camel's nostrils which it can close to keep sand out. The star-nosed mole has a beautiful nose with a star-shaped end; the proboscis monkey has a long pendent nasal extension.

The noses of many mammals are black, and sometimes wet and shiny. The skin is uneven, with a series of tiny bumps on it, like an orange skin. Noses of this type have slits at the outer bottom end of the nostril; this feature allows the nostril size to be adjusted. There is also a frontal groove which extends down to and parts the top lip. Typical animals with this type of nose include the **canids** and the **felids** (dogs and cats), and bears.

THE GENERAL COVERING OF THE BODY

SKIN

The skin is a major organ of the body, and its fabric varies with the animal it protects: from smooth, uneventful expanses in whales or frogs, to rough, folded areas in elephants and walruses. The skin is the wall which divides the animal from its environment, and in carrying out that duty it has to endure all the varied responses the environment applies to it, from heat, cold and desiccation to direct attacks from other forms of life.

Skin very often carries further protection for the body in the way of scales, hair or feathers. The skin of reptiles is water-resistant and is usually scaly. Where skin is continually subject to wear and tear it makes extra tissue; examples are the pads on the feet of many mammals, or the pads on the backsides of monkeys where they sit down. Where the skin is being harassed by insects, for example, evolution has supplied muscles which can twitch the skin to disturb the pests.

Skin fits quite tightly against the underlying tissues in some places, and is quite loose in others. Felids and canids have loose folds of skin around the neck as a defence against biting. In large animals the weight of the skin along the flanks tends to make it sag away from the body where the flank meets the belly; this is characteristic of elephants, and presumably occurred in the large dinosaurs.

The skin also has to make allowances for limb movement; an instance of this which is relevant to the model-maker is the fold of loose skin which can be seen in many animals at the top end of the front of the rear limb. This is needed to allow for skin displacement when the animal moves its rear legs to their full extent. When the limb is relaxed, the skin hangs down in a fold.

Skin has found other uses: it forms the infilling for webbed feet, the filling in bats' wings (and formerly in **pterosaurs**' wings), and the crests and dewlaps of various animals. It provides the 'wings' for flying squirrels, and the pouches for containing kangaroo youngsters. It even provides the covering of the cobra's hood, extending over the spread ribs to form the distinctive shape; while such diverse features as the warts on warthogs and toads, and the **scutes** of reptiles, are all special varieties of skin.

HAIR

Body hair is limited to mammals, and is used for protection. Most mammals have a complete coat of hair, and the density, length and other characteristics vary with the species: from the hollow hair of the polar bear to the sleek coats of horses, from great masses of hair on camels, sheep and yaks to much thinner coats on elephants. Some hairs, such as those in the tails of elephants, grow quite stout. Hair growing in manes around the spinal part of the neck (especially in male lions), and around the vulnerable part of the throat, provides protection from bites from males of the same species when they fight. Eyes are protected by eyelashes which tend to sweep away obstacles from the eyes.

On many mammals, long, coarse hairs grow from sensitive cells in regions above the top lip, adjacent to the nose, and provide the animal with a warning every time the hairs touch an obstacle. These hairs are called **vibrissae**.

It is useful to remember that hair tends to run in particular directions, and may form quite distinct mats and tufts; if such patterns are included in a model they will increase its realism.

FEATHERS

Birds are the only existing creatures which have feathers. These have several duties: they are used for flight, insulation, waterproofing, and in the body language of courting or territorial display. They help to protect the body; they are wind- and water-resistant, and so help to conserve heat and to shed rain. The flat feathers cover the body with a sleek aerodynamic shape, while the large wing and tail feathers form part of the bird's flying mechanism.

Feathers are made from keratin, the same material as nails and hair. Birds' feathers are modified reptilian scales, and birds show their reptilian ancestry in many ways, such as the reptile-like eye and the scales on the lower leg.

There are several types of feathers, from the small, fluffy feathers which usually lie close to the body and cover most of it, providing warmth, to the stronger and longer flight feathers which are sited on the wings and tail. In this book we are only concerned with the **pennae** or main feathers, which give the bird its shape and form a mechanism by which the bird can fly, manoeuvre and land safely.

The general arrangement of the wing flight feathers is shown in Fig 2.27. The pennae are generally divided into several groups: primaries, secondaries, tertiaries, rectrices (tail feathers) and coverts (covering feathers). The primaries, secondaries and tertiaries collectively are the **flight feathers**. Primaries, mounted on the bird's 'hands', control the airflow to push the bird forward in flight, and opening them up serves to reduce the stalling speed. Secondaries, mounted on the ulnae, control the airflow to maintain the bird in the air. Tertiaries, mounted on the humeri, work with the secondaries. **Rectrices** are stiff tail feathers. They allow the bird to stabilize its flight by providing guidance, balance and braking. They are mounted on the pygostyle. **Coverts** are contour feathers: they make a covering over the quills of the flight feathers so that the external surface of the wing is smooth.

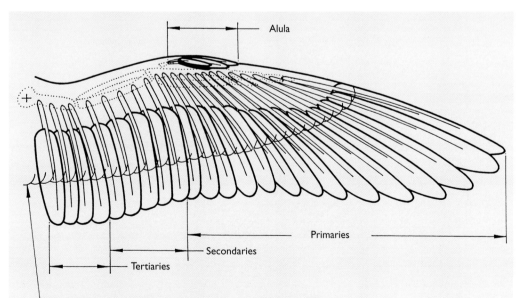

Alula

Primaries

Secondaries

Tertiaries

This line indicates the rearward extent of the covert feathers, which make a smooth air passage over the quills of the wing flight feathers

Fig 2.27 Schematic top view of a bird's wing, showing the arrangement of the wing feathers

31

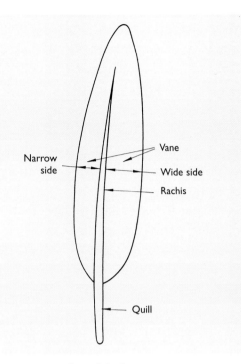

Fig 2.28 A typical vaned feather

Fig 2.28 shows a typical feather of this kind. It consists of a central stem, on part of which a **vane** is mounted. The stem is tapered; the wide end is the **quill**, and the part which carries the vane is the **rachis**. The quill is mounted in the body of the bird. It is round in cross section. The rachis is

U-shaped in cross section, and the feather is mounted on the body so that the U-shape faces down. The rachis is also curved sideways a little, so that the feather is slightly curved when looked at from above or below. Additionally, if you look along a wing flight feather you will see that the vanes are curved as they extend away from the rachis: the narrower vane is concave on its top surface and the wider vane is convex on its top surface.

The vane is mounted on each side of the rachis and extends outwards to form an area which is resistant to airflow. This causes the feather to act in the same way as a paddle. The vane extends further away from the rachis on one side of the feather than the other. This unequal arrangement of the vane enables the primary, secondary and tertiary feathers in combination to offer more resistance to airflow on the downbeat of the wing than on the upbeat (Fig 2.29). When a bird beats its wings downwards the wing does not move through the air easily, and so any movement of the wing relative to the bird's body pushes the bird upwards. The valve-like action of the primary feathers additionally works to reduce the stalling speed of the bird – in other words, to enable it to fly more slowly

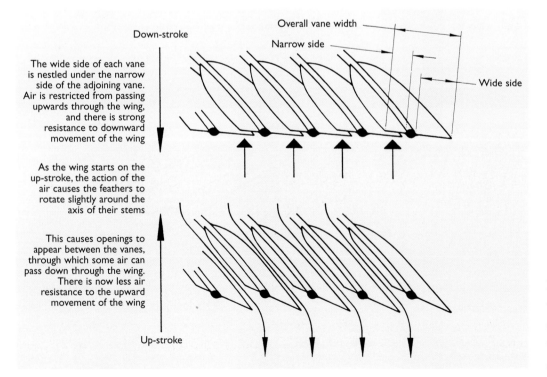

Fig 2.29 How wing feathers act as a valve to increase efficiency

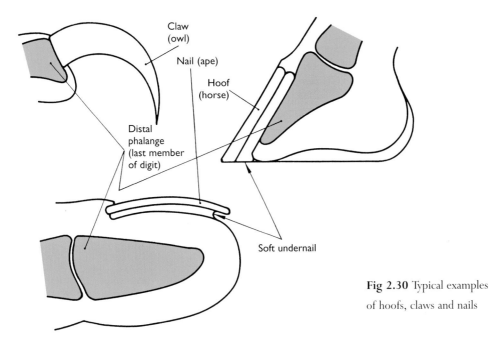

Fig 2.30 Typical examples of hoofs, claws and nails

without falling. The design of feathers, together with their action when the bird is flying, is an engineer's delight. The entropy of the system is amazing.

For keen modellers, a representation of the **alula** or bastard wing may be worth including. This is a tiny wing attached to the bird's 'thumb' (first digit), and is shown in Fig 2.27. It is used to modify airflow over the wing, to reduce stalling speed, and to help during take-off.

HOOFS, CLAWS AND NAILS

The digits have endpieces which may be either hoofs, claws or nails. Reptiles, amphibians and birds have claws; mammals may have any of the three options. Nails are confined to the primates (humans, apes, monkeys and lemurs) and the shrews.

All these pieces grow from roots in the digit and are mainly composed of keratin (a fibrous protein). Being on the ends of digits they find a variety of uses according to the animal's requirements: scratching, grasping, offence or defence, or fine manipulation of objects. Their shape varies considerably according to their use, and Fig 2.30 shows just a few of the variations.

HORNS AND ANTLERS

Horns are made of keratin, antlers of bone.

Horns grow continuously; they wear away, but they are not shed. They grow from the **processus cornus**, a hollow conical form which varies in size and shape in proportion to the overall size of the horn. This process is covered by the **corium** of the horn, which is made of keratin. The corium covers the cornus in a progressively thickening layer, until at the tip it forms a solid mass. The horns of a rhinoceros are rather different: they are formed by fibres of keratin growing from a flat cornus on the skull, and these fibres are cemented together to form the horn.

Antlers are renewed each year for the mating season. They grow from the cornus areas on the skull. The growing antler is covered by skin (called velvet), which nourishes the antler until it is fully grown, and is then shed. After the mating season there is an isolating process at the point where the antlers meet the skull, the antler is no longer supported, and it falls off. As the animal gets more mature, so the antlers increase in size and complexity of shape each year.

BEAKS

Amongst the tetrapods today, beaks are a speciality of the birds – although it could be said that tortoises and turtles have beaks, since the tissue they have in that area is the same hard epidermal (skin) material from which beaks are made. In the ancient world, pterosaurs such as *Quetzalcoatlus* and some dinosaurs such as *Triceratops* had beaks.

The beak covers the entrance to the mouth and the nose, and the nostrils are situated at the top, towards the rear of the upper half of the beak. Many different varieties have evolved for different purposes; Fig 2.31 shows a range of beaks and the uses to which they are put.

SCALES, PLATES, SCUTES AND SPINES

Scales or horny scutes are variations of skin, and they are located on or in the skin.

Dinosaurs had dermal armour much like that of crocodiles today. Crocodiles, alligators and gavials all have scutes in the skin. Although the scutes are horny, they have areas of smooth skin between them so that

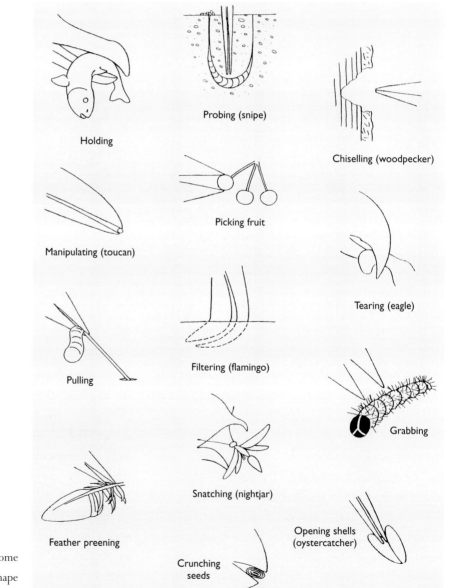

Fig 2.31 Beaks; some examples of how their shape has evolved to suit their use

Holding

Manipulating (toucan)

Pulling

Feather preening

Probing (snipe)

Picking fruit

Filtering (flamingo)

Snatching (nightjar)

Crunching seeds

Chiselling (woodpecker)

Tearing (eagle)

Grabbing

Opening shells (oystercatcher)

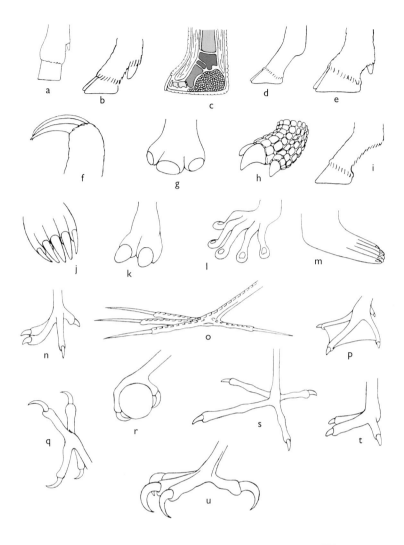

a	Klipspringer
b	Pig
c	Elephant
d	Deer
e	Cow
f	Sloth
g	Rhinoceros
h	Armadillo
i	Horse
j	Mole
k	Camel
l	Tarsier
m	Seal
n	Walking bird
o	Lily-trotter
p	Swimming bird
q	Climbing bird
r	Perching bird
s	Wading bird
t	Running bird
u	Predatory bird

Fig 2.32 Examples of hands and feet

the skin as a whole is quite flexible. Tortoises and turtles have bony protective shells which cover the body. These are made up of plates, formed from bone with keratin on top. The plates are fused together, and as the animal grows each plate grows with it.

Lizards have quite a range of features on their bodies: horns, crests, spines, scales. Smooth scales cover the bodies of snakes. Birds have scales on their legs, and these may be a last remaining remnant of the skin of the dinosaurs from which birds are descended. Rats have scales on their tails. Porcupines and hedgehogs have spines. Many animals have pads on the underside of their feet which are covered by small studs of hard skin called **papillae**. The armadillo has horny plates all over, and pangolins are covered in scales made of hair.

HANDS AND FEET

These parts of the body have almost as much character as the head. They certainly need the model-maker's close attention, because there is a lot of detail in their construction. The shapes of hands and feet show what sort of job they have to do, and it should be noted what shape they take when they are doing their job. Camels have wide feet to prevent sinking in desert sand; lily-trotters have toes so long and widely spread that the bird can walk on lily leaves; polar bears' massive hairy feet form ice shoes which prevent slipping on the ice; elephants have great spongy feet to spread the weight. Falcons and eagles have strongly clawed feet for grasping, whilst mountain goats have tiny hoofed feet. Fig 2.32 shows just some of the many different forms.

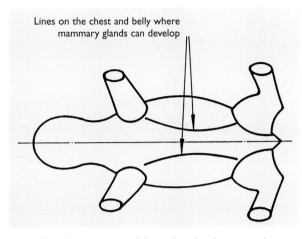

Lines on the chest and belly where mammary glands can develop

Fig 2.33 Schematic view of the underside of a mammal, showing location of mammary glands

MAMMARY GLANDS

Mammary glands are the feature which distinguishes mammals from all other animals. The number and location of these glands vary. Pigs, for example, have glands all the way along the milk ridges which extend along the ventral parts of the body from the front limbs to the rear limbs (Fig 2.33). Elephants have only two, over the pectoral muscles, and cows have four on the belly, these being grouped on an udder. Many animals, such as guinea pigs, have two on the belly.

GENITAL ORGANS

Some models, in order to be realistic, need to show genital organs. The scrotum of bulls, for instance, is a very prominent feature. The **prepuce** extends from the scrotum forwards along the sagittal plane, almost to the **umbilicus** (navel). Sometimes there is a tuft of hair at the forward end (see Fig 3.8 on page 44).

WET AREAS

Some parts of the body surface are characteristically wet: the eyes, the nostrils, the mouth, the musk glands on the sides of an elephant's head. Sometimes it might be appropriate to show sweat on the surface as well.

EXTRANEOUS SURFACE MATTER

Animals get muddy and sweaty; sloths carry algae. If an animal is shown feeding it may have some hay in its mouth; feeding lions may have blood on their faces. A frog may be carrying eggs or even young on its back; a mother orang-utan may have a baby clinging to her.

COLOUR

Use a copy of your drawing to set down the animal's coloration and pattern of markings. This will help enormously if the colours and pattern are complicated – get it right on the drawing first. Note that most animals are darker on the top than they are on the underside, for camouflage.

BODY LANGUAGE

This is the point which determines whether your model will look alive or not. Does it show just the right position of the head? Is the stance right? Can you see the right muscles tensed? Is the animal really relaxed? Would you expect it to leap at any moment? The more carefully you study your chosen animal at the outset, the more chance you have of getting these things right.

COLLECTING AND ORGANIZING INFORMATION

Once you have chosen the animal you want to model, the first thing you need to do is to familiarize yourself with it. You really want to get that close to it you can smell it, if you see the kind of familiarity I mean. You want to know what sort of expression it will have if it is hungry, angry, or wants to play. You want to know what sort of calls it makes when mating, and when fighting. You want to know what body positions it takes up when faced with certain conditions. When modelling, you will want to know how your animal looks from above, from below, from every direction.

If you are painting a picture you are only concerned with two dimensions: height and width. It is vastly different when you are modelling in three dimensions: here you have height, width *and* depth. This third dimension means that you have to allow for an unlimited number of different views of the model.

Time spent on this sort of study will pay off handsomely when you start to set the information down to record your animal. You will then be in a good position to describe it, and to model it. You will carry its character into the model. (A model can be made to exactly the right measurements and still be just a lump. The person who gets the character into their model helps to make it live.) Think how much you know about an old friend, compared with someone strange you pass in the street. Quite a lot, you might think - but think a little bit more: just how familiar are you with the appearance of the old friend? Just what shape are his nostrils? Exactly how

much do his ears stick out? When you ask questions like this you will start to realize just how little you really know about the details of your friend's appearance. Remember this when collecting information for your proposed model.

WHERE TO COLLECT

There are many ways to collect information: be with the animal itself, go to the zoo, the farm, the countryside, natural history museums, veterinary colleges, libraries. Natural history museums and veterinary colleges will have stuffed animals, skeletons, preserved specimens and monographs; reference libraries will, of course, have books.

Zoos, farms, museums, colleges, libraries all have staff. These people specialize in what they do. Ask them for help. All of these people, if they know you are interested, are extremely powerful in supplying knowledge. (When talking to your librarian, ask for functional anatomy. When talking to the curator of your museum, ask for monographs.)

WHAT TO COLLECT

Information of all sorts can be useful, but first of all you will want to collect the kind of information which provides the main building blocks to form your model: the lengths of the legs, the size and shape of the head, the general attitude of the body. Most of this information will be in the form of measurements.

a Dog

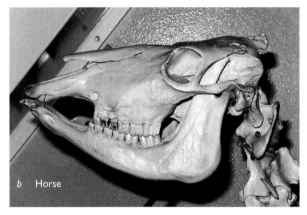

b Horse

To get these measurements you will need to see the live animal, the stuffed animal and, if possible, the skeleton for measurement (Fig 3.1). Use of a measuring stick, marked off in whatever units you prefer to use, will form a basis for measurement; include it in any photographs you take (Figs 3.2 and 3.3). Probably in addition to this you will need to collect photographs taken by other people. Beware of drawn illustrations – they can be very good, but some are very bad. Take colour photographs of any specimens; take them from all angles, from any spot. When making the model you will want to know just what it will look like from that very spot. If you guess, you will guess wrong. Collect information like a sponge; you can sort it out later.

If you model animals to any extent you should start a library, and whenever you see any useful information, take a copy. Set up files collecting the information together in an orderly fashion. Photograph your own models – even the bad ones. You will soon start to use your library.

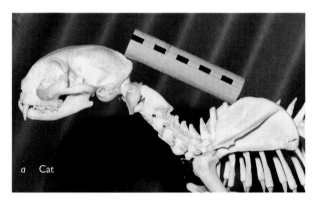

a Cat

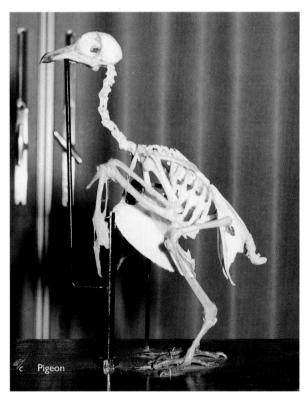

c Pigeon

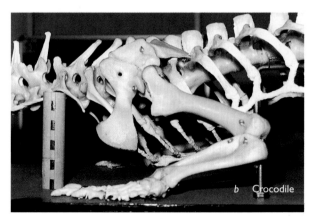

b Crocodile

Fig 3.1 Measurements taken directly from the skeleton are invaluable to animal modellers

Fig 3.2 Use of the measuring stick in reference photographs

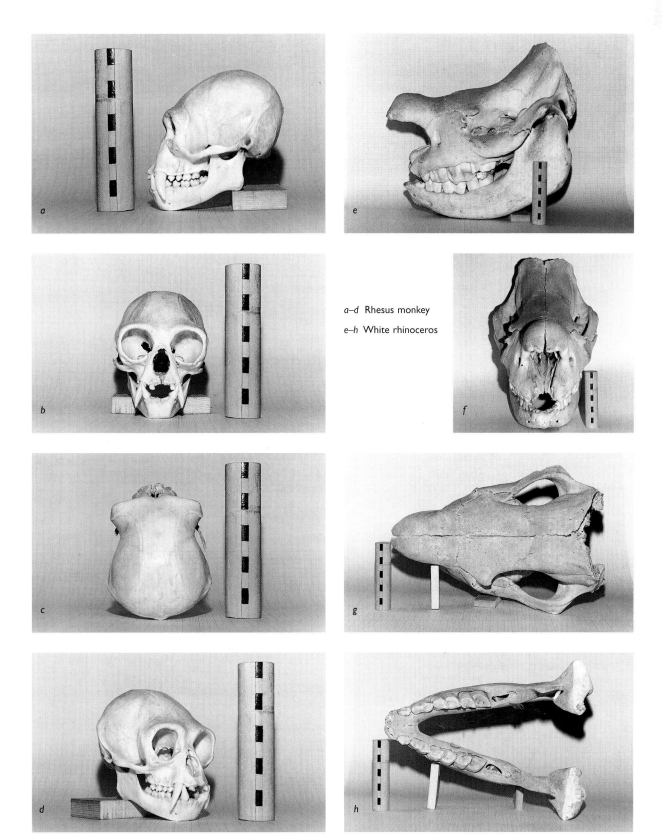

a–d Rhesus monkey

e–h White rhinoceros

Fig 3.3 Aim to build up sets of photographs showing the same item from different directions. Using the measuring stick in each photograph will enable you to correlate measurements from one view to another

HOW TO COLLECT

Once you have plenty of information about your animal, you can start to put it in order to make your drawing. The detail you have will be in many different forms: photographs, measurements, sketches, notes, photocopies. Maybe a museum has loaned you a skeleton, a stuffed animal, a model, or a preserved specimen.

If you have a good set of drawings or photographs of the animal's skeleton, you can get all the leading measurements from this. Provided the drawings are all in scale with one another, or the photographs include a measuring stick, all you have to do is to take the measurements, then later scale them up or down according to the size of your intended model. This is why it is so useful to get skeletal details: you have direct access to the fundamental dimensional information for your model.

If you have access to the skeleton itself, you also get life-size measurements. Fig 3.4 shows some photographs of the skeleton of the extinct dwarf elephant *Palaeoloxodon falconeri*, which I was commissioned by Dr Plodowski to reconstruct for

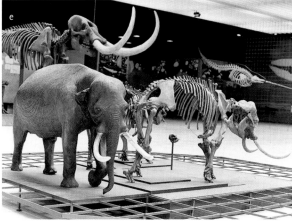

Fig 3.4 Reconstructing the extinct dwarf elephant
Palaeoloxodon falconeri (Photographs by courtesy of
Dr G. Plodowski, Forschungsinstitut und Naturmuseum
Senckenberg, Frankfurt/Main)

a–d Views of the original skeleton
e The completed model installed next to the skeleton at the
Frankfurt natural history museum (see also photograph on
page 126)

the Frankfurt natural history museum. Taking
measurements from information like this is ideal.

If you do not have skeletal information, then you
must turn to other sources. First of all, photocopy
each useful photograph and at the same time enlarge
it to a size at which you do not have to strain to see
details. Better still, photocopy it to the actual size of
your model. Black and white copies will do. Give
each a reference number. I will call these
photocopies 'reference images'.

(When using material of this sort, first check the
copyright law which is applicable in your country. If
you are not allowed to make photocopies for your
own private use, then trace the photograph instead.)

Now, if these reference images are not skeletal
photographs or drawings, carefully draw on them

the skeletal details; the information you learned in Chapter 2 should be helpful here (Figs 3.5–3.7). Draw in the spine, and put crosses on the joints to indicate the limb positions. One point to note in Fig 3.6 is the long fingers and toes the deer has; this is precisely the kind of detail you need to be aware of when plotting the positions of the joints on your reference images.

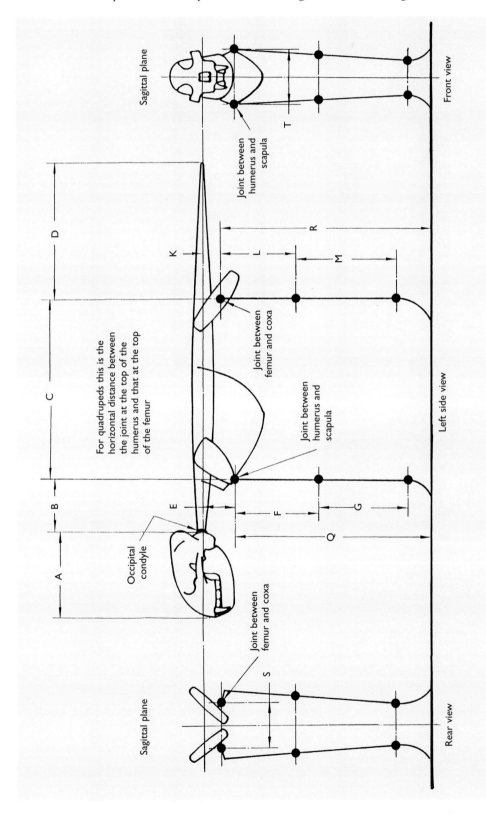

Fig 3.5 Schematic drawing showing some of the leading measurements needed when specifying a tetrapod (see Fig 2.7 for explanation of the lettered measurements)

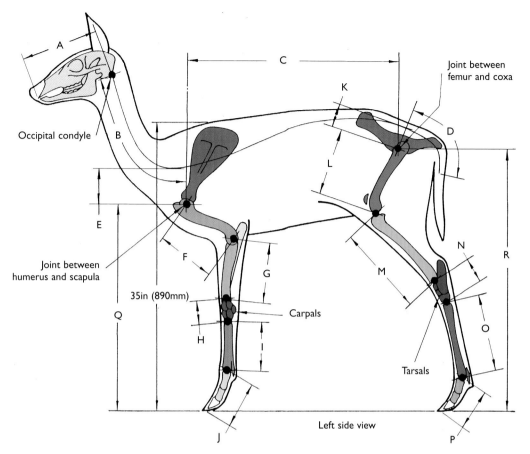

Fig 3.6 A simple drawing of a female fallow deer (*Dama dama*), showing how the measurements indicated in the previous figure apply to a real animal

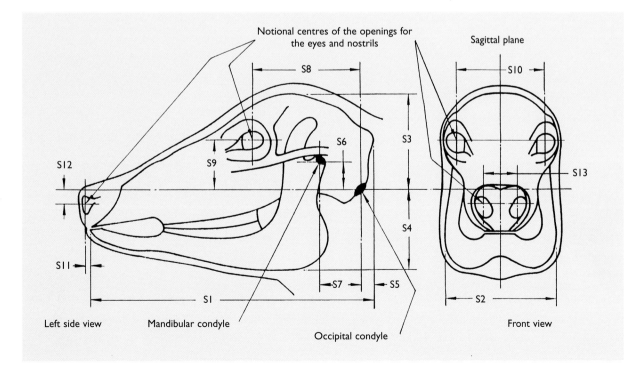

Fig 3.7 The head and skull of a deer, showing some of the leading measurements needed when specifying a tetrapod's head

When examining photographs or other views of animals, be aware of the effects of perspective. The view of a bison in Fig 3.8 is a three-quarter view, and you have to be very careful if you are going to take measurements off this. You will need to know how perspective distorts measurements. Perspective is explained in many drawing books, and all modellers should be aware of its effects.

Fig 3.8 The outline of a bison in three-quarter view, as it might appear when traced from a photograph. Measurements taken from this kind of view need to be treated with caution because of the effects of foreshortening

Again, when working from photographs, remember that the direction of light can alter the appearance of the image. Also be aware of this when comparing one photograph with another.

HOW TO GROUP THE MEASUREMENTS

Now take your reference images and measure (in whatever units you prefer) the various features indicated by letters in Figs 3.5–3.7. Put these measurements into a schedule, as shown in Table 3.1. This can then be used directly to draw your animal, once the measurements in the schedule have been scaled up or down as required.

Body skeleton (see Fig 3.6)		Skull (see Fig 3.7)	
A	2.7	S1	2.8
B	4.1	S2	1.4
C	6.5	S3	0.6
D	3.7	S4	1.0
E	1.0	S5	0.3
F	1.6	S6	0.0
G	2.2	S7	0.25
H	0.4	S8	0.85
I	2.0	S9	0.15
J	1.0	S10	1.1
K	0.5	S11	0.2
L	2.0	S12	0.4
M	3.3	S13	0.3
N	0.4		
O	2.7		
P	1.0		
Q	6.2		
R	8.1		

Table 3.1 Example of a schedule of initial measurements made from photographs or other original information

Once I have my first set of measurements, I then convert them to life-size dimensions. (Of course, if you have had the opportunity to measure a skeleton, the measurements are already life-size.) A model of any scale can then be made simply by scaling the measurements up or down according to the intended size of the model.

HOW TO OBTAIN A SINGLE SET OF MEASUREMENTS FOR MAKING THE DRAWINGS

If you are not able to obtain measurements in such a direct way, then you will have to combine information from more than one source. This will probably mean photographs, or whatever, which are at different scales, from different viewpoints, at different distances, and quite possibly showing different animals of the same species.

Take all useful photographs or drawings and enlarge them by photocopying, as mentioned before, to make reference images. Give these images reference numbers, and draw on them the parts of the skeleton which are likely to be useful, using the reference letters given in Figs 3.5–3.7. Measure these useful parts and put the measurements in a schedule as before, using a separate column for each reference image. Table 3.2 (which represents the measurements of the deer shown in Figs 3.6 and 3.7) shows an example of what this will look like; in this case, four reference images (numbered *i–iv*) were used for the body measurements and three (*v–vii*) for the head. The entries for A shown in bold type in columns *v–vii* are derived by subtracting S5 from S1as shown in the same column.

	Body skeleton (see Fig 3.6)				Skull (see Fig 3.7)		
	i	*ii*	*iii*	*iv*	*v*	*vi*	*vii*
A	4.05	4.86	2.16	5.67	**1.74**	**4.05**	**3.04**
B	6.3	7.4	3.3	8.93			
C	9.0	12.1	5.1	13.91			
D	6.03	6.7	2.71	6.95			
E	1.2	1.6	0.89	2.1			
F	2.51	3.2	1.09	3.71			
G	3.1	4.1	1.65	4.75			
H	0.62	0.75	0.31	0.82			
I	2.75	3.5	1.32	4.4			
J	1.1	1.9	0.88	2.9			
K	0.7	0.91	0.41	1.12			
L	3.1	3.9	1.6	4.8			
M	4.2	5.72	2.71	6.55			
N	0.58	0.74	0.39	0.82			
O	4.03	4.9	2.06	5.56			
P	1.9	1.1	0.81	2.2			
Q	10.2	12.5	5.22	13.95			
R	12.15	14.58	6.48	17.01			
S1					1.96	4.48	3.36
S2					0.96	2.5	1.75
S3					0.45	0.99	0.69
S4					0.77	1.25	1.1
S5					0.22	0.43	0.32
S6					0.00	0.00	0.00
S7					0.2	0.38	0.25
S8					0.49	1.36	1.02
S9					0.22	0.22	0.12
S10					0.77	1.95	1.39
S11					0.15	0.32	0.25
S12					0.32	0.68	0.49
S13					0.25	0.49	0.36

Table 3.2 Example of a schedule of measurements compiled from multiple reference images

Because the head and body measurements here have been taken from different sources, they must be connected so that we can establish a relationship between them. This is done by ensuring that one of the dimensions quoted is common to both sets of measurements. In Table 3.2 it is measurement A – the length from the front of the skull to the occipital condyle – which appears in all the columns and provides the necessary connection between the body and head measurements.

A little arithmetic is now needed to obtain the measurements you require for your model. The arithmetic is simple, and plays an important part in determining the specification of your animal, so please don't be put off by it. Just go through each step in turn. The whole process is straightforward and it gets easier each time you do it.

We are going to average out the measurements from our seven reference images, and in order to do this we first need to reduce the measurements in the seven columns to a uniform scale. It is best to start with a dimension which is easily measured and quite large, so the percentage of error will be small. For this example I have chosen measurement R (height from hip joint to ground level) as my starting point. We will leave the figures in column i as they are, and convert the others to the same scale.

To do this, we first divide the figure for R given in column i by the equivalent figure in each of the other columns. This gives:

column i	$12.15 \div 12.15 = 1.0$
column ii	$12.15 \div 14.58 = 0.83$
column iii	$12.15 \div 6.48 = 1.875$
column iv	$12.15 \div 17.01 = 0.71$

This means that in order to convert the figures from image ii, for example, to the same scale as image i, all the measurements in column ii have to be multiplied by 0.83. Now start to draw up Table 3.3 by writing these ratios in at the head of each column.

To get the equivalent figures for columns v–vii, we need to make the same calculation using measurement A. The A figure in column i is 4.05, so:

column v	$4.05 \div 1.74 = 2.33$
column vi	$4.05 \div 4.05 = 1.0$
column vii	$4.05 \div 3.04 = 1.33$

Write these figures in at the head of each column, and then multiply the dimensions in each column of Table 3.2 by the appropriate amount; Table 3.3 shows the result. Note that by this stage each dimension should be fairly consistent across all the columns. If any one dimension is seriously out, this reference image should be discarded.

Even though they are now at the same scale, the measurements will still vary somewhat from column to column, especially if your reference images are of different individuals. The next step is to simplify our figures by taking the average figure for each of the leading measurements. (You calculate an average by adding up all the figures in the row and then dividing the total by the number of columns.) The result is shown in the middle column of Table 3.4.

HOW TO MODIFY THE MEASUREMENTS TO SUIT YOUR MODEL

There is just one more thing to do. Your averaged set of measurements is probably not the size you want to make your model. So, choose one of the dimensions you have and decide what size you want that measurement to be. For instance, measurement C (shoulder joint to hip joint) in Table 3.1 is 6.5. Suppose you want this measurement on your model to be 10.0 (inches, centimetres, or whichever unit you prefer). All you have to do is to divide 10 by 6.5, which gives 1.54. Now multiply all of the measurements in Table 3.1 by 1.54 and set them down in another column. You have now converted all of these measurements to the right size for your model.

	Body skeleton				Skull		
	i	ii	iii	iv	v	vi	vii
	x 1.0	x 0.83	x 1.875	x 0.71	x 2.33	x 1.0	x 1.33
A	4.05	4.03	4.05	4.03	4.05	4.05	4.04
B	6.3	6.14	6.188	6.34			
C	9.0	10.04	9.56	9.88			
D	6.03	5.56	5.08	4.93			
E	1.2	1.33	1.16	1.49			
F	2.51	2.66	2.04	2.63			
G	3.1	3.4	3.09	3.37			
H	0.62	0.623	0.58	0.58			
I	2.75	2.9	2.48	3.12			
J	1.1	1.577	1.65	2.06			
K	0.7	0.755	0.77	0.8			
L	3.1	3.23	3.0	3.4			
M	4.2	4.75	5.08	4.65			
N	0.58	0.61	0.73	0.58			
O	4.03	4.07	3.86	3.95			
P	1.9	0.91	1.52	1.56			
Q	10.2	10.38	9.79	9.9			
R	12.15	12.1	12.15	12.08			
S1					4.57	4.48	4.47
S2					2.31	2.5	2.33
S3					1.05	0.99	0.92
S4					1.79	1.25	1.46
S5					0.51	0.43	0.43
S6					0.00	0.00	0.00
S7					0.47	0.38	0.33
S8					1.14	1.36	1.36
S9					0.51	0.22	0.16
S10					1.79	1.95	1.85
S11					0.35	0.32	0.33
S12					0.75	0.68	0.65
S13					0.58	0.49	0.48

Table 3.3 The measurements from Table 3.2 converted to a uniform scale

One thing I do is to convert the dimensions to life size of the animal and keep this schedule for reference. In order to do this you will need to establish a good, representative life-size measurement to start from. Returning to the example of the deer, I know that the height of a fallow doe at the withers is around 35in (890mm). Measurement R in Fig 3.6 is 0.9 times the height at the withers, which makes 31.5in (800mm). The figure for R in Table 3.4 is 12.12, and dividing 31.5 by 12.12 gives 2.6. Multiplying the figures in the middle column of Table 3.4 by 2.6 gives us a set of life-size measurements in inches, as shown in the right-hand column of the same table. (If you prefer to work in metric units, the principle is just the same; just take 800 as your starting measurement instead of 31.5.) The

	Measurements averaged from Table 3.3	Life-size measurements (in inches)
A	4.04	10.5
B	6.24	16.2
C	9.62	25.0
D	5.4	14.0
E	1.3	3.4
F	2.46	6.4
G	3.24	8.4
H	0.6	1.6
I	2.81	7.3
J	1.6	4.2
K	0.76	2.0
L	3.18	8.3
M	4.67	12.1
N	0.63	1.6
O	3.98	10.3
P	1.47	3.8
Q	10.07	26.2
R	12.12	31.5
S1	4.51	11.7
S2	2.38	6.2
S3	0.99	2.6
S4	1.5	3.9
S5	0.46	1.2
S6	0.0	0.0
S7	0.39	1.0
S8	1.29	3.4
S9	0.3	0.8
S10	1.86	4.8
S11	0.33	0.9
S12	0.69	1.8
S13	0.62	1.6

Table 3.4 Averaging the measurements from Table 3.3 and converting them to life-size

measurements obtained in this way can be used to construct a model to any scale you choose.

This chapter has shown you how to establish some of the measurements you will need when constructing your model. To establish enough measurements to allow you to draw and make a really accurate model, you will have to collect a lot more. However, treat them all the same way. The process becomes very easy once you get the swing of it. Don't get disheartened by the amount of work required to establish this set of dimensions. If you want a realistic model then it is necessary to have realistic information. Then we can go on to make the drawing.

MAKING DRAWINGS

In this chapter we will go through the making of the drawings from the skeleton outwards. This is the best way, because it ensures that you get the construction right.

If you do not have skeletal details, then you will have to use your photographs and any other information you have. Gather dimensions such as the distances between joints in the limbs, the length of the body, and as many as possible of the other leading measurements set out in Figs 3.6 and 3.7. Your reading of Chapter 2 will help you to identify what is required.

Anyone who wishes to make something which is not absolutely simple should realize the need to prepare drawings first. Drawings are a convenient way of collecting our thoughts together, modifying them, showing them to other people, recording them. They help us to make sure that by the time we start making the article we have collected our thoughts and compared and organized our information thoroughly enough to make sure that what we are doing is right in every way and that we are not going up any blind alleys.

A drawing is a means of communication; the better it is, the easier it is to understand. It is also a recording for future use. A drawing needs to communicate the shape of its subject together with its measurements. All aspects of this communication should be crystal-clear. Don't forget it's much easier to redraw something than alter the model. Some modellers make a maquette (see page 86) from the drawings to check their accuracy, and if necessary modify the drawing accordingly. I use maquettes often, especially when the pose is not simple.

A drawing consists of lines, measurements and notes. I will not be putting numerical measurements or dimension lines on the working drawings in this book, because placement and size will be indicated by graticules instead.

The various views shown on the drawing should be arranged one with the other so that they show the subject in the way it would look when turned over on the table or in the hands. It is best to label the views so that any other person reading the drawings will know what view or section or part they are looking at. The naming of the views should follow the guidance given in Fig 2.1 (or Fig 6.2). As you get used to making working drawings and then using them, you will no doubt use several expedients to simplify the amount of drawing work required, whilst ensuring that all the information is still there. If you care to examine the working drawings shown in this book, you will see some of the methods I use. However, do learn the textbook method first, then use short cuts later.

MATERIALS

Let us take a quick look at the materials we will need when we are making our drawings. Rather than going into the large and varied array of drawing equipment available, I will just cover the basics here.

The first requirement is a large, flat surface to work on, arranged so that you are comfortable when you

draw. Make sure it is big enough. (If you can get a drawing board with a parallel-motion drawing system on it, so much the better. If you cannot, then a straightedge and a set square will do just as well; the drawing job will take just that bit longer.) Your drawing area needs to have plenty of light – daylight or otherwise. The light must be arranged so you are not drawing in a shadow.

If you use plain paper, be sure to buy the best you can afford; it will pay for itself in durability. (See also the remarks on graticules, below.)

For drawing your lines you will need two drawing pens: one for thick lines, the other for fine lines. The thicknesses you choose will depend on the intricacy of the drawing (you may have to draw many lines in a small space), the type of line you need to draw (see below), and the overall size of the drawing. You will also need one for writing notes on your drawings. Pens are simpler to use than pencils. If you want to use pencils, then use reasonably hard ones, which will give a cleaner line and last longer between sharpenings.

Always keep pencil points in good order. Fig 4.1 shows the right way to sharpen an ordinary pencil. Use a sharp knife; I use a scalpel. Cut the wood away to leave around 5⁄16in (7–8mm) of lead showing. Now use sandpaper or a similar abrading material to shape the point. Blocks made up for this purpose are readily available at the local art shop, or you can make one yourself. (Use several strips of medium or fine-grade abrading material mounted on top of one another, then mounted on a strip of thick cardboard or wood. Stick the assembly together at the ends.) The point can be conical or wedge-shaped; wedge-shaped points last longer.

LINES

The most important feature of a drawing is the lines of which it is composed. Lines should be only where they are wanted, not trailing about all over the drawing; make them just as long as they need to be, and of uniform type throughout their length. Notes should be placed on the drawing so that they are in the right position and can be read clearly.

a Pencil in need of sharpening

b Using a scalpel

c Strip of abrading material to sharpen the point

d The pencil correctly sharpened and ready for use

Fig 4.1 The right way to sharpen a pencil

Fig 4.2 Use of different lines in technical drawing

Fig 4.2 shows how different lines are used for specific purposes:

A a continuous thick line. This is used to indicate exposed features of the subject. It should be much wider than all the other lines – about twice their width.

B a thin line, broken to form dashes. ('Thin' lines are half the width of 'thick' ones.) This line needs to be regular in its features: the dashes of the same short length as one another and the short gaps of the same length as one another. This line is used to indicate concealed features of the subject (in Fig 4.2, for example, the upper surface of the neck, which is concealed by the head in the frontal view). What I have quoted here is the recommendation made by the British Standards Institution; however, very often I use a line of the same width as the outline. I regard it as a broken outline.

C a thin line, broken at regular intervals to form a dot or a dash (a dash is easier in pencil). The dots or dashes should be of the same size, the short gaps to be of the same length as one another. This line is used for centre lines.

D a continuous thin line. This is used for graticules and measurement lines, and to connect various views and features in the drawing. It is also used for hatching (see Fig 5.28 on page 105).

DRAWING TO SIZE

At some time you will have to decide on the scale of your drawing. The best size to draw is the same size to which you propose to build your model; then there is no fiddling about with size comparisons whilst you are in the process of modelling. Photocopying can be of use here: drawings can be reproduced smaller or larger as you wish.

USE OF THE GRATICULE

I very often use metric-divided graph paper when I am drawing. I use size A1 graph paper divided into centimetres and millimetres; paper divided into inches is also available. The process of drawing is that much simpler: you need not be concerned about drawing construction lines at right angles, as the right angles are already there. All of the measurements are also there.

Cover your graph paper with tracing paper and draw on that. Once you have chosen the size of your graticule, draw it lightly on the tracing paper and note somewhere on the paper what each square of your graticule represents in model size and/or life size. Now you don't need any measurements or dimensions on the drawing. Just take off the measurements from your schedule, put them in their right place using your graticule, then draw on

and around them to form your drawing. Draw the graticule more heavily in the areas showing the details of your drawing.

The graticule also allows you to enlarge or reduce the drawing from one scale to another. If you already have your drawing completed at one scale and you want a copy at another size, then just determine the new size – say half the size of the original – draw a new graticule with its squares half the size, and make your new drawing on that, using the graticules for comparison. All of the working drawings in this book have been drawn this way.

It is easy to make your own graticule at the size you want by taking a pre-printed graticule and either enlarging or reducing it by photocopying to the size required.

When the time comes to use the drawing, decide on the overall length or height of the model, then count how many divisions of the graticule the animal occupies in its length or in its height. All that is necessary then is to determine how large those divisions of the graticule need to be in order to make up the length or height required for the model. For example, suppose the drawing shows the height of the model to be nine divisions of the graticule, and you want your model to be 6in tall. Then each graticule square needs to be reduced to ⅔ (that is, ⅔) of an inch square. A simple way of doing this is to make a ruler with divisions on it equal to one and a half of your original graticule divisions. Use this on the drawing as an inch measuring stick. (It does not matter whether you prefer to use imperial or metric measurements; the same principle works equally well with both.)

If your drawing is A3 size (297 x 420mm) or smaller, then photocopying can easily be done straight off the tracing paper. If not, any drawing centre will be able to make same-size prints from your tracing.

When using the graticule to enlarge and reduce, it may be handy to know how to divide a line into any number of equal segments. In Fig 4.3,

i shows ab, the original line to be divided. The length of this line might represent, for example, the intended overall length or height of the model.

ii shows the original line ab with a second line ac, originating at a, drawn at a convenient angle from it. Line ac is of a length which is easily divided into the number of segments required in line ab.

iii shows line ac with the required number of divisions marked on it.

In *iv*, a line is drawn from c to b.

In *v*, lines are drawn parallel to line bc from each division on line ac to cross line ab; line ab is now divided into the required number of segments.

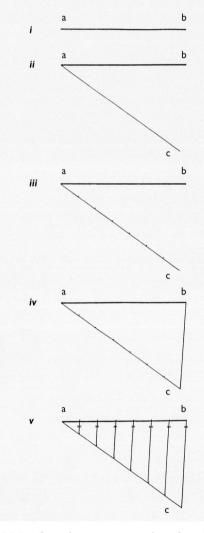

Fig 4.3 Dividing a line into any number of equal segments

MAKING YOUR FIRST DRAWING

Now you have come to the point where you are ready to draw the animal. Remember that it is only necessary to draw just enough information to give you a completely clear picture of what you want to make. This is a good time to urge you always to draw as accurately as you can.

It is always best to draw the skeleton first. Your drawing will then start off with a firm foundation. I will therefore take you through the process of this first drawing on the assumption that you have plenty of information about the living animal as you see it, that you have learned something of Chapter 2 – that is, you know how a tetrapod is put together – and you have your schedule of measurements as shown in Chapter 3.

VIEWS

Your drawing will need to provide several views of the animal. If you look at a person's head from a side view, you can see how big the head is from front to back and top to bottom. If you want to know how wide the head is, you cannot tell this from a side view, so you really need a front view to tell you this (or a rear view). The names of the views (according to Fig 2.1 or Fig 6.1) should be put on the drawing, so that anyone looking at it may know which way they are looking. But now you may need to know what sort of shape the head is when you look at it from the top: is it oval or round, or perhaps almost square? You cannot tell this from the side, front or rear views, so you need a top view. This is why you must have several views on your complete finished drawing: you need enough views so all of the information is there. Even on, say, a tortoise drawing it will be necessary to put in a view of the underside of the shell, simply because this is the only view which will give you the patterning of the shell there.

Where are we going to place these views? The generally accepted convention is that the views are related one to the other so that they show the way the subject would be brought to view if it were rolled around on the table or in the hands. The side views and front and rear views are on a horizontal line with one another, the top view is generally under the side view, and the bottom view is generally over the side view, as shown in Fig 4.4 (see also Fig 6.2 on page 117).

Drawings can also include **sections**. These are views which illustrate what the animal would look like if cut across at the plane of the section. As modellers we use these very often; they help us to envisage what that part of the animal looks like in three dimensions. The parts of the subject cut through by the section are usually indicated by hatching.

There are other views, known as **auxiliary views**, used when you want to illustrate features which can only be seen from one unconventional viewpoint. Sometimes you also need special views of parts of the animal which do not show well in the ordinary views. For instance, the special view of the elephant's ear in Fig 5.28 shows the ear laid out flat, whereas in life the ear is dished and turned over at the top.

You should now know roughly what views you are going to need for your drawing. You will find that all drawings need a side view. This will be one of the leading views (that is, it will carry vital information). The outline of this view is the profile of the animal in the sagittal plane. Together with this view you will need a top view and at least a front view. When you have drawn these you will then be able to tell whether you need a rear view, sections, or any special views.

DRAWING TO THE 'ATTENTION' POSE

When I am faced with modelling an animal I have not modelled before, I first draw it in what I call the

Fig 4.4 The conventional arrangement of the various views in a technical drawing (in everyday terminology; see Fig 6.2 for the technical terms)

'attention' pose. This is with the animal standing and arranged so that the body is in a natural rest position, with the head and tail in line with the body, not turned to the side. All of the limbs are in a rest position and there is no gait. When I have determined the animal in this condition, I can properly then go on to arrange the animal in any pose I want. Later I may want to model the animal in another pose; all I have to do is to modify the 'attention' pose to get the new pose. The 'attention' pose drawing is a reference drawing.

As I have already said, it is always a good plan to draw your animal at the same scale at which you intend to model it. You can then work straight off the drawing when tracing shapes for profiles. If your model is going to be a woodcarving or a stone sculpture, you will be able to see just how tight the curves are and how much clear working space there is going to be; these are important points. If you cannot draw to model size, then choose a scale which is easily translated to model size – say ½ or ¼ of the intended size. This will make it easier to get model-size photocopies, too.

Now we need to consider some of the most important measurements. So that the finished drawing will be useful to us, I shall choose for this practical example one of the animals to be modelled in the next chapter: the cat.

	Body skeleton (see Fig 3.6)	Skull (see Fig 3.7)
A	7.5	
B	8.5	
C	25.9	
D	27.5	
E	2.1	
F	8.2	
G	8.7	
H	0.8	
I	2.7	
J	1.8	
K	2.5	
L	9.5	
M	10.1	
N	1.5	
O	4.3	
P	1.7	
Q	17.8	
R	19.7	
S1		8.0
S2		6.3
S3		3.3
S4		2.5
S5		0.5
S6		0.0
S7		2.6
S8		4.3
S9		1.35
S10		37.0
S11		0.0
S12		0.0
S13		0.8

Table 4.1 Schedule of measurements for the cat drawing

THE BASIC FRAMEWORK

First of all I obtain a schedule of dimensions, shown here as Table 4.1. This schedule is made up in the same way as Table 3.1 on page 44. In the following discussion, whenever I refer to 'measurement R' or 'a distance of Q', etc., the reference is to the measurements in Table 4.1.

Estimate the size of the views on the drawing, and draw a line across the paper which will represent ground level for the side, front and rear views.

Draw a horizontal centre line above this at a distance of Q from it, then do the same for measurement R. Now measure the distance C between these two lines and draw two vertical

Fig 4.5 Locating the top joints of the limbs

centre lines. You have located the tops of the front and rear limbs (Fig 4.5).

Now, there are several joints between these and the ground, and I find that a set of cardboard limb pieces held together with thread is a useful aid to finding the positions of these lower joints. Fig 4.6 shows the making of a set of card limb pieces which allow the limbs to be placed in the natural pose required for the current project.

Mark off the lengths of each of the limb bones on a sheet of card and cut them out. Fig 4.6*a* shows the pieces cut to length; I have pointed off each end and coloured each piece in accordance with Fig 2.7 (page 11). Fig 4.6*b* shows them stuck together on a thread which is stretched between pins. They are left to dry, then the pins taken out, and then they are labelled on the back to show which animal they portray, which limb, and at what scale. Fig 4.6*c* shows the limb pieces pinned to the drawing. (For the sake of illustration I have used a completed drawing of the skeleton, so you can see how the limb pieces relate to the actual bone positions.) First pin the upper ends to the body at the scapula and the pelvis, then move the pieces around until you have the pose you want. Pin the limb joints in position, keeping the thread tight. Make sure the phalange bones don't quite touch the ground. The assembly now shows just where the joints need to be placed for that particular pose. Mark the centre lines of the joints on the drawing and remove the limb pieces. File them with the rest of the information you have on this animal, ready for use next time. Fig 4.7 shows the drawing with the limb joints marked and the cardboard pieces removed.

One added complication is that your animal may have splayed limbs, and your drawing will need to cover this point; Fig 4.8 shows an example. Splayed limbs project sideways from the sagittal plane, as well as forward or backward, so they lie at compound angles. This means that in all of the regular views the

a The pieces for the front and rear limbs, colour-coded to match the limb drawings in this book. Each piece must be accurately cut to length according to your measurement schedule for the animal

b The thread is stuck on the back of each piece

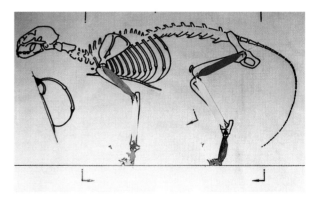

c The articulated pieces can now be adjusted to the pose required. As this photograph makes clear, the limb pieces do not represent the *shapes* of the bones, but *only* the positions of the joints

Fig 4.6 Making cardboard limb pieces to plan the positions of the joints

limbs are foreshortened. The procedure here is to make your limb pieces as shown in Fig 4.8, but using wire instead of thread to hold them together. Use wire which is fine enough to allow the limbs to be bent at the joints. Now set the top end of the limb (taking the forelimb as an example) against its socket

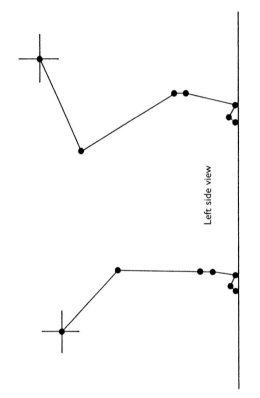

Left side view

Fig 4.7 Limb joints in place

as shown in the side view on your drawing, and raise the foot to the ground level shown on the drawing. If you keep the foot flat against the paper the limb will not be in its natural position, so now, keeping the top of the limb in its socket, lift the foot vertically away from the paper until you reach a natural position for the limb. Still holding the upper end of the limb against its socket, let go of the other end; the stiffness of the wire will keep the limb in place. You can now measure the distance of each joint both fore and aft and sideways from the top of the humerus, and plot these positions on your drawing.

You may have some trouble putting the tips of fingers and toes in place when you start modelling, because there are so many small parts whose arrangement differs from one animal to another, but stick with it – if you get these right, your model will be that bit more realistic. The ends of the limbs contribute a lot to the animal's character.

The next thing to do is to establish the general run of the spine of the animal. For this you will need the measurements of E and K in Fig 3.6. Open the compasses to these two measurements and draw them in as arcs using the upper limb joints as centres (see Fig 4.9). Make sure that E represents a mid-position of the scapula on the ribcage. This determines the position of the top of the humerus when the animal is in the 'attention' position.

You will very often find there is another important measurement needed here, which is where the spine has an upper level between the front and rear legs. Draw this point in. This is usually the highest point of the back.

The next point to secure is the position of the junction between the skull and the spine (the position of the occipital condyle). Draw this in place using the top joints of the limbs to help place it. You will notice that this measurement (B) has to be taken round a

curve, rather than in a straight line. I use string for this. One end has a knot in it, corresponding to the occipital condyle; a mark on the string indicates the position of the sacrum, and the string is cut off at the distal end of the last tail vertebra. You could make a full model of the spine if you wanted to.

The height of the occipital condyle will depend on whether the animal holds its head up or down. You will need to place the skull so that the eyes are in mid-position and the gaze is horizontal – that is, with the animal looking at the horizon. This is the natural attitude of the head in the 'attention' position.

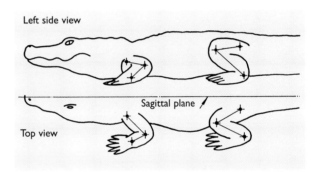

Fig 4.8 An example of an animal with splayed limbs

You now have four guiding points for the spine of your animal. One more useful point would be the distal end of the last tail vertebra. (The string will be useful again here.) Plot the centre line of the spine in position, using the top joint of the rear legs for guidance; the height, again, depends on the animal and the pose.

One more point about the line which the spine takes, is that there is often a 'step' in this line where it goes over the rear legs at the sacrum. If you don't watch out for this you may put the centre line of the tail in the wrong place.

Draw in the line of the spine through the points you have marked, and your drawing should look like Fig 4.9.

That is enough of the side view for the moment; it is time to look at the front, rear and top views.

Draw in the sagittal plane centre lines where these three views are going to be (Fig 4.10). The positions of the limb joints are transferred from the side view to other views as follows. Draw a horizontal centre line (*i* in Fig 4.10) from the top joint of the front limb to the centre line of the front view. Draw the horizontal centre line *ii* from the top joint of the rear limb to the centre line of the rear view. Draw the vertical centre line *iii* from the top joint of the front limb to the centre line of the top view, and the vertical centre line *iv* from the top joint of the rear limb to the centre line of the top view. Your drawing will now look like Fig 4.10.

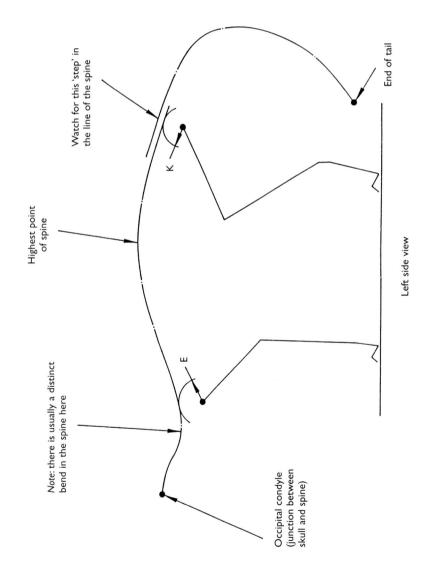

Fig 4.9 The line of the spine drawn in

Fig 4.10 Laying out the front, rear and top views

Fig 4.11 Locating the top joints of the front and rear limbs on front, rear and top views

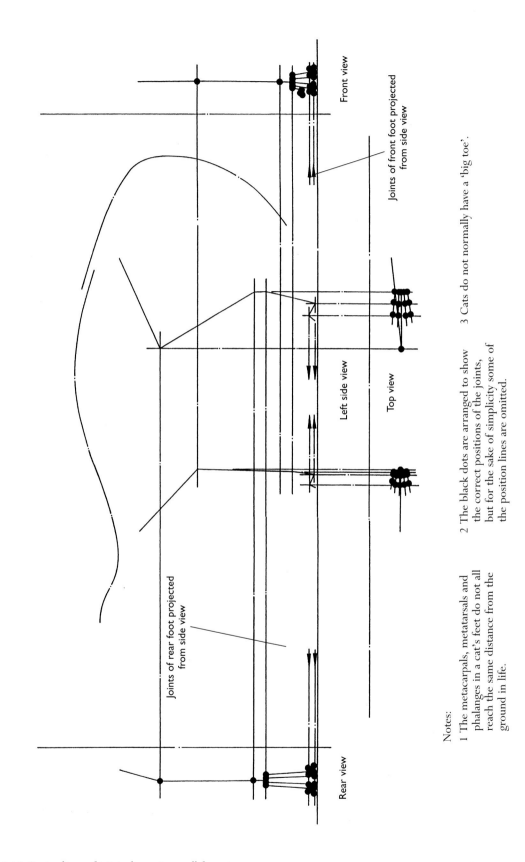

Front view

Joints of front foot projected from side view

Left side view

Top view

Joints of rear foot projected from side view

Rear view

Notes:

1 The metacarpals, metatarsals and phalanges in a cat's feet do not all reach the same distance from the ground in life.

2 The black dots are arranged to show the correct positions of the joints, but for the sake of simplicity some of the position lines are omitted.

3 Cats do not normally have a 'big toe'.

Fig 4.12 Centre lines of joints drawn in on all four views

Now put in the positions of the top joints of the front and rear limbs in the front, rear and top views. Mark them with small dots or crosses. (You will need to refer to your own animal schedule to establish the distance of these joints from the centre line; the specimen schedule in Fig 3.6 only covers the side elevation.) Your drawing will now look like Fig 4.11.

The rest of the joints of the limbs can now be plotted in much the same sort of way, measuring their distance from the centre line. Again it is best to plot them with little dots or crosses. When that is done, join them up, and you will have plotted all of the centre lines of the limbs in all of the views (Fig 4.12).

We are now well advanced with the body framework; now let us have a look at the rest of the animal.

THE SKULL

Skulls vary a lot in shape when you compare one species with another, as we saw in Fig 2.3 (page 5). Some skulls almost match the living outside shape of the head, as does the human skull (Fig 4.13). Others, like that of the sperm whale, do not match at all (Fig 4.14).

In Fig 4.15 I have chosen a living dinosaur together with a mutant ape. The disparity in shape is apparent: the crocodile is all mouth and little brain, the human has a small mouth and a large brain. However, the basic reasons for the existence of these parts of the organisms are the same: the mouth is for taking in food and the brain is for thinking. The variations make sense when you consider the uses these features are put to. The crocodile needs an enormous bite and does not need much brain power; the human needs only a small mouth but needs a lot of brain power.

I have shown in Fig 4.15 both the main features and the leading measurements required by the model-

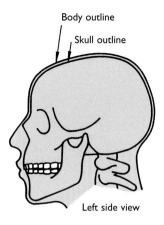

Fig 4.13 The human skull closely matches the outer shape of the head

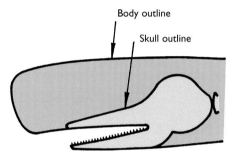

Fig 4.14 The skull of the sperm whale does not resemble the outer shape at all

maker. You need to locate the occipital condyle to fix the position of the head on the spine. You need the location of the eyes in relation to the occipital condyle. You need the overall measurements of the skull to determine the structure of the head. It is a matter of measuring, drawing, measuring, until you have enough information on your drawing for the image to be sufficiently complete. Your model needs the skeletal shape underneath; you then build on that. For the sake of variety I will clarify this by going through the drawing of a horse's skull. To simplify the discussion I have limited this to a side view; the other views, of course, would be developed in the same way.

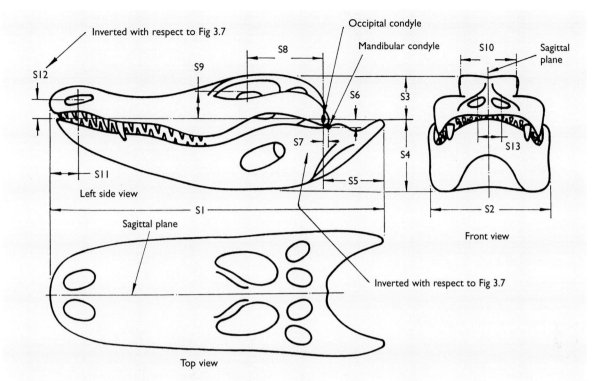

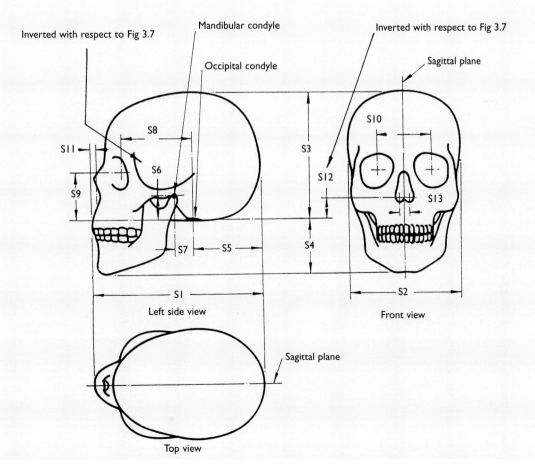

Fig 4.15 Variations in skull measurements between a crocodile and a human

a Draw the occipital condyle, with vertical and horizontal lines through it to form the basis of the graticule

b Add the rest of the graticule and draw the eye socket

c Mark in the length and height of the skull

d Mark in the hinge point of the jaw (mandibular condyle)

e Draw in the margins of the nasal openings and the incisor teeth

f Draw in the cheek teeth

g Plot any points you consider useful in determining the profile of the skull

h Draw in the profile

i Draw the zygomatic arch (the prominent bony ridge below the eye socket)

j Add any other salient features

a

b

c

d

e

f

g

h

i

j

Fig 4.16 Developing a drawing of a horse's skull

Fig 4.16 shows how the drawing is built up. As I have said before, it is best to work from the skeleton, but if you do not have access to this, use your photographs for information. Your reading of Chapter 2 will help here.

If the shape of the skull is complex, then it is best to draw it out on its own separate drawing at a large enough scale to show all the required details clearly. The skull when copied onto the body drawing can show less detail.

Now we return to our cat drawing. The skull is constructed in the same way as the horse skull, and

Fig 4.17 shows it added to the main drawing. For the sake of clarity, the remaining details which will eventually go on the main drawing are illustrated separately in the next few figures.

SPINE AND RIBCAGE

Here we need only those details which are going to affect the accuracy of our model. We are not concerned with how many vertebrae or ribs there are, but we are concerned with the way they supply support and control movement. They provide fixing for muscles, and their shape influences the external shape of the animal.

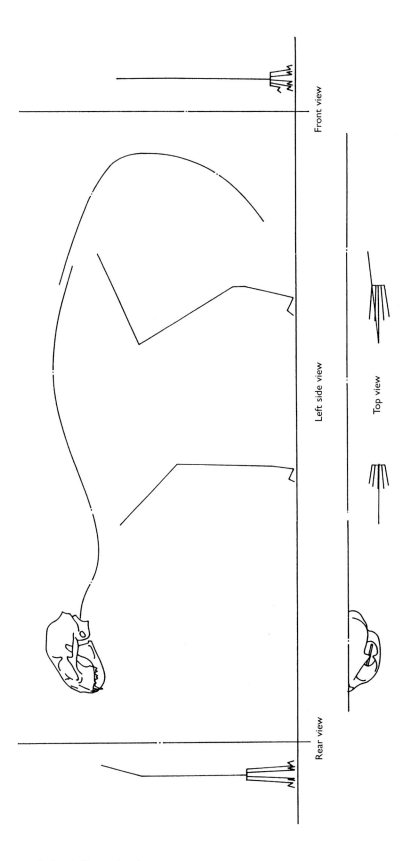

Fig 4.17 The cat drawing with the skull completed

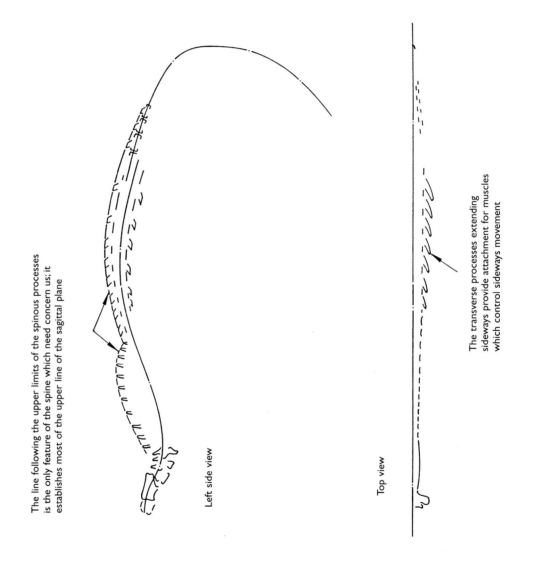

The line following the upper limits of the spinous processes is the only feature of the spine which need concern us; it establishes most of the upper line of the sagittal plane

Left side view

Top view

The transverse processes extending sideways provide attachment for muscles which control sideways movement

Fig 4.18 The all-important line formed by the various processes of the spine

Starting with the centre line of the spine as shown in our existing side and top views, we need to observe how the spinous processes (see Fig 2.4 on page 8) project from this line. We can then draw in a line corresponding to the upper ends of these processes (Fig 4.18). Note how these processes become larger in the areas where more muscle needs to be secured further away from the centre line of the spine, mostly at the scapula position and in the middle of the lumbar region (near the loins).

To complete our drawing of this part of the body, we need to draw the ribcage with the sternum.

Start with the centre line of the spine in the side and top views. Draw the centre line of the sternum in the side view, and draw in the clavicle, if your animal has one, in both views. Draw in the outline of the framework of the ribs in both views (Fig 4.19). Draw these outlines fairly carefully, because the ribs determine a lot of the body shape.

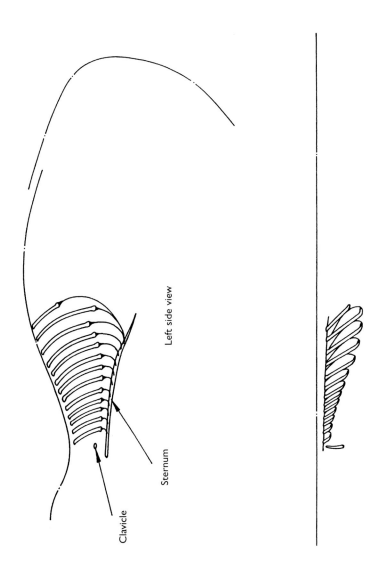

Left side view

Sternum

Clavicle

Top view

Fig 4.19 The ribcage and sternum

This seems a good time to bring in the concept of the auxiliary view. This is a subordinate view, chosen to show details which do not readily show up on the main views but which need to be clarified. This example (Fig 4.20) shows the shape of the ribcage when looking along the body. Draw a line on the side view (A–A) to indicate where the auxiliary view is to be seen from; the arrows at each end of this line show which way we are looking. In this case, the auxiliary view gives the shape of the rib span. Draw in the sagittal plane centre line in any convenient place, parallel to the line A–A. Draw the required view of the ribs around this centre line, and mark it as 'view at A–A'.

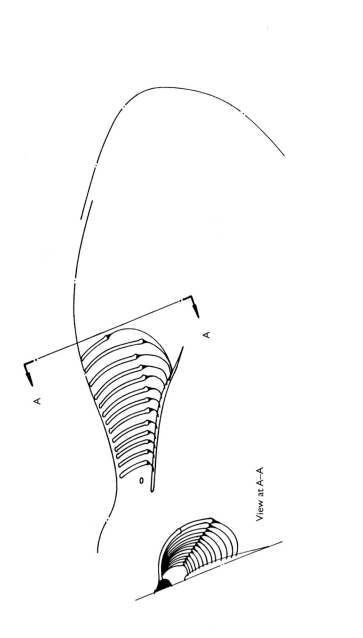

Fig 4.20 The auxiliary view of the ribs

THE FRONT LIMB

We have already established the positions of the limb joints on our main drawing. Draw in the humerus and the radius and ulna. Draw in the scapula, taking care because it controls the body surface of much of the animal's back. The scapula lies at a compound angle. Generally, it slopes rearward from the head of the humerus, with its inner surface parallel to the line of the ribcage and a small distance from it (see Fig 2.25 on page 24). There is space between the scapula and the ribcage for various muscles. Draw in the clavicle (Fig 4.21).

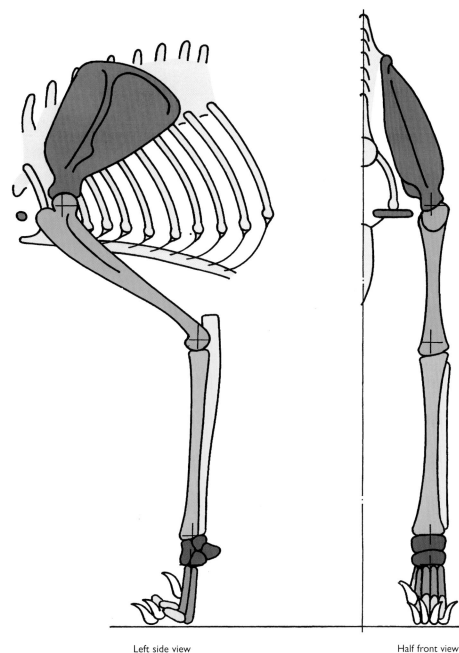

Sagittal plane

Left side view

Half front view

Fig 4.21 The front limb

THE FRONT FEET

Feet and hands vary greatly from animal to animal, because they have evolved to suit the job they are required to do: clawing at prey, perching on branches, taking a lot of weight, and so on. So give your model's feet and hands some special attention. Be prepared to get them right; they are not just blobs on the ends of the limbs. As with the skull, sometimes it is better to draw the feet to a larger scale on a separate sheet because of the concentration of detail in a small area.

Looking at a cat's front feet, you will see that for walking the third and fourth metacarpals (see Figs 2.7 and 2.12) come virtually to the ground, the second and fifth do not come down quite so far, and the first only comes some halfway to the ground. The proximal and middle phalanges are all folded up while the foot is relaxed. The distal phalanges carry the claws, and relax, pulling the claws into the foot, for walking (Fig 4.22). The pads on the feet come between the bones and the ground.

THE REAR LIMB

The positions of the joints have already been established. Use these as a guide to draw in the femur, fibula, tibia, patella and pelvis (Fig 4.23).

THE REAR FEET

Like the front feet, these are relaxed for walking; the disposition of the bones and claws is the same as in the front foot, except that often the first metatarsal is missing – so in fact many species of cats and dogs don't have a big toe.

THE COMPLETED SKELETON

We have worked all through the skeleton now, and if you bring all of your drawings together to make a complete skeletal drawing it should look like Fig 4.24.

THE MUSCLES, INTERNAL ORGANS, FAT, SENSE ORGANS AND SKIN

Drawings of the type shown in Fig 4.24 are in the essence of realistic model-making, because the skeleton is the major determining factor in shaping the body profile. Whatever the animal is doing, the skeleton determines the shape. Muscles in themselves are floppy and plastic. They only help to shape the body by virtue of their bulk – specifically when they are energized, when they take up a linear concentration of bulk at the position of their main mass (see Fig 2.21 on page 21).

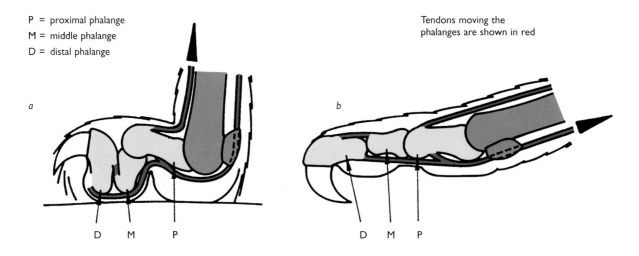

P = proximal phalange
M = middle phalange
D = distal phalange

Tendons moving the phalanges are shown in red

a b

D M P D M P

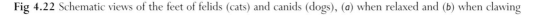

Fig 4.22 Schematic views of the feet of felids (cats) and canids (dogs), (*a*) when relaxed and (*b*) when clawing

Sagittal plane

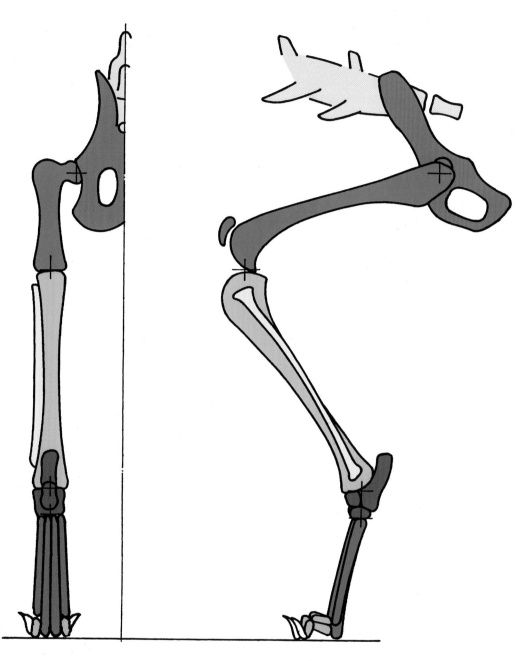

Half rear view

Left side view

Fig 4.23 The rear limb

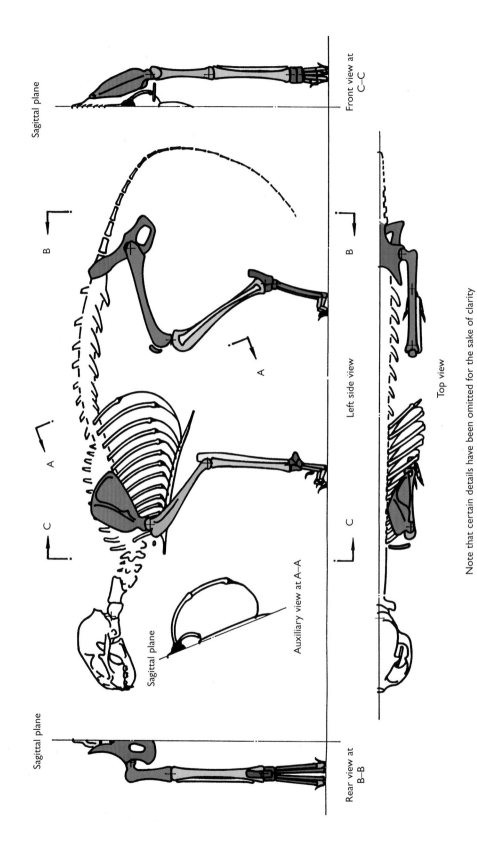

Fig 4.24 Cat skeleton: the 'attention' pose

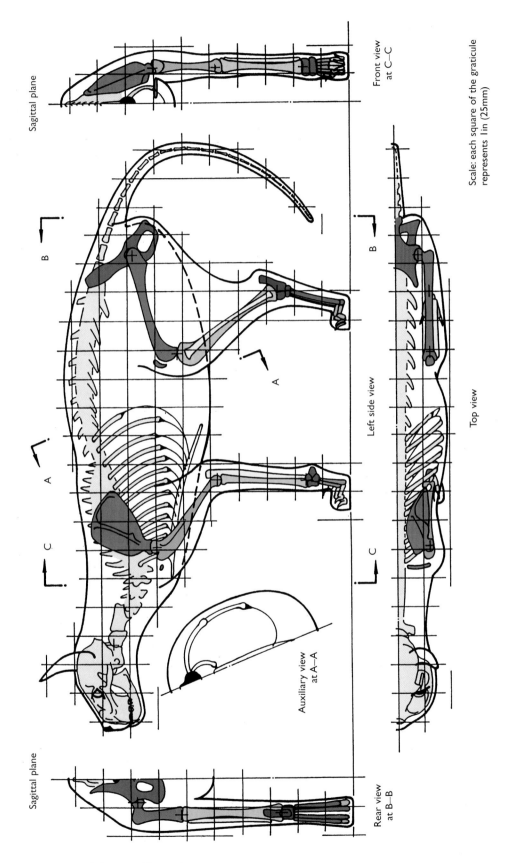

Fig 4.25 Cat (*Felis catus*): skeleton and living shape

The earliest time to study the effect of musculature on body profile is when the pose has been decided. This is because the pose determines which muscles are energized and which are not (see Fig 2.22 on page 22). So remember: the skeleton determines the underlying shape, and musculature is only a secondary formation.

When determining the effect of muscles on body shape it may be helpful to visualize the skeleton as if it has been forced into a tight-fitting rubber balloon; then visualize the balloon being pushed out evenly in places by the bulk of muscles which are energized or relaxed. The change in outline caused by the muscles can be seen as a smooth change away from the angularity of the skeletal profile. (The roundness of the abdominal area is mainly caused by the bulk of internal organs.)

There is no room in this book to describe and illustrate each muscle as it is laid on the skeleton. Fig 2.24 on page 23 shows a general layout of the superficial musculature of the cat, and the accompanying Table 2.1 gives the names, shapes, origins and insertions of the most prominent muscles. The half-section of the horse in Fig 2.25 (page 24) shows the general arrangement of deep muscles between the scapula and the ribcage. Once you know the general arrangement of muscles on the body, and have some knowledge of how they work, then laying out each muscle is not necessary; just draw the outer form which the muscle produces as it is either energized or relaxed.

I thoroughly recommend *Gray's Anatomy* (see Further Reading on page 124) to all animal-model makers. The book is readily available. It concerns only human anatomy, but that is no matter; as I have already said, musculature is very similar in most tetrapod species. The chapter on The Muscles and Fasciae will identify all of the muscles, tendons, origins, insertions and layering of muscles which the model-maker needs to know.

The difference which muscles, tendons and internal organs make to the skeleton of the cat to form the body profile is shown in illustration Fig 4.25. Generally note the gentle run along the throat from the jaw to the front of the ribcage; the run of the line of the belly from the lower end of the ribcage to the rear of the pelvis, passing between the rear legs; the line of the rear of the neck from the skull to the spine between the upper parts of the scapulae; the bunching of muscles just below the elbow and the knee, around the sides of the scapulae, and at the rear of the femur.

If you change the pose from this 'attention' position, then the action of the musculature will change. You will then need to determine which muscles are energized, and consequently shortened and thickened.

Tendons running near the surface form parts of the finished body shape; your own Achilles tendon is an example of this.

You can now put in the fat, sense organs, and the skin and its appendages (pads, ears, hair, nose), as described on pages 27–36.

When you have worked through all of this you have your first accurate animal drawing as it would be in life, where the animal stands at the 'attention' pose (Fig 4.25). *I do hope you are pleased with it; it is the result of quite a lot of effort.* Each time you do this job it becomes that little bit easier, and it is a good way of learning about your animal.

If you now decide to build this animal, look what an advantage you have. All the shape is there, drawn to a convenient size, all on one or two pieces of paper. If you make your model from it, it should come out looking realistic – at least it will have the right proportions. However, one of the first things you will say is that it is not in the pose which you want to model. So now let's have a look at the ways in which we can modify the 'attention' pose.

DRAWING AND PREPARING FOR THE POSE YOU WANT

Drawing for the required pose means changing your 'attention' drawing – for example, the head may be turned or tilted, the jaw moved, the spine bent, the limbs repositioned, the tail moved, the ears twitched – until the animal is in the position you want to model (see Fig 5.25 on page 102 for an example). Remember that the body shapes will vary somewhat if the finished pose is markedly different from the 'attention' pose; you will need to remember which muscles are pulling where – what flesh is being squeezed or stretched to create the pose.

Simple movements such as placing the limbs in a striding position can be drawn with the aid of your cardboard limb pieces which you used when drawing the 'attention' pose (see Fig 4.6 on page 57). Using these, the new positions of the limbs can be identified (for an example, compare Figs 5.26 and 5.27). Do not forget to allow for the movement of the scapula, as indicated in Fig 5.27, and make sure the shoulders are in the right position. Simple movements of the head and tail can be drawn just as easily.

If the model pose required is markedly different from the 'attention' pose, then it is much better to make a flexible maquette from your existing drawing and then form the model pose by flexing the maquette to the position you want. This has two advantages: you can use the information about size and proportion which you have already worked out in the 'attention' pose, and you can strike a realistic pose in the maquette (Figs 5.9, 5.12 and 5.22 show this technique in use). The maquette allows you to preview the pose preparatory to making the final model.

One point you will need to be aware of is the order in which the legs are moved. Almost without exception, quadrupeds when walking use what I call the **quadrupedal gait**. The striding of the limbs follows this pattern: left front leg forward – right

rear leg forward – right front leg forward – left rear leg forward – left front leg forward. This is extremely important for correct body position. If your model is walking it must follow this gait.

Only a few quadrupeds when walking slowly use what is called **pacing**. Giraffes and camels pace when walking slowly, and pacing is used by many quadrupeds when wanting to move faster than the quadrupedal gait will allow. The striding of the feet in pacing follows this pattern: left front and left rear legs forward – right front and right rear legs forward – left front and left rear legs forward. Sometimes all the feet come off the ground for short periods between paces, depending on the speed of movement.

The **trot** is used for faster movement again. The striding of the legs in trotting follows this pattern: left front and right rear legs forward – all feet off the ground – right front and left rear legs forward – all feet off the ground – left front and right rear legs forward. When a quadruped moves at a still faster gait it turns into a **gallop**. The rhythm and relative movement of the limbs now become complicated. If galloping is to be a feature of your model, make a special study of the various parts of the gait before you decide which pose to adopt. Indeed, study all of these movements of the limbs so you know what the animal is doing, and make a maquette.

ADAPTING YOUR DRAWING TO THE METHOD OF CONSTRUCTION

Are you going to carve down to the model? Are you going to use stone or wood? Are you going to build up to the model, using 'clay' of one kind or another? Are you going to use armatures or a frame, or armatures plus a frame?

Whatever your choice, you can make the working drawings which will suit that particular method of construction. The next chapter will show what I mean.

USING YOUR WORKING DRAWINGS TO MAKE THE MODEL

Now you have your working drawings in front of you, it is time to see how you can use them during the making of the model.

The first thing the drawing does is to define shapes; transferring these shapes to the model material will be one of your main considerations. This means the use of tracing paper and profile gauges, and, with wood and stone carving in particular, the use of callipers.

The next thing the drawing does is to demonstrate how all of the individual shapes relate to one another to form the overall shape of the model. A good drawing will give a detailed specification of the animal in the 'attention' pose. However, unless it is a major effort of draughtsmanship it will not give a detailed specification for every little bit of a model which is in a complicated pose. The vital step in this case is to make and use a maquette. The maquette is made from the 'attention' information and then bent to the pose, however complicated it may be.

Drawings can also be made to show the position of datums, and the use of fixtures to aid in the construction of the model. Indeed, drawings can include instructions for making the fixtures themselves.

DRAWING FOR DIFFERENT METHODS OF CONSTRUCTION

However you propose to make your model – whether by building it up from the inside, or carving it from a solid block – you will be constantly referring to your working drawings for information on the intended shape of each part. Your task will be made that much easier if you have adapted your drawing so that it includes precisely the kind of information you are going to need as you work.

The starting point for producing working drawings like those shown later in this chapter is the 'attention' drawing which represents the skeleton and musculature of the animal. From this a new drawing is developed, translating the animal shape into a framework. This framework can eventually be used as an internal frame determining the shape of the animal from the middle outwards, or as a network of body contour lines which specify the shape to which profile gauges can be made to control carving procedures. The difference is that the carving profiles show the finished shape of the model, whereas the frame drawings have to be made a little smaller all round, to allow for adding the model 'skin' on the outside. (See the difference in Fig 5.21 between the body formers and the dotted line which denotes the finished body outline).

The majority of my models are constructed from the inside, using a variety of formers and armatures to support the outer skin. The formers may be made of card, plywood, or whatever material seems appropriate given the size and complexity of the model.

The framework drawing starts with the sagittal plane profile, which provides the shape for the first

former. The remaining profiles are then drawn out to determine the shapes of the remaining formers; the positions of these must be carefully chosen to ensure that the construction of the frame will adequately define the shape of the animal. Long, thin members such as limbs, necks, tails and elephants' trunks usually require the use of an armature which follows the length of the feature, with formers spaced along it. (Armatures are discussed on page 85.)

The criss-cross frame, as used for the tortoise model in this chapter, is useful when there is a lot of sideways extent to the body: the extra formers parallel to the sagittal plane hold the whole frame shape together. This is especially appropriate in the case of the tortoise, simply because the shell does not change shape – it does not bend sideways as most bodies can.

When making leg formers, it is often helpful for the underside of the feet to be made with a projecting piece sticking out to touch the ground, as in the elephant drawing, Fig 5.28. This allows space for the finishing layer of material on the underside to be given the right shape.

Outer coverings for framework models can be made from a variety of materials: papier mâché, plaster, cement, paper, car-body filler, fibreglass. The fibreglass can carry all of the normal fillings. The resin can have added to it strands of glass, glass mat, glass rope, glass ribbon, carbon fibre (for extra tensile strength), fillers which are used just to add to the bulk, pigments, or metallic dust to give a metallic finish. The object of this outer covering is to give the framework model its outer body profile. The covering is best done in three stages:

The **first covering** serves to extend the shape determined by the formers so as to give the body a continuous profile, and to form a continuous body-shape former which has enough strength within its own bulk to maintain its shape and to take the

bangs and knocks which it will suffer during its life. Indeed, the framework now encased inside the body can be regarded as having done its job when the first covering is in place. (It would be no good making an animal model for open display in a public museum which could not stand children climbing all over it!) The material used depends on the scale of the model and the use to which it will be put: large models will need fibreglass draped over the formers, but as the model size comes down materials such as fabric or paper can be used. (Both fabric and paper are best stuck to the formers after being wetted with an adhesive such as PVA.) Paper laid on in several thicknesses is quite strong. Indeed, a good composite method is to use a paper or fabric cover first and then add a layer of fibreglass over this to give the strength; the fabric or paper then acts as a form over which the fibreglass can be draped.

The **second covering** serves to detail the profile with whatever is necessary – a smooth skin texture, scales, or a hairy coat – so as to finish the outside of the model for shape and form. The material used can be papier mâché, plaster, cement of various forms, reconstructed stone, car body filler, or whatever material suits the model and the model-maker.

The **third covering** serves to give the model its final colour. Again the type of pigment used depends upon the model and the maker. Sometimes I incorporate the third covering into the outer layers of the second covering by mixing in a powder pigment, especially if the model is intended for open public display. For a model which is going to be displayed on a domestic table or some such, acrylic colours laid on the surface will do.

DATUMS

Datums are simply references shown on the drawing to specify a particular line, spot or angle. They mark the basic foundation points of a system. If an instruction on a specification states that 'you will take

all of your measurements from this spot', then that spot is a datum. On an animal model, the sagittal plane is invariably one of the most important datums.

FIXTURES

Fixtures to help support the model during construction are another feature which you may want to incorporate in your working drawing. Fig 5.1 shows two fixtures used in assembling an elephant model which is to be built by the framework method. The same sort of fixtures could be used for any model where support is needed in this way.

Fig 5.1a shows a support used when assembling the cross-section formers A onto the sagittal plane piece B (which corresponds to piece 1 in Fig 5.28), to which the opposite-side formers C have already been fixed. The sagittal plane former rests on the horizontal surfaces D of the support, clear of obstruction at E, ready for gluing the remaining formers.

Fig 5.1b shows a support used when assembling the legs (shown by dotted lines) to the body ABC. The support holds the body upright and steady, and at the right height from surface F, which represents ground level. Two pins G are inserted through holes in the sagittal plane piece (see item 12 in Fig 5.28), and these rest on the upper ends of the four support pillars H. The spacer I between these pillars is just thick enough to allow the body assembly to enter between the pillars.

It is always worthwhile to make any fixture which allows you better control during assembly.

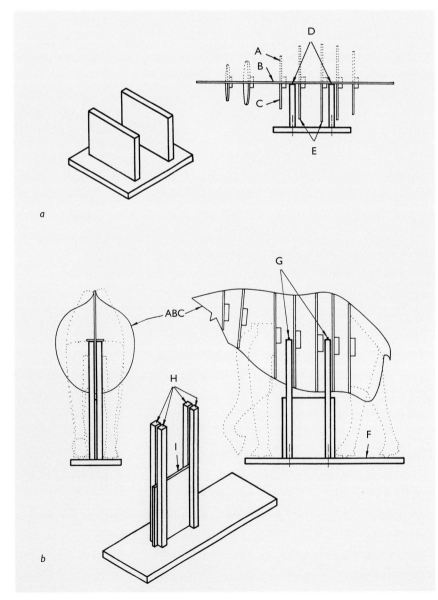

Fig 5.1 A typical set of supports for use in constructing an elephant model

TRANSFERRING SHAPES FROM THE DRAWING TO THE MODEL

TRACING

Fig 5.2*a* shows the main use of tracing paper for the model-maker: transferring shapes from one place to another. The technique is as follows: the tracing paper is put over the drawing and taped or pinned to prevent it from moving while the shape is traced onto it. The tracing paper is then taken off the drawing and turned over, and a soft pencil is rubbed over the lines which show through. The tracing paper is again turned over, placed on the piece of wood (or whatever the drawing is to be transferred to), and again prevented from moving while the drawing is gone over with a stylus-pointed instrument (a ballpoint pen will do). When the drawing is complete, the tracing paper is taken off to expose the required shape drawn on the model-making material.

PRICKING THROUGH

A more direct method of transferring shapes, if you do not mind damaging your drawing, is to prick through the drawing onto the model material using a sharp-pointed awl. The awl is shown next to the pencil in Fig 5.2*a*, and Fig 5.2*b* shows the result.

PROFILE GAUGES

Fig 5.3 shows one of the universal profile gauges that can be bought. These simply consist of a number of thin laminate sliders, mounted together so they can slide past one another, but at the same time held under some pressure so they stay where they are put. If you intend buying one of these, get a good one with plenty of laminates, and with the laminates having a long sliding stroke; this will enable your profile gauge to accommodate larger profiles.

Fig 5.2 Two ways of transferring shapes from the drawing to the modelling material

a By tracing: two pieces have been traced onto the plywood from the tracing-paper pattern which is partly visible at the upper left. The two plywood pieces, left-hand and right-hand, have the positions of the other formers marked on them so that when they are stuck together these marks will be visible on both sides

b By pricking: the ear and legs of an elephant (the latter to be made up in fabric as described on page 108) have been marked onto their respective materials by pricking through the drawing with an awl. (The awl is shown next to the pencil in Fig 5.2*a*)

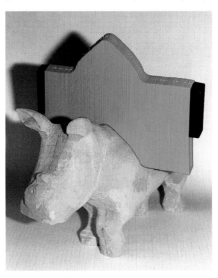

Fig 5.3 Recording an outline with a universal profile gauge

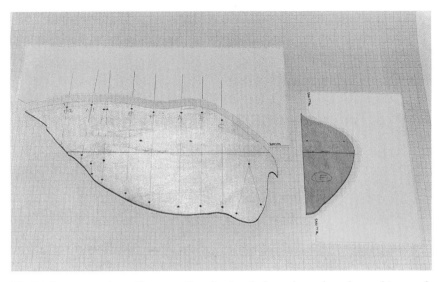

Fig 5.4 Purpose-made profile gauges (in yellow) and plywood templates for marking out formers

Fig 5.4 shows two non-adjustable C-shaped profile gauges (in yellow), made for a specific job. These are used to check wood and stone carvings. Make them as durable as is necessary – a profile gauge which does not stay in shape is not much good. Mark on each gauge just what it is for. (Incidentally, the two pieces of plywood in this figure are templates for marking out elephant formers. Templates are another aid you can use, but you only need these when you want to build several models. We won't go into production processes in this book – one model at a time will do.)

Whilst making your model, ensure that the sagittal plane remains evident on it as long as possible. It is a datum to which you will often have recourse when measuring the model's progress toward the final shape determined by the drawing, maquette and gauges. The closer your model progresses toward completion of its shape, the more you will need accurate and minuscule definition of each detail of the surface of your model. You will only get this if your references are there to use. About the most common reference you will need is the cross sections of the body. If you are building your model on a framework, of course, it will have cross-section formers inside, but for a carving or sculpture you will need a C-gauge to offer against the model in

progress. It must be offered up in the right place and in the right direction and attitude so as to give the right position of the relevant part of the body surface. There will only be one time it can fit properly, and that is, of course, when the work of removing material at this point is finished. When the modelling is in progress the gauge will not reach the sagittal plane, and usually it will not touch the model along its whole length (Fig 5.5).

Fig 5.6 shows how sets of C-gauges can encompass the whole of a model so that on completion they give a correct all-round profile. They are designed to touch one another all the way around.

Remember that, whereas the formers of a framework model are all fixed in the correct positions relative to one another, the C-type gauges are independent, and the user has to be most careful that when a C-gauge is offered up to the model it is in exactly the right attitude.

When carving or sculpting a surface, do remember that when a part of the finished surface is established on any part of the model, *all* of the finished surfaces *all over* the model are now defined, although they may not yet be uncovered. It is as well to remember this when offering up a profile gauge.

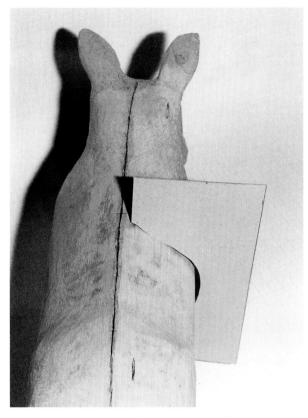

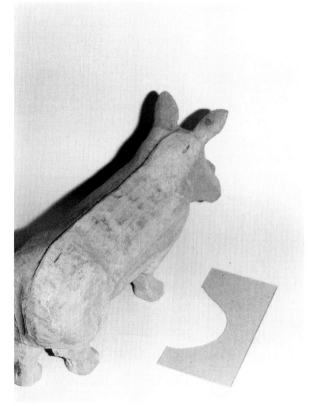

Fig 5.5 Using a purpose-made C-gauge to test the cross section of a woodcarving. The sagittal plane has been clearly marked on the model as a reference; note that the gauge will not reach the sagittal plane until shaping has been completed at this point

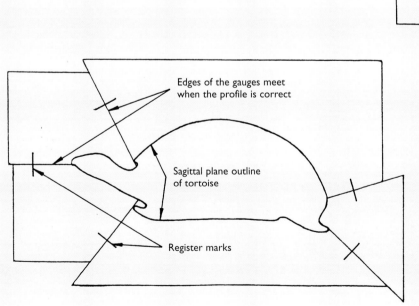

Edges of the gauges meet when the profile is correct

Sagittal plane outline of tortoise

Register marks

Fig 5.6 A matching set of C-gauges to encompass an entire model

CALLIPERS

Fig 5.7 shows how to make a pair of callipers. The size of the graticule squares can be what you like – a useful size is 1in (25mm). Make two jaw pieces from thin plywood to the pattern provided. Drill them, as shown, with a clearance hole to suit the diameter of the available bolt. Assemble by putting a plain washer on the bolt, then the two jaws with their gauging fingers facing one another, then a second plain washer, a hexagon nut, and finally a wing nut. Tighten the assembly with the hexagon nut, then bring the wing nut up to the hexagon nut and tighten. The jaws should move quite stiffly.

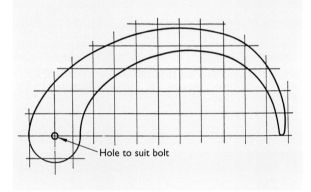

Hole to suit bolt

Fig 5.7 Pattern for a calliper jaw

It is worth practising the use of callipers (Fig 5.8). A good maquette and adequate calliper facility (external and internal) will stand you in good stead for making adequate and purposeful progress when model-making.

Very often your maquette will not be the same size as your model, so any calliper measurement from the maquette needs to be multiplied by a modulus to arrive at the model dimension. This can be a tedious process and is best avoided if possible. If it cannot be avoided, then it is best to make the module an easy one to apply: double or three times the size of the maquette, for example. When faced with a modulus which is not so convenient, there are several alternative methods which can be used to make the operation more efficient and less of a drain on calculator, brain and temper.

One method is to make a scale rule, which is easily done by the method shown in Fig 4.3 on page 52. Make line ac a ruler for use on your maquette, and let the length ac represent, say, 10 units. Mark off these 10 units on the line ac. Now draw the line ab, the length of which is 10 units at the scale you wish to use for the model. Join points b and c, and draw lines parallel to line bc from each of the divisions on line ac to cut line ab. Line ab is now divided into 10 units for use as a ruler on the model.

Other devices which might be used are proportional dividers and proportional callipers, in which the ratio between the scale of the maquette and that of the model is established by setting an adjustable fulcrum. Once the ratio is set, any measurement made at one end of the device is displayed at the other end with the ratio applied.

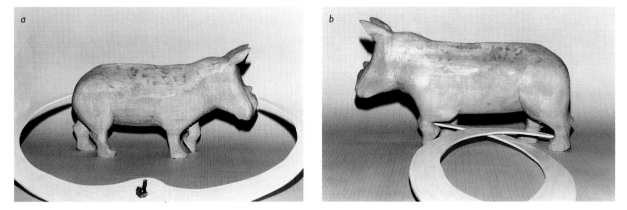

Fig 5.8 Use of the callipers to take (*a*) outside and (*b*) inside measurements

ARMATURES

Armatures, as used by model-makers, serve to support the body of material from which the model is made; indeed, they act very much like a skeleton.

Usually armatures are made from wire. The wire can be of any diameter which suits the purpose. There is on the market square-section wire specially designed for armatures. So far as I am concerned, this is expensive, when I can go to the builders' merchants and buy galvanized steel wire for a fraction of the price. Wire is extremely useful also for many frame, support and shaping purposes; I recommend it.

I have got used to using a relatively fine wire and twisting it together when I want more strength. A useful way of determining the modelling of digits or feather quills is to use a five-strand wire armature for the limb and carry the individual strands through to the digits. The whole thing can then be bent around until the required pose is attained with each digit in its place; the gorilla in Fig 5.9*b* is an

example of this method. Long limbs may need reinforcing by running steel rods up the frame structure, and then wiring or cementing them in before putting on the outer covering to make the finished shape.

With necks and tails it is always best to provide armatures so the model pose can be adjusted easily. This applies even to carvings, if the pose is anything other than the simplest: a maquette incorporating adjustable armatures is easy enough to make, and saves a lot of speculation about just where in the block of wood or chunk of stone the animal's body surface lies.

Fig 5.9 shows two uses of armatures. In the horse, armatures form the basis of the pose. They pass from the head right through to the tail, where the individual strands form the tail hairs. Three of the leg armatures carry through into the base to hold the whole model steady. In the gorilla, the limb frames are supported by armatures and these are carried down into the fingers and toes. (See also Figs 5.12 and 5.22.)

a The limb armatures of the horse are inserted into the base for stability

b The gorilla's limb armatures are multi-stranded and separate at the ends to form the fingers and toes (see Fig 5.38 on page 113 for the completed model)

Fig 5.9 Uses of armatures

MAQUETTES

The classic definition of a maquette is a model to a smaller scale than the proposed finished model. The object is to clarify as much as possible of the design and shape before working on the main model itself; in this way, any faults can be rectified before beginning work on the main model. This makes a lot of sense, especially if you are a sculptor who is going to work on a large piece of expensive marble. Of course, the average model-maker is not going to work on marble, but the principle is still the same.

If your model has anything other than the simplest pose, then the making of a maquette is recommended. It will give a preview of the proposed model, and will show what the model will look like when viewed from all angles. It will show where carving clearances are getting tight, and quite possibly prevent you from making some mistakes. It is much easier to modify a maquette than the finished model – indeed, modifying a maquette may only mean bending some part of it. A maquette made to the 'attention' drawing can be bent to the shape required for the current model then, when you have finished with it, put in store for the next model, which may have an entirely different pose. I don't usually finish off my maquettes to the ordinary standard – that is, to the whole skin-shaped image; I usually leave it at the bare bones and former stage. This is usually enough for the whole body to be seen.

A lot of my own finished models are made up in the same way as maquettes. The benefits of this approach are obvious.

In the following section I describe how to make a variety of models, chiefly by the framework method. These instructions can be used to make either a maquette or the framework of a complete model. In either case, the points made in the panel opposite need to be borne in mind from the outset.

- When making a frame of this kind, do make sure that you allow for the thickness of the frame material when planning the shapes of the formers. The thickness of the sagittal plane former, for example, must be taken into account when determining the shape of the crosswise formers which abut onto it. An example of this can be seen in Fig 5.11, where the width of formers 4 and 5 is reduced by half the thickness of the sagittal plane former 1, so that when all are glued together the overall width will be correct. Any slots or notches which are cut for the insertion of a cross-member must also match the thickness of the material. The allowances shown in my drawings are appropriate for the material I used; you may have to adjust them if your material is different.

- Make sure that all your armature wires are long enough to begin with; you can always cut any excess off after assembly.

- Before final assembly, it is best to make a dummy run to check that pieces go into their right position easily.

MAKING MODELS

There follow in this section drawings of the common frog, *Rana temporaria*; the spur-thighed tortoise, *Testudo graeca*; the domestic pigeon, *Columba livia*; the domestic cat, *Felis catus*; and the African elephant, *Loxodonta africana*. For each animal I include a drawing which shows the skeleton and the living shape, except in the case of the tortoise, where the shell provides enough of the body shape, so the skeleton is not required. Additionally, there is a drawing showing the armatures and the frames needed to construct the model by the framework method. For the pigeon I have added a drawing which shows the profiles required to produce the model by carving.

COMMON FROG
(*Rana temporaria*)

Fig 5.10 shows both the skeleton and the living shape of the frog. Note that the frog's pelvis acts like a spring. When the frog jumps, the pelvis straightens to add to the power of the jump; so, if you model the frog as it is jumping, make all of the spinal column straight. It is useful with a jumping frog model to allow extra on the rear limb armature for the wires to go into the base. The model can then be posed in the required position on the base.

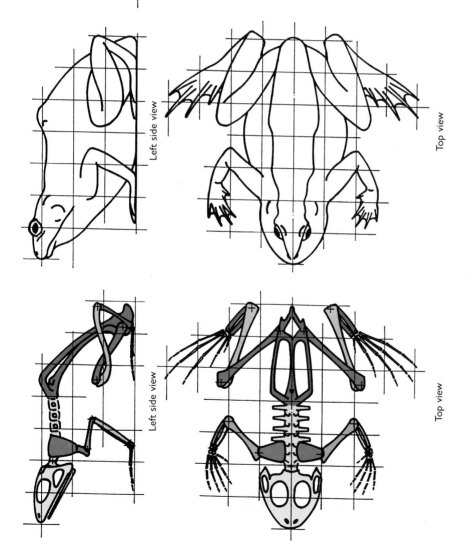

Front view

Left side view

Top view

Left side view

Top view

For a life-size model, each square of the graticule represents 1cm or ¹³⁄₃₂in

Note that the feet have been spread a little further apart than in the usual sitting position, so as to show more clearly in the top views

Fig 5.10 Common frog (*Rana temporaria*): skeleton and living shape

To make a model or a maquette by the framework method, follow the instructions set out below. Bear in mind the advice given on page 86 for making a framework of this kind.

Make the following parts, as shown in Fig 5.11:

1 Central section of the body at the sagittal plane. Make one piece.

2 Section at the eye line C. Make one piece.

3 Former at D. Make one piece.

4 Half-section at A–A. Make two pieces.

5 Half-section at B–B. Make two pieces.

6 Armature for front legs. Make one set.

7 Armature for rear legs. Make one set.

Stick 4 and 5 together, making sure that you have one left-hand and one right-hand set.

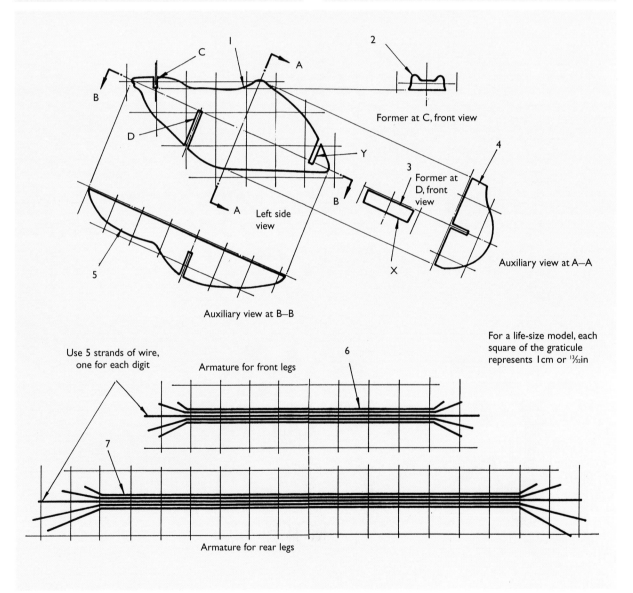

Fig 5.11 Armatures and frame for the frog model

Stick one set of 4 and 5 on each side of 1, making sure that each goes on the correct side. Each of these assemblies should fit exactly on the section line B–B.

Stick 2 into slot C so as to touch pieces 5.

Stick 3 in slot D so as to touch pieces 5.

Stick front leg armature 6 centrally onto piece 3 at X.

Insert rear leg armature 7 centrally into slot Y and stick onto pieces 5.

Leave all to dry.

Bend the armatures at the joint positions to obtain the natural model pose you want. Cut any excess off the armatures at the digit extremities. This completes the framework.

Complete the model by filling in the body and putting the finishing coats on it (Fig 5.12). This model is so small when modelled to a life-size scale that complete filling of the frame is the best option. There is no need for a first covering as described on page 79, so the second covering can go straight on in whatever material you wish to use – I would use a cement or car-body filler in this instance. Fig 5.13 shows the finished model.

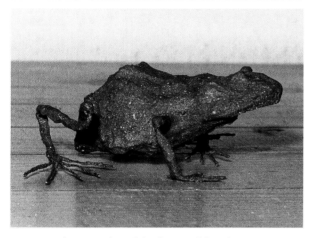
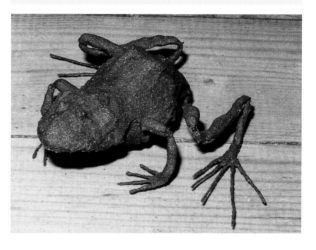

Fig 5.12 The outer skin of the frog model under construction.

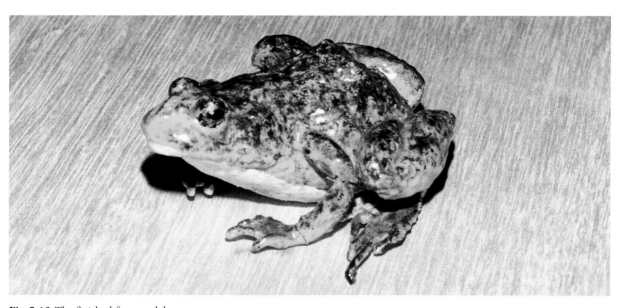

Fig 5.13 The finished frog model

SPUR-THIGHED TORTOISE
(*Testudo graeca*)

Fig 5.14 shows the living shape of the tortoise. Since most of the shape is given by the rigid carapace, it is not necessary in this case to make a study of the skeleton.

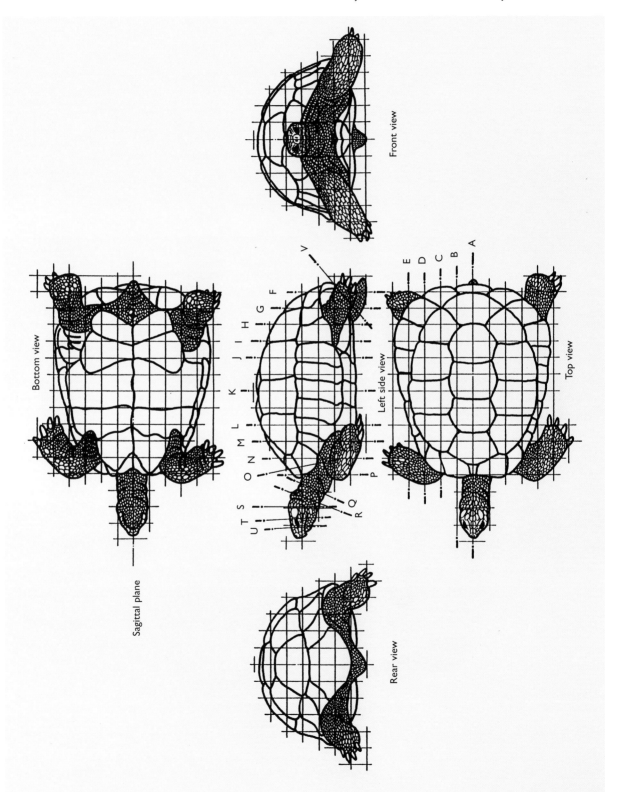

Fig 5.14 Spur-thighed tortoise (*Testudo graeca*): living shape

To make a framed model or maquette, follow the instructions set out below. Bear in mind the advice given on page 86 for making a framework of this kind. All the parts of the frame can be the same thickness.

Cut one piece of each of A, F, G, H, I, J, K, L, M, N, O, P, Q, R, S, T, U, V, as shown in Fig 5.15. Note that for pieces F–V the drawing gives only half the required shape.

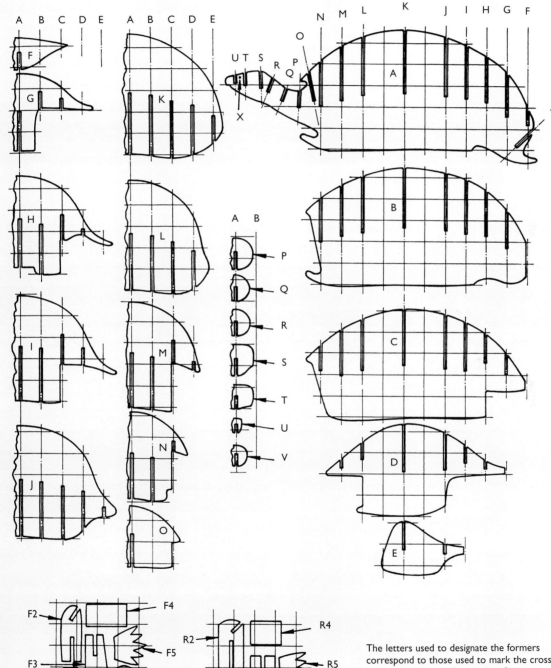

The letters used to designate the formers correspond to those used to mark the cross-section positions in the previous figure

For a life-size model, each square of the graticule represents 15mm or ⅝in

Fig 5.15 Criss-cross framework for the tortoise model

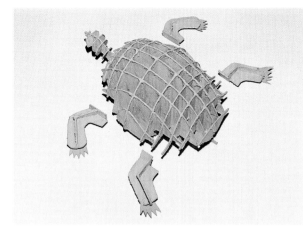

a The framework of the tortoise model ready to receive the legs

b A close-up of the leg frameworks

c The first covering of newspaper

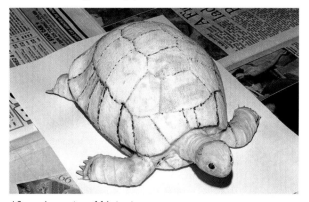

d Second covering of fabric pieces

Fig 5.16 The tortoise model under construction

Cut two pieces of each of B, C, D, E, F1, F2, F3, F4, F5, R1, R2, R3, R4, R5. To make the claw pieces F5 and R5, I have used pieces cut from the curved top of a plastic mineral-water bottle; this has an agreeable curvature to it.

Drill a small hole at X on piece A. This serves as a reminder of the position of the eyes.

To assemble the body, starting with the sagittal plane piece A: position piece V first, then all the rest of the cross-members, and finally the remaining longitudinal pieces B–E. Assemble the four legs. Be sure to make one left and one right front foot and one left and one right rear foot. The close-up of the legs in Fig 5.16*a* and *b* shows how the parts fit together.

Prop the body up so that it is clear of the ground, leaving room where the legs come to the ground. Assemble the legs to the body. This completes the framework.

Stick newspaper on the frame as a first covering to give the basic body shape (Fig 5.16*c*). To finish the model, I stuck on fabric cut to sizes which correspond to the shell pattern (Fig 5.16*d*). This gives a good basis for the last coat of colour and finishing texture.

Fig 5.17 shows the completed model.

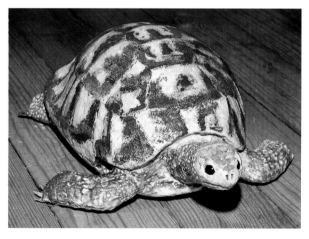

Fig 5.17 The completed tortoise model

DOMESTIC PIGEON
(*Columba livia*)

I have included in this section some notes about bird anatomy and physiology, because of some of the specialities of birds. The skeleton and living shape of the pigeon are shown in Fig 5.18. Fig 5.19 is an enlarged section across the body of a bird at the wing junction. Birds vary from other tetrapods in this area because of the extra duty put on the body when the bird is flying. The pectoral muscles are extremely strong and massive. (They are the chicken or turkey breast you eat for dinner.) The major pectorals pull the wings down. Their origin is at the sternum, which in its turn is enormously deep. The whole of the bird's body is quite stiff and strong. The ribs overlap one another, and the thoracic vertebrae (see Fig 2.6) are almost fixed relative one to another. In addition, the pelvis is extremely strong because the landing shocks are taken here.

Fig 5.18 Domestic pigeon (*Columba livia*): skeleton and living shape

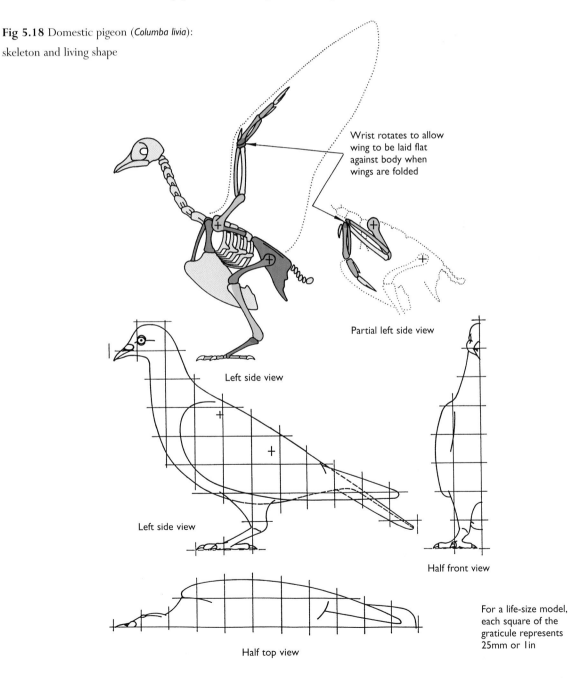

Wrist rotates to allow wing to be laid flat against body when wings are folded

Partial left side view

Left side view

Left side view

Half front view

Half top view

For a life-size model, each square of the graticule represents 25mm or 1in

93

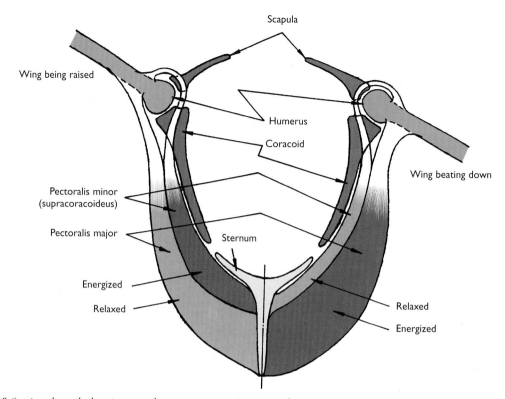

Fig 5.19 Section through the pigeon at the wing junction (corresponding to the position of former I in Fig 5.20)

The attachment of the wing to the body is achieved by the proximal end of the humerus making a joint with the scapula (which is tiny) and with the **coracoid**. This bone is well developed in birds and reptiles; it joins the humerus to the sternum, so that as the bird's wings beat down the lifting force travels along the coracoid to the sternum to lift the body. In addition, the clavicle bone follows much the same path as the coracoid but is much more slender. Its purpose in many species is to give mobility to the proximal end of the humerus, allowing it to move relative to the ribcage; however, in birds the whole system is tightened up and the clavicles are fused together at the sternum to form the **furcula** (the wishbone). When the bird is in flight the furcula bends and straightens as the wings beat, acting like a shock absorber.

The pectoral major and minor muscles originate at the sternum and travel up the ribcage to the head of the humerus. The pectoral major muscle pulls the wings down and is therefore attached (inserted) to

the underside at the head of the humerus; the pectoral minor's job is to pull the wings up, so it has to be attached (inserted) to the humerus bone on the topside. To do this it has to thread through the joint at the proximal end of the humerus.

There are triceps, biceps, flexor and extensor muscles in the wing in much the same way as there are in your arm. However, the bird also has a tendon which runs from the distal part of the radius and ulna to the proximal end of the humerus; this steadies the front edge of the wing. (It is as though you had a string from your wrist to your shoulder.)

There are one or two points worth noting about birds' legs. Note in Fig 5.18 how the tibia and fibula are fused into what is called a **tibiotarsus**. Sometimes the tibiotarsus also has some tarsal bones fused to its distal end. Additionally, the metatarsal bones have tarsal bones fused at their proximal end to form what is called the **tarsometatarsus** bone. This simplifies the ankle joint, but does nothing to

simplify the names of the bones! The important point is simply to realize that there are fewer bones in a bird's legs than in the normal tetrapod leg. Note, too, that there are reptilian scales on the feet from the proximal end of the tarsometatarsus downwards, shades of their dinosaur ancestry.

The building of a bird model framework, which can be used either as a maquette or as the basis of a finished model, is described below. If you are going to carve the pigeon, work to Fig 5.20, referring to the information on pages 81–3 about the use of profile gauges.

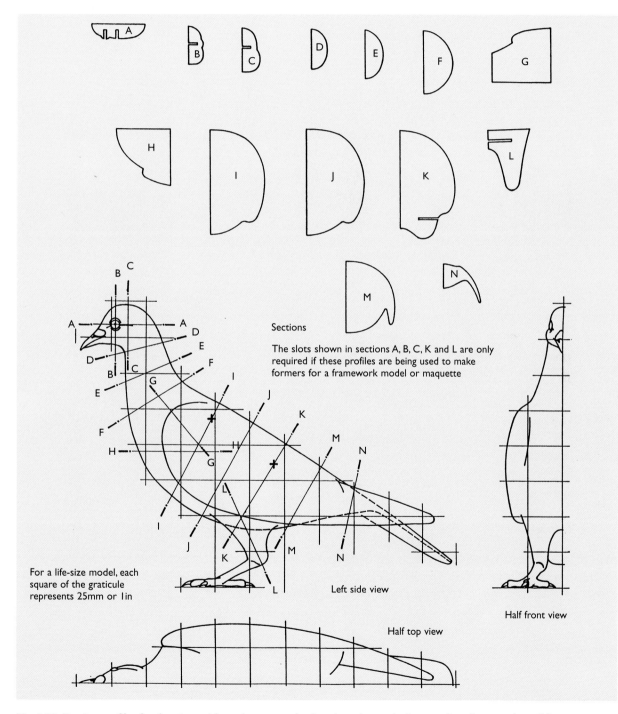

Sections

The slots shown in sections A, B, C, K and L are only required if these profiles are being used to make formers for a framework model or maquette

For a life-size model, each square of the graticule represents 25mm or 1in

Left side view

Half top view

Half front view

Fig 5.20 Carving profiles for the pigeon (these shapes can also be adapted to make formers for a framework model or maquette)

The maquette or frame described here uses four
armatures: neck, tail and base, legs and feet, and
wings. Fig 5.21 shows both armatures and formers.

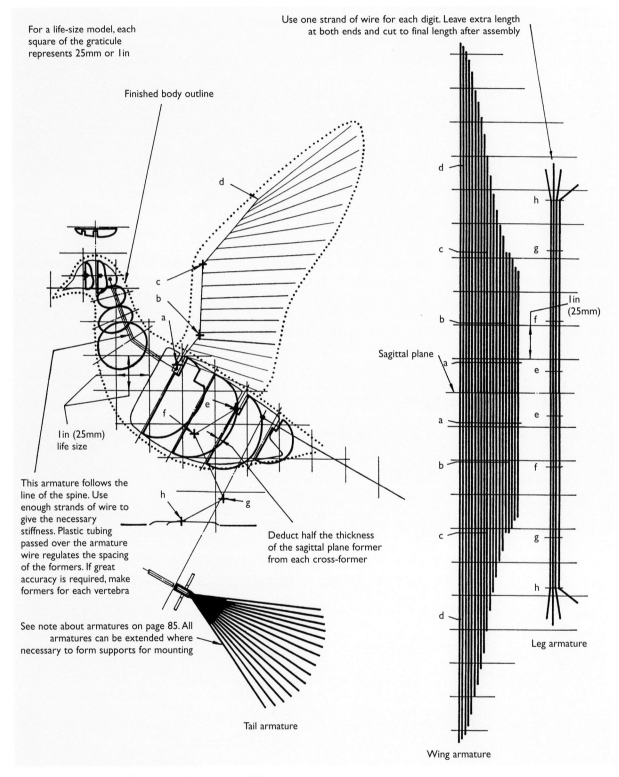

For a life-size model, each
square of the graticule
represents 25mm or 1in

Finished body outline

Use one strand of wire for each digit. Leave extra length
at both ends and cut to final length after assembly

d

c

b

a

Sagittal plane

1in (25mm)
life size

This armature follows the
line of the spine. Use
enough strands of wire to
give the necessary
stiffness. Plastic tubing
passed over the armature
wire regulates the spacing
of the formers. If great
accuracy is required, make
formers for each vertebra

See note about armatures on page 85. All
armatures can be extended where
necessary to form supports for mounting

h g

Deduct half the thickness
of the sagittal plane former
from each cross-former

Tail armature

d
h
c
g
b
f
1in
(25mm)
a
e
a
e
b
f
c
g
h
d

Leg armature

Wing armature

Fig 5.21 Armatures and frames for the pigeon model

Obtain the drawing, preferably to the same scale as the maquette.

Trace out the shapes of the formers on tracing paper. In this case there are 12 formers. One is for the centre line of the head, and one for the centre line of the body. Of the remaining ten, seven are made in matching halves; the other three form sections of the neck (Fig 5.22a). Transfer the tracing to the maquette material (card, plywood or other material as preferred) as described on page 81, and cut the pieces out. If more than one piece of the same shape is wanted (as with the paired cross-section formers in this case), trace and cut the number required.

Cut a sufficient number of small squared blocks of wood to hold the formers in place while the glue is drying. (Some of these can be seen on the far left in Fig 5.22a.)

Obtain lengths of appropriate wire for the armatures (see page 85), and fine wire for binding these together. (The latter can be electricians' wire intended for winding solenoids or motors.)

Obtain some plastic tubing (the type used for domestic aquarium air pipes is useful) to provide a flexible support for the neck formers.

Stick the cross-section formers to one side of the main head and body pieces, gluing on the small wooden blocks to steady the larger formers (Fig 5.22b). Allow to dry. It is advisable to make dummy runs first to make sure every piece goes into place properly.

Set up the head and the body ready for the formers on the opposite side, using supports similar to those illustrated and described on page 80 (Fig 5.22c). Stick the remaining formers to the head and the body (Fig 5.22d). Allow to dry.

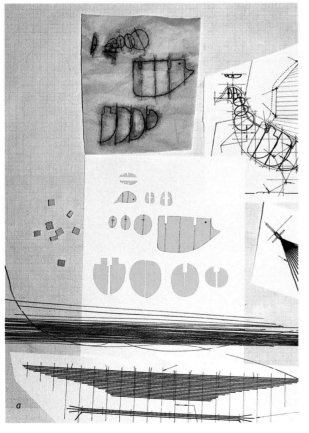

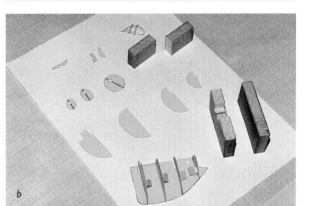

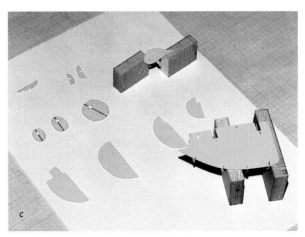

Fig 5.22a–i Stages in making a maquette of a pigeon

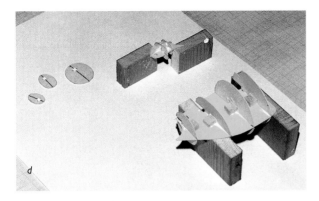

d

Take a few strands of armature wire for the neck. Attach the central part to the body, fold in half, twist the strands together, and stick in place. Fig 5.22e shows clearly how the notches cut in the top of the main body former assist in attaching the neck, leg and wing armatures.

Cut four pieces of tube to fit the spaces between the neck formers. Thread the tubes and the neck formers alternately onto the armature. Cut the armature wire to a length which will give some overlap on the head. Stick on the head and leave to dry.

Use four armature wires to make the major part of the framework of the tail. Fig 5.22e shows how the tail armature is extended to form part of the base as the bird comes in to land, and so provides the means of mounting the model on its base. Find the midpoint of these wires, which is where they will attach to the body; attach as shown in Fig 5.21. Arrange the wires to form the tail shape and bind and glue them into position on the body. In this case, they also need to be bent at ground level to form the base. Leave to dry.

Use four wires to form the leg armature, the centre top of which locates in a notch in the top edge of the main body former. Bend to shape, bind and stick to form the leg pieces, leaving the individual strands at each end to form the feet, which are only roughly shaped at this stage. Leave to dry, then stick the leg armature in position and leave to dry again.

Make up the wing armature. Use heavier-gauge wire for the bones and the first few primary feathers, then a finer gauge to form the area of feathers behind the bones. Stick together at the leading edge and leave to dry. These wires can then be shaped and cut to form any shape of wing (Fig 5.22f).

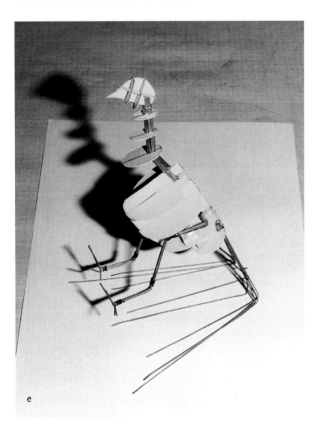

e

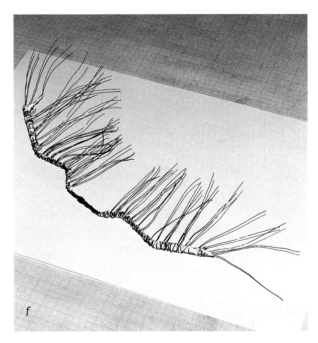

f

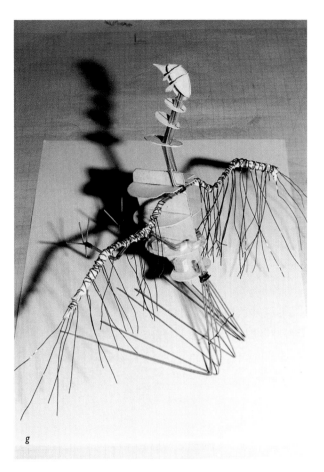

g

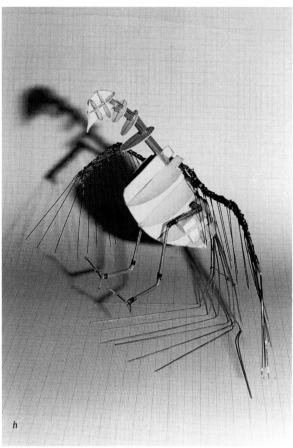

h

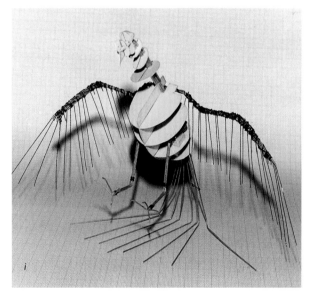

i

Stick the wing armature into the appropriate notch in the top of the body former and leave to dry (Fig 5.22g).

All of the basics of the maquette are now assembled. It is just a matter of cutting the excess pieces of wire off and bending until the required pose is achieved. The maquette allows you to put the animal in any pose which it could adopt in life. Fig 5.22h and i show the neck bent forward, the feathers spread downwards and the claws outstretched in the characteristic pose of a bird coming in to land.

If more body form is required, then a surface layer can be applied to the body. Indeed, the whole thing can be finished off to make a complete model. If the piece is to be used as a maquette, then all relative dimensions can be taken off it. All carving clearances can be seen. The whole pose can be examined from every angle. All those unsatisfactory details can be corrected until everything is right.

DOMESTIC CAT
(*Felis catus*)

I used the cat in Chapter 4 as an example of my method of making the drawing from the skeleton outwards. Fig 5.23 shows the basic 'attention' drawing. The frame drawing (Fig 5.24) shows a slightly different way of making the neck flexible.

The finished model is shown in Fig 5.25, which illustration shows the degree of movement which can be achieved by this method. Otherwise, the method of construction is the same as before, and need not be treated in detail here.

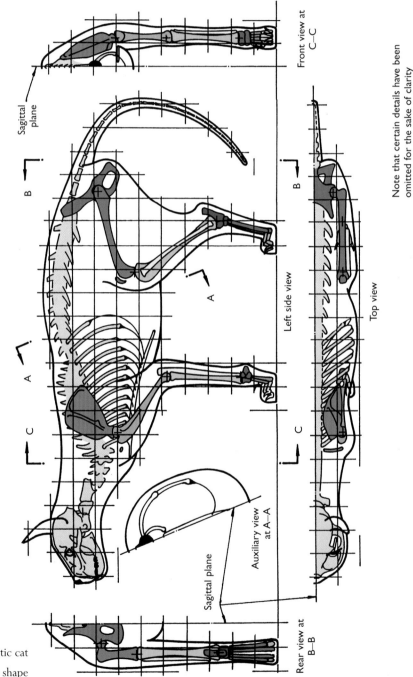

Fig 5.23 Domestic cat (*Felis catus*): skeleton and living shape

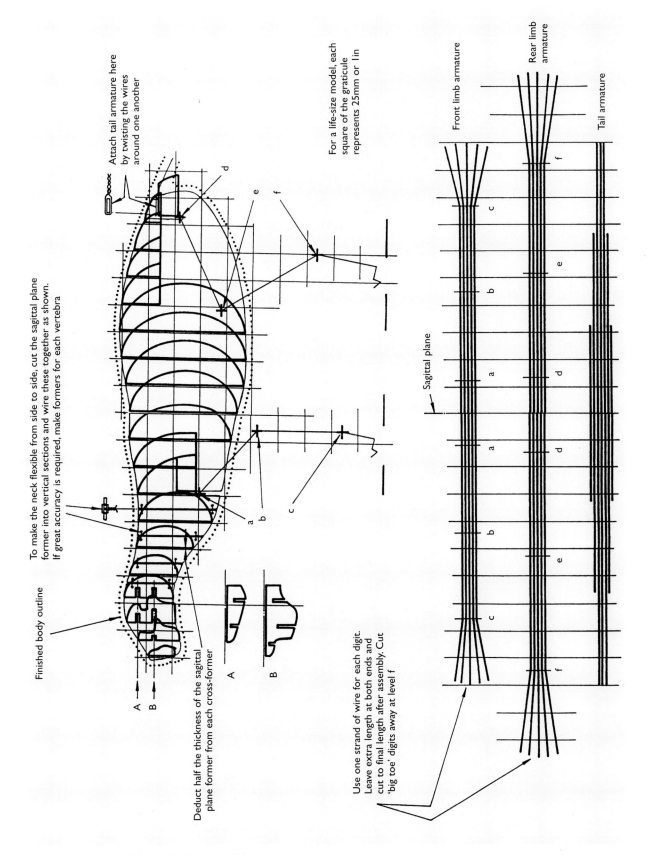

Fig 5.24 Armature and frame for the cat model

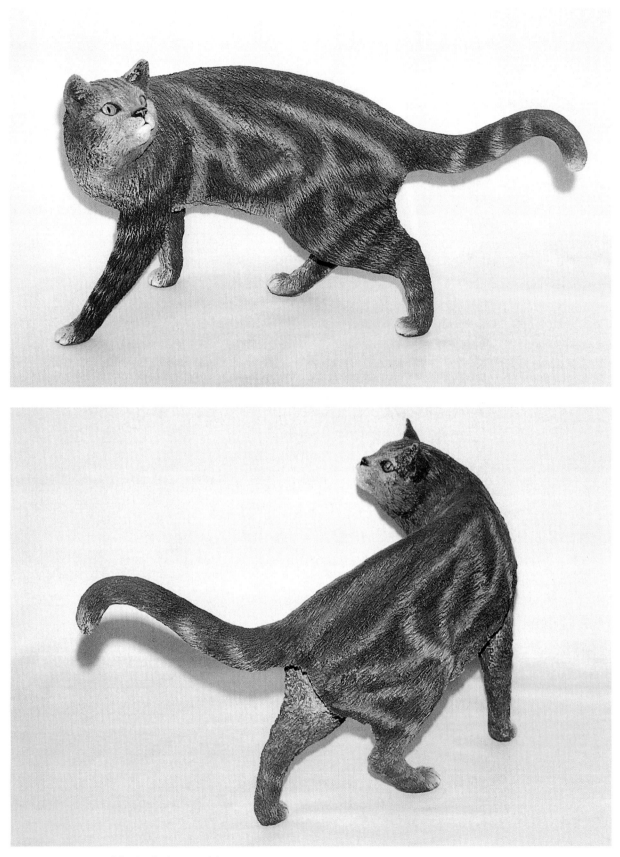

Fig 5.25 Two views of the finished cat model

AFRICAN ELEPHANT
(*Loxodonta africana*)

Fig 5.26 shows the skeleton and the living shape. The alternative limb positions shown in Fig 5.27 were arrived at by using the cardboard limb pieces, as described on pages 57–9. Do not forget to observe the 'quadrupedal gait' described on page 77.

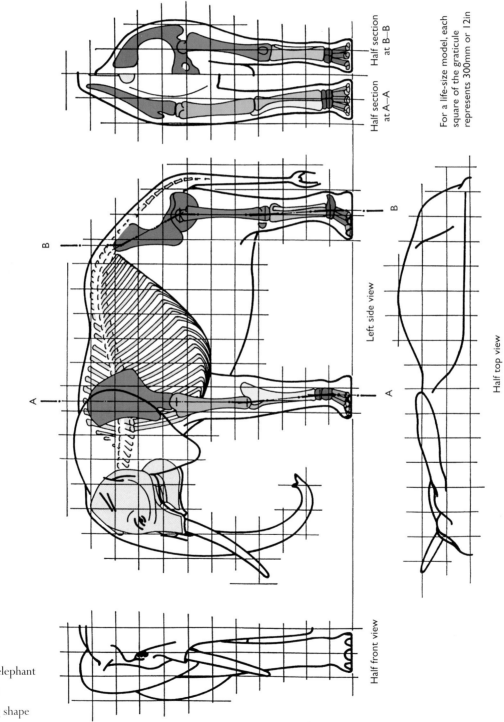

Fig 5.26 African elephant (*Loxodonta africana*): skeleton and living shape

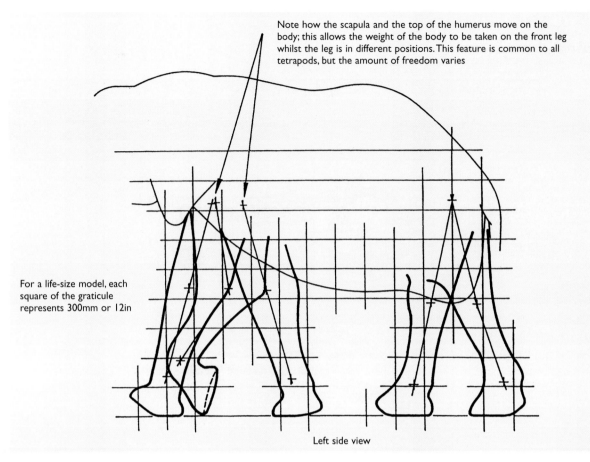

Note how the scapula and the top of the humerus move on the body; this allows the weight of the body to be taken on the front leg whilst the leg is in different positions. This feature is common to all tetrapods, but the amount of freedom varies

For a life-size model, each square of the graticule represents 300mm or 12in

Left side view

Fig 5.27 Alternative leg positions for the elephant model

Fig 5.28 shows the framework and armatures for the model. Because the legs are so robust, they have part of the frame in them, so armatures are restricted to the trunk and tail. (Many people are surprised how long an elephant's tail is: the tail hairs nearly reach the ground.) The trunk structure shows a slightly different kind of armature, with five wires, one through the middle and four arranged round the outside. The one through the middle has plastic tubing on it, as before, to maintain the correct spacing between the trunk formers. The trunk is manipulated to its finished position, then the four outside wires are fixed at their ends, thus holding the trunk in place.

The skull of the elephant is made in two sections, which allows the head to be nodded to the finished position. The ears are made from fabric, with as many layers as necessary for strength (see Fig 5.28). The ear is stuck to the lower levels of the surface layers of the body, and then the finishing layers are put on afterwards. The ear is dished at the front end and the top turned over backwards as in life.

To make a framed model or a maquette, follow the instructions set out below. The procedure is much the same as before, but because of the complexity of this particular model I have thought it advisable to go through the process in some detail. Bear in mind the advice given on page 86 for making a framework of this kind. You will need two different thicknesses of frame-making material: one thickness for the tusks, and one for the rest of the framework. This is the time to choose them. You will need to decide the thickness according to the scale of the model, to ensure the strength of the framework. I have shown the tusks as an eight-section laminate, but again this is a choice for the individual builder. When these two thicknesses of material are to hand, construction can begin.

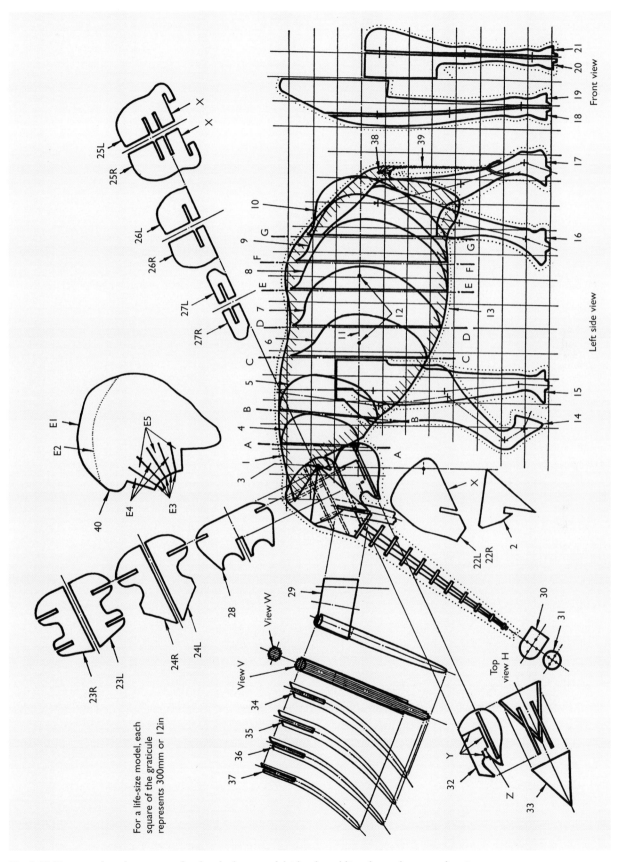

Fig 5.28 Framework and armatures for the elephant model (the dotted line shows the outer shape)

Make the following formers as shown in Fig 5.28:

1 Central section of body at the sagittal plane. For the sake of clarity, the edge of this piece is indicated by hatched lines in the drawing. (It is also shown clearly in Fig 5.4 on page 82.) Make one piece. Mark all section lines and the datum line (marked 11 in the drawing) on both sides.

2 Central section of head at the sagittal plane. Make one piece.

3 indicates the position of the occipital condyle, where parts 1 and 2 join. The point at the rear end of part 2 fits into the angle at the front of part 1, allowing the head to nod. This enables the head to be adjusted to the required angle and glued there at a later stage.

4 Half-section at A–A. Make two pieces.

5 Half-section at B–B. Make two pieces.

6 Half-section at C–C. Make two pieces.

7 Half-section at D–D. Make two pieces.

8 Half-section at E–E. Make two pieces.

9 Half-section at F–F. Make two pieces.

10 Half-section at G–G. Make two pieces.

Mark the horizontal datum line 11 on both sides of each piece through which the line passes. This will be a great help in aligning the pieces during assembly. On piece 1, drill two small holes (12) on the datum line, just large enough to accept a short piece of wire or a small nail.

Lay piece 1 flat and glue one each of formers 4, 5, 6, 7, 8, 9 and 10 to it, using small wooden blocks for reinforcement as described on page 97. When dry,

turn it over and place it on the fixture shown in Fig 5.1a. Glue on the remaining pieces 4, 5, 6, 7, 8, 9 and 10, with small wooden blocks as before.

When dry, pass a piece of wire (or a small nail) through each of the two small holes which you drilled on the datum line, and use these to support the body on the fixture shown in Fig 5.1b. If the fixture has been made to the correct height, the feet will just touch the work surface when the legs are assembled.

Now cut out the following formers for the legs:

14 Left foreleg, left side view. Make one piece.

15 Right foreleg, left side view. Make one piece.

16 Left rear leg, left side view. Make one piece.

17 Right rear leg, left side view. Make one piece.

18 Outer part of foreleg, front view. Make two pieces.

19 Inner part of foreleg, front view. Make two pieces.

20 Inner part of rear leg, front view. Make two pieces.

21 Outer part of rear leg, front view. Make two pieces.

The leg pieces 18, 19, 20, and 21 will need to be cut at the positions of the leg joints, as shown by the small crosses in the left side view; the separate pieces are then stuck to 14, 15, 16, and 17, and finally the four completed legs can be assembled onto the body. Front legs are glued to formers 1 and 6, rear legs to formers 1 and 10 (Fig 5.29). (You may have noticed that in the front view pieces 20 and 21 appear to be too long and pass below the ground-level line. The pieces made to this pattern will in fact be the correct length when placed in a pacing position as shown in the left side view.)

Fig 5.29 The elephant framework with its legs attached, mounted on a version of the support fixture shown in Fig 5.1*b*

The skull is made in two halves, and requires the following formers:

22 Make two pieces, 22L and 22R. The small hole towards the rear is to mark the position of the occipital condyle.

23, 24, 25, 26, 27 Cut two of each as shown. Assemble the left side as one unit and the right as another, then stick the left assembly onto 22L and the right assembly onto 22R. Make sure that surfaces X on 22 and 25 are flush.

28, 29, 30 Cut one of each. The set of five holes drilled through piece 30 will accommodate the wires forming the trunk armature.

Assemble by gluing the left and right head piece assemblies onto piece 28, at the same time gluing and pushing piece 2 into position in the centre of the head so that it is sandwiched between 22L and 22R. The small holes in pieces 22L and 22R indicate the correct position of the pointed rear end of piece 2. Fit piece 29 into the slot in pieces 2 and 22, and glue piece 30 into position at the front of the skull.

Make a set of round formers for the trunk, of which an example is shown at 31. Some ten pieces will be sufficient. The diameter of each piece should correspond to the width of the trunk at that point, as shown in the left side view, always allowing for the thickness of the covering. Assemble the trunk pieces onto piece 30, using five pieces of stout wire for an armature. Pieces of tubing cut to the right length are threaded between each piece on the central wire to control the length of the trunk. Bend the trunk to its natural position, and twist the wires at each end to make the whole assembly secure (Fig 5.30).

To make the lower jaw, cut two pieces 32. Make cuts where shown at Y. These cuts enable the jaw pieces to be twisted at Z, so that the upper part forms an angle with the lower part, as shown in the top view H; be sure to make one left-hand and one right-hand piece. Cut one piece 33 and glue it between pieces 32, ensuring that the whole assembly is square across its top edge. Note that the front ends of the two pieces 32 will need tapering so that they fit nicely together in the middle of the lower lip.

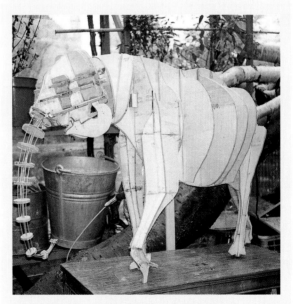

Fig 5.30 The completed trunk armature

Assemble the mandible assembly to the head as shown in the left side view. Assemble it centrally and push it forward to touch piece 29.

The tusks are best laminated as shown in views V and W. I have shown an eight-level laminate. Pieces 34, 35, 36 and 37 show the basic shape of each laminate of the tusks. The eight laminates together need to make a width which is just in excess of the finished width of the tusk, to allow for smoothing them down after assembly. The slots cut in each tusk allow them to be mounted on the supporting piece 29. The mounting of tusks and horns for other animals can be done in the same way; antlers are best made with a multi-wire armature, using separate strands of wire for each prong.

Cut four pieces each of parts 34, 35, 36 and 37, and make two sets of laminates in the order 37–36–35–34–34–35–36–37. To ensure that the slots are accurately aligned, use a scrap piece of material of the same thickness as piece 29; pass this through the slots in the laminates whilst the glue is setting. Put some clingfilm over it so it will come out easily when the glue is set.

When set, round off the tusks to their final shape, using abrasives or spokeshave as preferred. I always enamel them at this stage. Clean off the sloping end at the top of each tusk, which buts against the underside of formers 24L and 24R, then glue the tusks onto piece 29 in their natural position.

Now assemble the head onto the body. The body piece may have to be reduced slightly in width at the front to fit between parts 22L and 22R. Push the pointed end of part 2 to meet the body at point 3, as described above. Nod the head in a 'yes' movement to the desired position.

A small hole (38) through the rear end of the central former allows a wire assembly for the tail (39) to be secured. Make up the tail from fine wire, one strand for each pair of hairs at the tip. Use a generous length of wire; it can be cut to its final length later. Pass the wires through the hole 38 until they are central, twist them around the central section 1 as shown in the left side view, then twist them around one another to make a tail of the correct length.

Cut two ears (40) from fabric. Several layers of fabric may need to be stuck together as a laminate (using PVA glue or similar) to give sufficient rigidity to the ear shape. The ears need to be turned over backwards in the area E1 above the dotted line E2. Make the five cuts E3 to form the flaps by which the ear will be glued to the body. After the first layer of covering material has been applied to the body framework, assemble the ears onto the body by gluing the flaps E4 forwards and flaps E5 backwards.

The framework is now ready to receive the covering of your choice (Fig 5.31). Fig 5.32 shows a pair of elephant models made by this method.

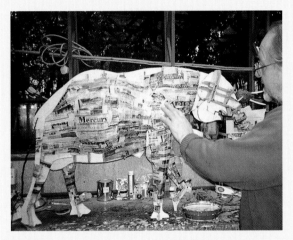

Fig 5.31 The armature receiving its first covering of newspaper

Fig 5.32 Two completed elephant models

SOME OF MY OWN WORKING DRAWINGS

I show here parts of some of my own working drawings, as an indication of the amount of detail I find to be useful when recording information for my own use. If you are producing a drawing which is only going to be used by yourself, then you can save a lot of time and effort in several ways. One particular method is to put views on top of one another. The skeleton can often be omitted, except at those points where it directly controls the living body shape. But as I have said before, it is not generally advisable to take short cuts in drawing until you are sure you know what you are doing.

WHITE RHINOCEROS (*Ceratotherium simum*)

I have included the rhino drawing (Fig 5.33) to show how you can save space by putting one view on top of another. This also includes the footprint at the bottom left. Note too the tail drawn above its usual place. See Fig 5.34 for the completed model.

Fig 5.33 My own working drawing of the white rhinoceros (*Ceratotherium simum*)

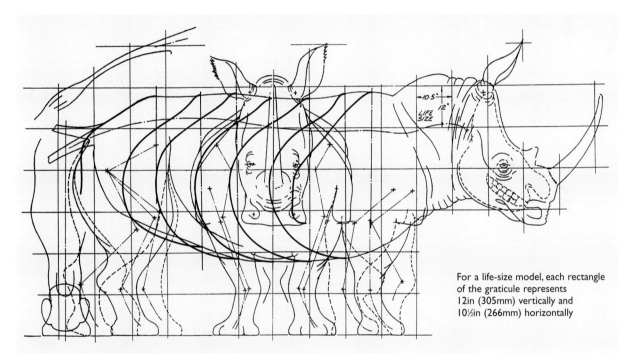

For a life-size model, each rectangle of the graticule represents 12in (305mm) vertically and 10½in (266mm) horizontally

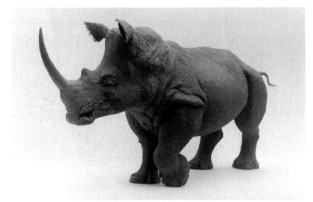

Fig 5.34 The completed rhinoceros model

HIPPOPOTAMUS
(*Hippopotamus amphibius*)

The hippo drawing (Fig 5.35) shows various auxiliary views, giving information which cannot be shown clearly in any ordinary view. It also shows how to save space by superimposing front and rear views, and by combining two characteristic postures in one drawing. I opted for the open-mouthed pose in the final model (Fig 5.36).

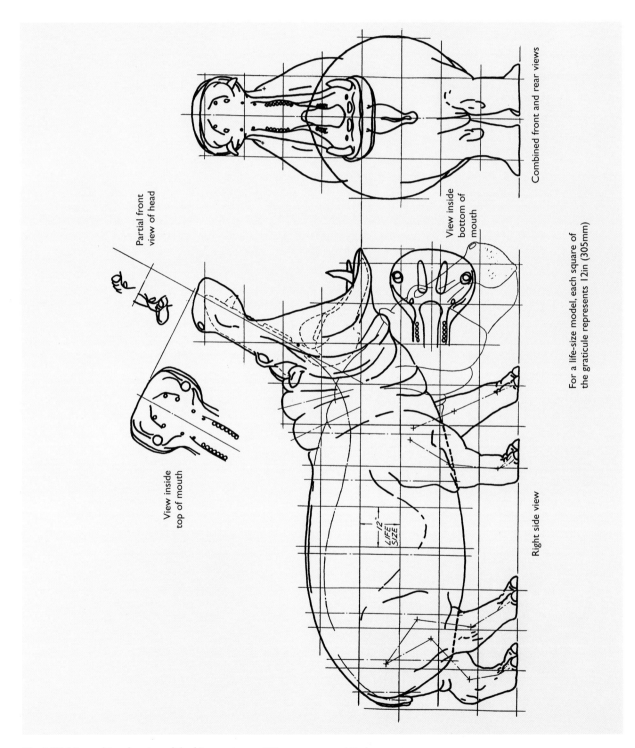

Fig 5.35 My working drawing of the hippopotamus (*Hippopotamus amphibius*)

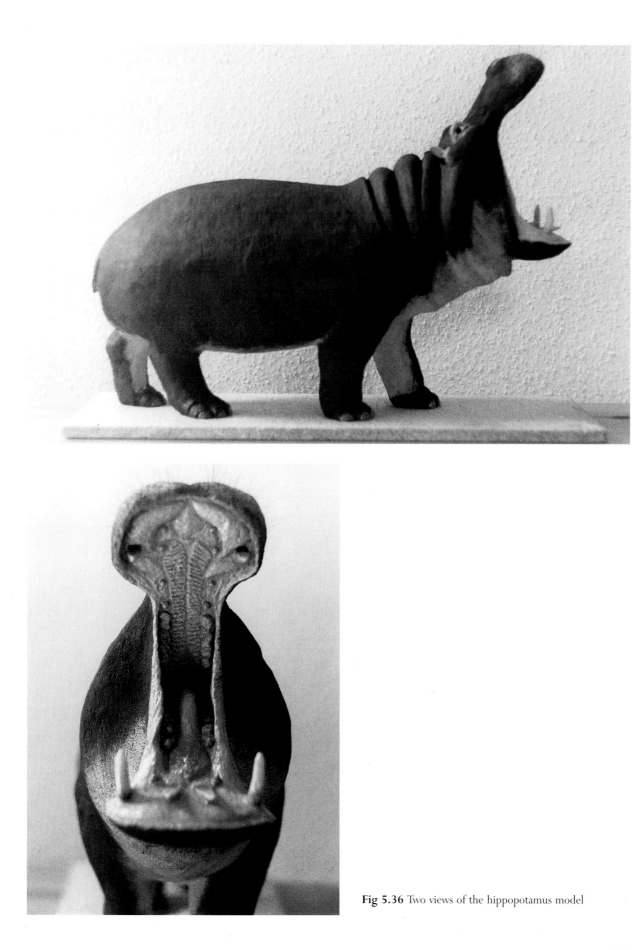

Fig 5.36 Two views of the hippopotamus model

GORILLA
(*Gorilla gorilla*)

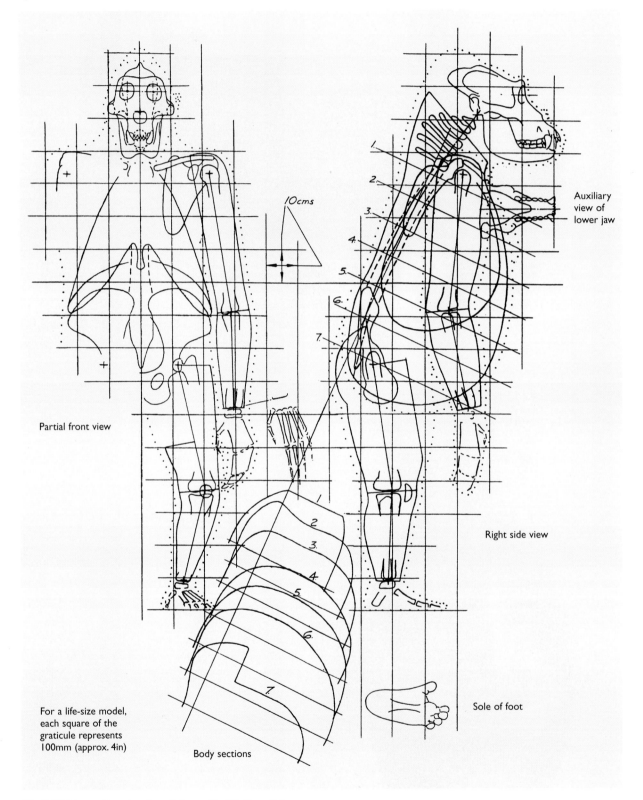

10cms

Auxiliary
view of
lower jaw

Partial front view

Right side view

Sole of foot

For a life-size model,
each square of the
graticule represents
100mm (approx. 4in)

Body sections

Fig 5.37 My working drawing of the gorilla (*Gorilla gorilla*)

The gorilla (Fig 5.37) is of particular interest because it is both a biped and a quadruped. The spine does not have the curvature seen in humans; the gorilla's spine is still that of a quadruped. The large clavicles are a relic of brachiation. The neck has large upstanding processes on the vertebrae, and is stiff; to look sideways, the gorilla has to turn its body. The pelvis is wide and flat and extends upwards nearly to the lower ribs, making the body stiff. The gorilla is a 'knuckle walker': weight is taken on the backs of the middle phalanges of the second to fifth digits of the hands.

The sections 1 to 7 are for external body shape; the profiles of the legs, arms, and sagittal plane of the body, on the other hand, are shaped to allow for model wall thickness. The note showing 10cm on the graticule is for life size; since animals vary so much in size, 4in can be taken as a close enough approximation in imperial measurements.

The model is shown under construction in Fig 5.9 (page 85), and complete in Fig 5.38.

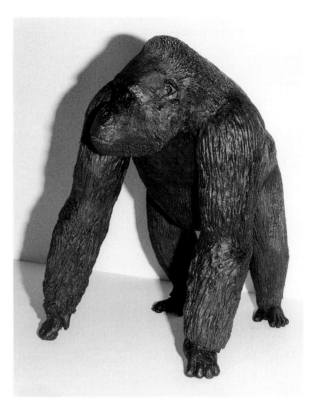

Fig 5.38 Two views of the completed gorilla model

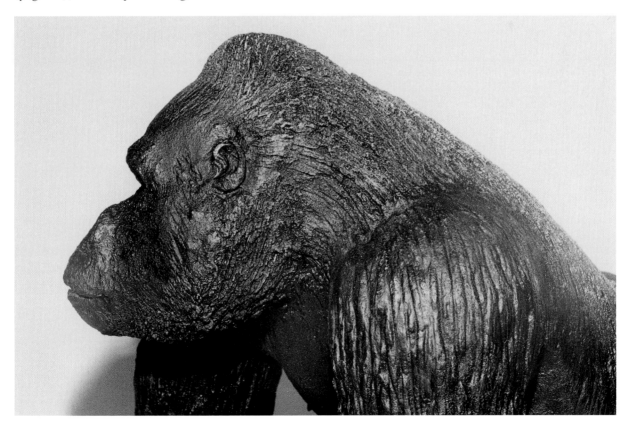

GIRAFFE
(*Giraffa camelopardalis*)

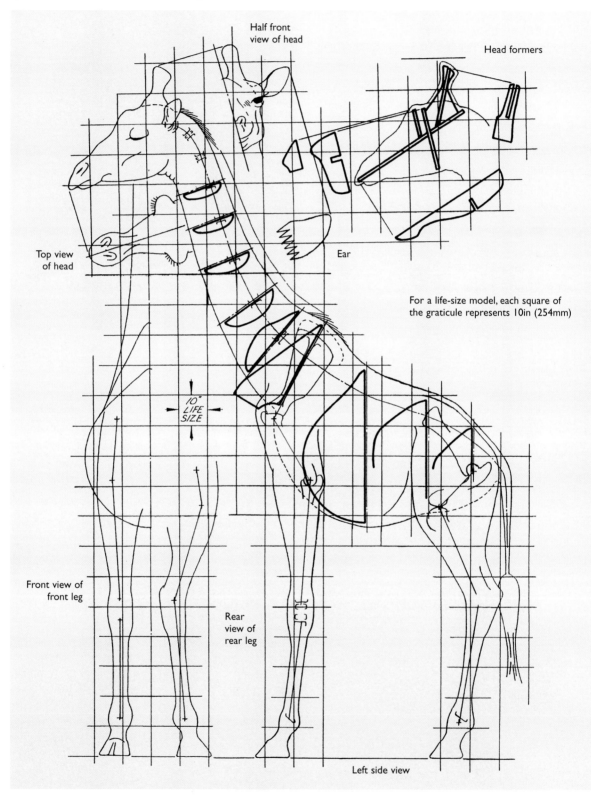

Half front view of head

Head formers

Top view of head

Ear

For a life-size model, each square of the graticule represents 10in (254mm)

10"
LIFE
SIZE

Front view of front leg

Rear view of rear leg

Left side view

Fig 5.39 My working drawing of the giraffe (*Giraffa camelopardalis*)

The giraffe drawing (Fig 5.39) shows auxiliary views of the head, and a pattern for the ear. Fig 5.40 shows the model complete.

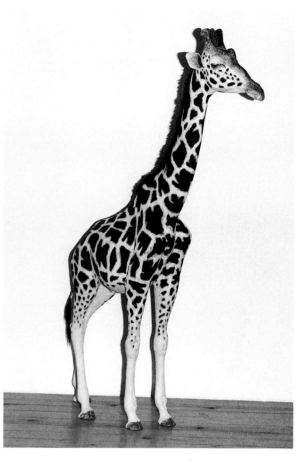

Fig 5.40 Two views of the completed giraffe model

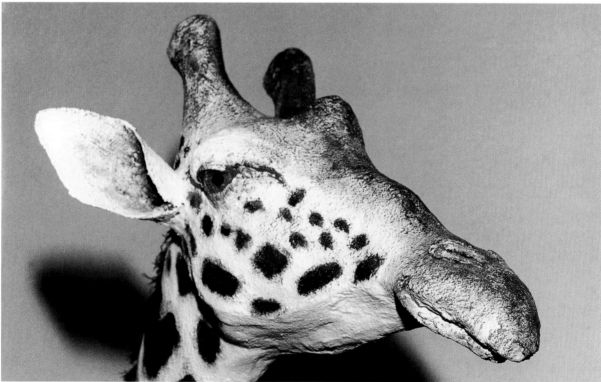

A FEW REMINDERS ABOUT MODEL-MAKING

1 Remember that the fundamental build of all tetrapods is the same.

2 Get used to the animal you want to model: 'feel it', 'smell it'.

3 Do ask museum, library, farm, zoo staff for information.

4 Do collect a library of useful information.

5 Remember that pretty well all animals have a plane of symmetry, the sagittal plane.

6 Always start by drawing your animal standing 'to attention'.

7 Don't forget the 'quadrupedal gait' of most quadrupeds.

8 Draw separately any special points about your model.

9 Don't be put off by the bit of arithmetic required to establish the measurements you need. The work is not difficult and is well worth it.

10 Only go into detail as far as you need to go.

11 Do try to keep your drawings neat.

12 Do put all old sketches into your library.

13 Always use a big enough piece of paper.

14 Do familiarize yourself with the main bones, joints, muscles. You will understand better what your model is doing.

15 Don't forget you want to catch the character as well as the shape - learn about the animal's body language.

16 Don't hesitate to make a maquette.

17 Photograph all your models, even the bad ones.

GLOSSARIAL SECTION

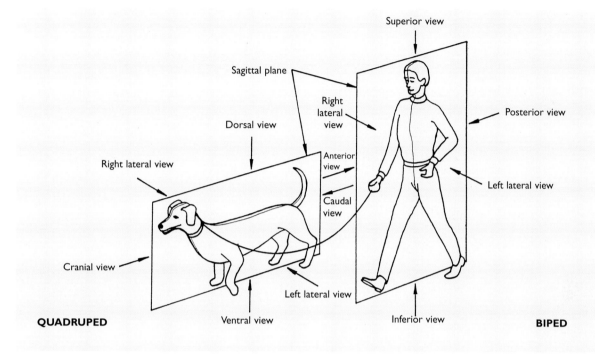

Fig 6.1 Describing an animal: names of the different views, in scientific terminology (refer to Fig 2.1 on page 3 for the everyday terms)

Fig 6.2 The conventional arrangement of the various views in a technical drawing (in scientific terminology; see Fig 4.4 on page 54 for the everyday terms)

alula the small 'wing' of feathers attached to a bird's thumb.

Amphibia the vertebrate class which includes frogs, toads, newts and salamanders.

appendicular skeleton the skeleton of the limbs and the **pectoral** and **pelvic girdles**.

armature an internal framework, sometimes flexible in shape, on which a model may be constructed.

Artiodactyla even-toed ungulates: mammals with two equal toes, in which the original third and fourth digits have evolved into cloven hoofs (cattle, deer, pigs, sheep, camels).

atlas the bone at the top of the spine on which the skull is mounted.

Aves the vertebrate class which comprises the birds.

axial skeleton the skull, vertebral column and ribcage (also the hyoid bone, but we are not concerned with this as modellers).

axis the bone on which the **atlas** is mounted.

biped any animal which normally walks on two legs.

brachiation locomotive swinging by using the arms whilst hanging from supports.

brachycephalic having a short, wide skull.

bursa cavity containing synovial fluid.

canid any animal of the dog family.

carapace the thick, hard upper shell of tortoises and some other animals.

carpal any of the bones in the wrist.

carpus the group of small bones which forms the wrist.

cartilage skeletal tissue which is firm but elastic.

caudal of the tail.

cervical of the neck.

clavicle collarbone.

coccygeal of the coccyx.

coccyx the vestigial tail which forms the lower end of the spinal column in humans and some other primates.

condyle a rounded projection on a bone which allows it to articulate to an adjoining bone.

contractile able to contract.

coracoid one of a pair of ventral bones forming part of the pectoral girdle in some tetrapods.

corium the keratin outer layer of a horn; also, the inner layer of the skin.

covert a feather which covers over the quills of flight feathers.

coxa hipbone (part of the pelvis).

cranial of the skull.

cruciate cross-shaped.

Deinonychus a carnivorous dinosaur.

digit any terminal division of a limb, such as a finger or toe.

digitigrade walking with only the digits, not the soles, touching the ground.

Diplodocus a large herbivorous dinosaur.

distal furthest away from the point of attachment.

Dryopithecus an extinct genus of ape.

Euoplocephalus a club-tailed, armoured dinosaur.

Eusthenopteron an extinct fish.

extensor a muscle that extends or straightens a limb.

felid any animal of the cat family.

femur thigh bone.

fibula the bone posterior to the tibia.

flexor a muscle that bends or flexes a limb.

furcula the fused clavicles of a bird, also known as the wishbone.

Glyptotherium an extinct armadillo-like creature.

graticule the division of a design into squares for convenience in making an enlarged or diminished copy (compare **grid**).

grid a network of lines for finding places on a map or drawing (compare **graticule**).

humerus the bone of the upper part of a tetrapod's forelimb.

Icthhyostega an extinct amphibian.

insertion the point of attachment of a muscle, or its tendon, at its more movable end.

intrinsic situated within a particular part of the body.

keratin the fibrous protein of which hair, nails and feathers are mainly composed.

Lambeosaurus a duck-billed dinosaur.

ligament strong band of tissue lending support to a joint.

lumbar relating to the lower back, near the loins.

Mammalia the vertebrate class comprising all the animals which suckle their young.

mandible the lower jaw.

mandibular condyle the joint between jaw and skull.

maquette a small model made and used to check the shape and pose of a proposed larger model.

medial canthus the inner corner of the eye.

meniscus a crescent-shaped cartilage between the ends of bones at joints which sustain a lot of pressure.

metacarpal any of the bones joining wrist to fingers.

metatarsal any of the bones joining ankle to toes.

nictitating membrane the 'third eyelid' found beneath the eyelids proper in reptiles, birds and some mammals.

occipital condyle the joint between the skull and the spine.

olfactory relating to the sense of smell.

orbit eye socket.

origin the point of attachment of a muscle at its less movable end.

Palaeoloxodon falconeri an extinct dwarf elephant.

papilla the root from which feathers or hairs grow; also, one of the small studs of hard skin which cover the pads on the feet of many animals.

passerine any perching bird, belonging to the order *Passeriformes*.

patella kneecap.

pectoral girdle the part of the skeleton which allows for the attachment of the front or upper limbs.

pelvic girdle the part of the skeleton which allows for the attachment of the rear limbs. It generally consists of a hoop of bones.

penna any of the principal feathers of a bird, including the contour feathers which determine the shape of the body.

Perissodactyla odd-toed ungulates: hoofed mammals with three toes on each foot, walking either on one toe (horses) or three toes (rhinoceroses and tapirs).

phalange (or **phalanx**) any of the bones of the finger or toe.

pinna the external part of the ear.

plantigrade walking with the whole sole of the foot touching the ground, as in the case of bears or humans.

prepuce foreskin.

proboscis a long snout.

processus cornus the hollow conical core of a horn, extending from the skull.

proximal nearest to the point of attachment.

pterosaur any of the various kinds of flying reptiles contemporary with the dinosaurs.

pygostyle a fused set of vertebrae at the end of the spine in birds, serving as the basis on which the tail is formed.

quadruped any animal which walks on four legs.

quill the wide part of the stem of a feather.

rachis the narrow part of the stem of a feather, to which the vane is attached.

radius the outer of the two bones of the forelimb, between **humerus** and **carpals**.

rectrix (plural: **rectrices**) any of the stiff feathers on a bird's tail.

Reptilia the vertebrate class which includes tortoises, turtles, lizards, snakes, crocodiles and some extinct orders such as the dinosaurs.

sacrum a fused set of vertebrae which forms part of the pelvis.

sagittal plane the imaginary division between the left and right sides of the body.

scapula shoulder blade.

scute a protective scale or plate in the skin of reptiles and some other animals.

section a drawing of a solid object showing what it would look like if cut through at a specified plane.

spinous process any spiny projection on a vertebra or other bone.

sternum the breastbone of vertebrates.

striated muscles those with a striped texture, covering most of the superficial areas of the body.

supracoracoideus muscle a muscle originating at the sternum and having insertion on the humerus.

synovial joint any joint which is lubricated with synovial fluid.

tarsal any of the small bones forming the ankle and heel.

tarsometatarsus a bone in the lower part of a bird's leg formed from **metatarsal** bones fused with **tarsal** bones.

tarsus the group of small bones which form the ankle and heel.

tetrapod any animal with four feet or limbs; the term includes, for example, humans and birds, as well as the **quadrupeds**, which use all four limbs for walking. The four orders of tetrapods are the **Amphibia**, **Reptilia**, **Aves** and **Mammalia**.

thoracic relating to the part of the body between neck and abdomen.

tibia the shinbone.

tibiotarsus a bone in a bird's leg formed from the fused **tibia** and **fibula**; it may also have **tarsal** bones fused to it at the distal end.

Tyrannosaurus a large carnivorous dinosaur.

ulna the inner of the two bones of the forelimb, between **humerus** and **carpals**.

umbilicus navel.

unguligrade walking on hoofs (which are modified claws). The ungulates (hoofed mammals) are divided into *Artiodactyla* and *Perissodactyla*.

vane the thin, flat part of a feather, as opposed to its stem.

Velociraptor a carnivorous dinosaur.

ventral the side of the body normally turned towards the ground in quadrupeds, or to the front in bipeds.

vertebra any one of the series of bones comprising the spinal column.

vertebrate any animal with a bony skeleton and a spinal cord.

vibrissa a hair growing from a sensitive cell mostly in the upper lip of certain animals, serving as a tactile organ

viscera the major internal organs of the body.

wishbone a bird's clavicle – see **furcula**.

zygomatic arch the bony arch of the cheek, which runs from the jaw pivot and under the eye.

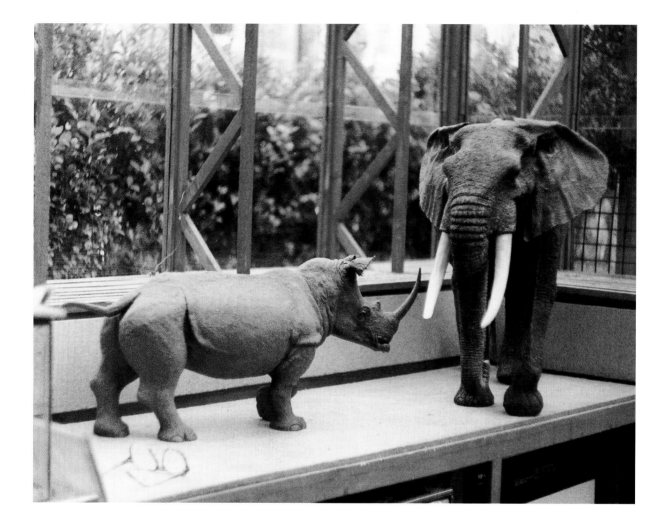

FURTHER READING

I list here a few books from which model-makers can expect to find worthwhile information. The list is not intended to be complete; the maxim for everybody is to get into the habit of seeking out your own information.

Alexander, R. M. (1994): Bones: *The Unity of Form and Function* (London: Weidenfeld and Nicolson; ISBN 1 297 83326 X). A superbly illustrated book with a most instructive text.

All the World's Animals: Sea Mammals (1984) (New York: Torstar; ISBN 0 920269 75 3). Instructive insight into mammal life at sea.

Campbell, B. (1974): *The Dictionary of Birds in Colour* (London: Peerage Books; ISBN 0 907408 07 9). An invaluable reference book.

Carrol, R. L. (1988): *Vertebrate Paleontology and Evolution* (New York: W. H. Freeman and Co.; ISBN 0 716 71822 7). Contains a wealth of knowledge about the formation of tetrapods.

Cutts, P. (1995): *Cat Breeds of the World* (London: Ultimate Editions; ISBN 1 86035 011 9). A nice collection of cat photographs.

Eldridge, N. (1991): *Fossils* (Princeton University Press; ISBN 0 691 02695 5). A curator's view on fossils.

Ellenberger, W., Baum, H., and Dittrich, H. (1949): *An Atlas of Animal Anatomy* (New York: Dover; ISBN 0 486 20082 5). Several detailed anatomical views of a range of animals.

Fehér, G. (1996): *Anatomische Zeichenschule* (Cologne: Könemann; ISBN 3 89508 222 8). An artists' book of anatomical drawings, useful also for the modeller.

Gambell, R. (1993): *The Concise Illustrated Book of Dolphins and Whales* (London: Grange; ISBN 1 85627 291 5). A small book, but if you are going to model one of the *Cetacea* you will find it invaluable.

Gray, H. (1901): *Gray's Anatomy* (New York: Crown; Congress catalog number 76 52804). Useful to all; still in print.

Grossman, S. (1943): *The Anatomy of the Domestic Animals* (London: W. B. Saunders). Anatomy of horse, ox, sheep, pig, dog, chicken.

Hutchinson, E. (1993): *The Book of Life* (London: Ebury Hutchinson; ISBN 0 0917 7749 6). A study of life through time.

Hvass, H. (1958): *Reptiles and Amphibians of the World* (London: Eyre Methuen). A wealth of coloured drawings of all sorts of reptiles and amphibians.

—— (1978): *Mammals of the World* (London: Eyre Methuen; ISBN 0 413 38650 3). A wealth of coloured drawings of all sorts of mammals.

Larousse Encyclopedia of Animal Life (1972) (London: Hamlyn; ISBN 0 600 02362 1). A true encyclopedia.

Lawrence, E. (1990): *Henderson's Dictionary of Biological Terms* (London: Longman; ISBN 0 582 06433 3). A useful pocket book to check technical terminology.

Macdonald, D. (1993): *Field Guide to Mammals of Britain and Europe* (London: Harper Collins; ISBN 0 00 219779 0). This book gives masses of information of particular interest to the model-maker.

McGowan, C. (1997): *The Raptor and the Lamb* (London: Henry Holt; ISBN 0 7139 9233 6). Natural history in the raw.

Mongini, E. L. & M. (1984): *World Encyclopaedia of Animals* (London: Macdonald; ISBN 0 356 14814 9). Not all tetrapods, but enough to be worth picking up and studying.

Napier, J. R. & P. H. (1985): *The Natural History of the Primates* (London: British Museum (Natural History); ISBN 0 565 00870 6). A good look at the primates.

Norman, D. (1985): *The Illustrated Encyclopaedia of Dinosaurs* (London: Salamander; ISBN 0 86101 225 9). A useful introduction to dinosaurs.

Parker, S. (1987): *Skeleton* (London: Dorling Kindersley; ISBN 3 8067 4401 7). An *ab initio* book, but right on the button.

Perrins, C. M. (1990): *The Illustrated Encyclopaedia of Birds* (London: Greenwich Editions; ISBN 0 86288 073 4). A superb reference book for birds all over the world.

Reader's Digest Book of British Birds, 2nd edn (1974) (London: Reader's Digest). Many coloured drawings for identifying British birds.

Ross, C. A., et al. (1989): *Crocodiles and Alligators* (London: Merehurst Press; ISBN 1 85391 092 9). An encyclopedic survey.

Rue, L. L. (1994): *Elephants* (New York: Todtri Productions, and Leicester: Magna Books; ISBN 1 85422 340 2). There are so many books on elephants, but this one includes some especially interesting photographs.

Stirling, I., et al. (1993): *Bears: A Complete Guide to Every Species* (London: Harper Collins; ISBN 0 00 219986 6). Useful information for the model-maker.

Tippey, D. (1996): *Carving Realistic Birds* (Lewes, East Sussex: Guild of Master Craftsman Publications; ISBN 1 86108 010 7). A practical guide to the detailing of model birds.

Turner, A. (1997): *The Big Cats and their Fossil Relatives* (New York: Columbia University Press; ISBN 0 231 10228 3). A natural history linking fossils with today's big cats.

Walker, W. F. (1987): *Functional Anatomy of the Vertebrates* (New York: Saunders College Publishing; ISBN 0 03 064239 6). Treatise on the structure of vertebrates.

Weishampel, D. B., Dodson, P., and Osmólska, H. (1990): *The Dinosauria* (Los Angeles: University of California Press; ISBN 0 520 06727 4). A specialist's book.

Young, J. Z. (1975): *The Life of Mammals* (Oxford: Clarendon Press; ISBN 0 19 857156 9). The first part of the book is of particular interest to the model-maker.

ABOUT THE AUTHOR

Basil F. Fordham is a retired company chairman. At one time he was a chief design engineer, in which capacity he was a Member of one senior professional institution and an Associate Member of another.

He has been a keen student of natural history from childhood, and since retiring he continues to paint and make models of animals. He makes reconstructions of extinct life, and model animals for natural history museums and educational establishments. His modelling also includes woodcarving and stone sculpting.

The photograph shows Mr Fordham with his reconstruction of *Palaeoloxodon falconeri* (see Fig 3.4). He has built two of these reconstructions, one for the Munich Tierpark and one for the Frankfurt natural history museum.

INDEX

African elephant (*Loxodonta africana*) 103–8
alula 33, 118
Amphibia 2, 118
anatomy and physiology 1, 3–36
 basic components 4–7
 covering of the body 30–6
 external features 27–36
 internal organs and fat 27
 joints and ligaments 15–20
 muscles and tendons 20–7
 sense organs 27–30
 skeleton 7–15
antlers 33, 108
appendicular skeleton 6, 10–15, 118
armatures 2, 78, 85, 118
Artiodactyla 15, 118
atlas 5, 16, 118
'attention' pose 53–4, 78
Aves 2, 118
axial skeleton 6, 7–10, 118
axis 5, 16, 118

ball-and-socket joints 16, 17, 18
bats 13, 29
beaks 34
bipeds 8, 118
birds 14, 34
 domestic pigeon (*Columba livia*) 86, 93–9
 feathers 31–3
 perching 20, 120
body language 36
bottom (ventral) view 53, 54, 117
brachiation 17, 118
bursa 15, 118

C-gauges 82–3
calf muscle 27
callipers 84
canids 30, 118
carapace 10, 118
cardboard limb pieces 57–9, 77
carpals 11, 17–18, 118
carpus bones 12, 118
cartilage 8, 15, 118
carving 2, 78
 profile gauges 78, 81–3, 95
 profiles 78, 95
cat, domestic (*Felis catus*) 100–2
 drawing 54–64, 66–76
 musculature 22, 23

caudal vertebrae 7, 9, 10
caudal (rear) view 53, 54, 60–4, 117
Ceratotherium simum (white rhinoceros) 109
cervical vertebrae 9
clavicle 17, 26, 71, 94, 118
claws 33
coccyx 9, 118
colour 36, 79
Columba livia (domestic pigeon) 86, 93–9
condyle 118
construction methods 2
 drawing for 77, 78–9
 see also carving; framework method
contractile fibres 20
coracoid 10, 17, 94, 118
corium 33, 118
coverings
 of the body 30–6, 72–6
 on models 79
coverts 31, 118
coxa 18, 118
cranial (front) view 53, 54, 60–4, 117
criss-cross frame 79, 91–2
crocodile 64, 65
cross section 82, 83
crosswise formers 86

datums 79–80
Deinonychus 17, 118
digitigrade stance 6, 15, 22, 119
digits 11, 17–18, 19–20, 118
Diplodocus 6, 7, 119
discs, intervertebral 8
dorsal (top) view 53, 54, 60–4, 117
drawing surface 49–50
drawings 49–77
 'attention' pose 53–4
 basic framework 55–64
 completed skeleton 72, 74
 and construction method 77, 78–9
 drawing to size 51
 front limb 71–2
 graticule 51–2
 lines 50–1
 materials 49–50
 muscles, internal organs, fat, sense organs and skin 72–6
 rear limb 72, 73
 required pose 77
 skull 64–6

spine and ribcage 66–70
 views 3, 49, 53, 54, 117
ears 29, 104, 108
elbow joint 17
elephant 29
 African (*Loxodonta africana*) 103–8
 extinct dwarf elephant (*Palaeoloxodon falconeri*)
 40–1, 120
ellipsoid joints 16
equipment 49–50
Euoplocephalus 6, 119
Eusthenopteron 12, 119
external features 7, 27–36
 covering of the body 30–6, 72–6
 sense organs 27–30, 72–6
extensors 26, 119
extraneous surface matter 36
eyes 27–9

fabric 79
familiarization with the subject 1, 37
fat 7, 27, 72–6
feathers 31–3
feet 17–18, 19–20, 27, 35, 72
felids 30, 119
Felis catus see cat
femur 11, 18, 72, 119
fibreglass 79
fibula 11, 12, 72, 119
first covering 79
fixtures 80
flat joints 16
flexors 26, 119
flight feathers 31–3
formers 2, 78–9
framework method 2, 80, 85, 86
 drawings for 78–9
frog, common (*Rana temporaria*) 87–9
front limb 71–2
 joints and ligaments 17–18
 muscles and tendons 26
 skeleton 10, 11, 13, 14
 see also wings
front (cranial) view 53, 54, 60–4, 117
furcula (wishbone) 94, 119, 121

galloping 77
genital organs 36
giraffe (*Giraffa camelopardalis*) 114-15
gorilla (*Gorilla gorilla*) 112–13
graticule 1, 51–2, 119
grid 119
 see also graticule

hair 30–1
hands 26, 35
 see also feet
head 4–5
 joints 16
 muscles and tendons 22–5
 see also skull
hinge joints 16, 17, 18–19
hip joint 18
hippopotamus (*Hippopotamus amphibius*) 110–11
hoofs 33
horns 33, 108
horse 13
 musculature 22, 24
 skull 64–6
human
 musculature 22, 23
 skull 64, 65
humerus 11, 17, 71, 119

Ichthyostega 12, 119
information 37–48
 sources 37
 see also measurements
insertion 20–1, 119
internal organs (viscera) 6, 7, 27, 72–6, 121
intervertebral discs 8

joints 6–7, 15–20
 drawing limb joints 57–9, 64

keratin 31, 33, 119
knee joint 18–19

lateral (side) view 53, 54, 55–9, 60, 117
life-size dimensions 44, 47–8
ligaments 7, 15–20, 119
limbs 6
 birds 14, 94–5
 cardboard limb pieces 57–9, 77
 drawing 55–9, 60–4, 71–2
 joints and ligaments 17–20
 movement 77
 muscles and tendons 26–7
 skeleton and variation in 10–15
 splayed 57–9
lines 50–1
Loxodonta africana (African elephant) 103–8
lumbar vertebrae 9

Mammalia 2, 119
mammary glands 36
mandible 7, 107, 119

mandibular condyle 16, 119
maquette 1, 49, 77, 78, 84, 86, 119
materials
 for drawings 49–50
 for outer coverings of model 79
measurements 37–48
 combining multiple sets of
 information 44–6
 grouping 44
 how to collect 40–4
 modifying to suit the model 46–8
 schedule of 44–8, 55
 what to collect 37–9
measuring stick 38, 39
medial canthus 28, 29, 119
meniscuses 18, 119
metacarpals 11, 72, 119
metatarsals 11, 72, 119
model-making 78–116
 African elephant 103–8
 armatures 85
 author's own working drawings 109–15
 common frog 87–9
 datums 79–80
 domestic cat 100–2
 domestic pigeon 93–9
 drawings for different construction
 methods 77, 78–9
 fixtures 80
 maquettes 86
 reminders 116
 spur-thighed tortoise 90–2
 transferring shapes from drawing
 to model 81–4
monkeys 29
mouth 29
movement 6–7, 77
multiple reference images 44–6
muscles 6–7, 20–7, 72–6

nails 33
neck 6
 joints 16–17
 muscles and tendons 22–5
nictitating membrane 28, 119
nose 29–30

occipital condyle 4, 5, 16, 59, 119
orbits 5, 7, 120
origin 20, 21, 120

pacing 77
Palaeoloxodon falconeri (extinct dwarf elephant) 40–1,
 120

paper 50, 79
papillae 35, 120
passerines (perching birds) 20, 120
patella 11, 19, 27, 72, 120
pectoral girdle 10, 11, 120
pectoral muscles 93, 94
pelvic girdle 10, 11, 120
pencils 50
pennae 31–3, 120
pens 50
perching birds 20, 120
Perissodactyla 15, 17, 120
perspective 44
phalanges 11, 18, 19, 72, 120
photocopies 41–4, 45
photographs 38, 39
physiology *see* anatomy and physiology
pigeon, domestic (*Columba livia*) 86, 93–9
pinna 29, 120
pivot joints 16
plane joints 16
plantigrade stance 6, 15, 22, 120
plastic tubing 97, 98
plates 34–5
pose
 'attention' pose 53–4, 78
 required pose 77
prepuce 36, 120
pricking 81
primary feathers 31
processus cornus 33, 120
profile gauges 78, 81–3, 95
proportional callipers/dividers 84
pterosaur 30, 120
pygostyle 6, 10, 120

quadrupedal gait 77
quadrupeds 8, 12, 120, 121
quill 32, 120

rachis 32, 120
radius 11, 12, 17, 71, 120
Rana temporaria (common frog) 87–9
rear limb 72
 joints and ligaments 18–20
 muscles and tendons 26–7
 skeleton 10, 11, 12, 14
rear (caudal) view 53, 54, 60–4, 117
rectrices 31, 120
reference images 41–4, 44–6
Reptilia 2, 120
rhinoceros, white (*Ceratotherium simum*) 109
ribcage 10, 66–70
ribs 10

sacrum 7, 9, 120
saddle joints 16
sagittal plane 3, 60, 82, 120
sagittal plane former 80, 86
sandpaper 50
scale (size of drawing) 51, 52, 54
scale rule 52, 84
scales 34–5, 95
scapula 9, 17, 26, 71, 77, 120
schedule of measurements 44–8, 55
scrotum 36
sculpting see carving
scutes 34–5, 120
second covering 79
secondary feathers 31
sections 53, 121
sense organs 27–30, 72–6
sharpening pencils 50
shoulder joint 17
side (lateral) view 53, 54, 55–9, 60, 117
size see scale
skeletal muscles 7, 20–7, 72–6
skeleton 7–15
 appendicular 6, 10–15, 118
 axial 6, 7–10, 118
 collecting information 40–4
 drawing 53, 55–72, 73, 74
skin 30, 72–6
skull 5, 7
 drawing 64–6, 67
 see also head
spine 7–10
 drawing 59, 60, 66–70
spines 34–5
spinous process 8, 121
splayed limbs 57–9
spur-thighed tortoise (Testudo graeca) 90–2
stance 6, 12–15
 classification of tetrapods 15
sternum 10, 69, 121
striated muscles 20, 121
supports 80
supracoracoideus muscle 94, 121
synovial joints 15–16, 121
 types of 16

tail 6, 104, 108
 joints 16–17
 muscles and tendons 25–6
 vertebrae 7, 9, 10
tarsals 11, 19, 121

tarsus bones 12, 121
tarsometatarsus 20, 94–5, 121
teeth 29
templates 82
tendons 7, 20–7, 76, 94
tertiary feathers 31
Testudo graeca (spur-thighed tortoise) 90–2
tetrapods 2, 3, 121
 classification by stance 15
third covering 79
'third eyelid' 28, 119
thoracic vertebrae 9
tibia 11, 12, 72, 121
tibiotarsus 20, 94, 121
tongue 29
top (dorsal) view 53, 54, 60–4, 117
tortoise 14
 spur-thighed (Testudo graeca) 90–2
tracing 81
transferring shapes 81–4
trotting 77
trunk, elephant's 104, 107
trunk (torso) 6
 joints 16–17
tubing, plastic 97, 98
tusks 108
Tyrannosaurus 12, 121

ulna 11, 12, 17, 71, 121
umbilicus 36, 121
unguligrade stance 6, 15, 22, 121
universal profile gauges 81

vane 32, 121
ventral (bottom) view 53, 54, 117
vertebrae 7, 8–9, 121
vertebrates 8, 121
vibrissae 5, 31, 121
views 3, 49, 53, 54, 117
 see also under individual views
viscera (internal organs) 6, 7, 27, 72–6, 121

wet areas 36
whales 14
white rhinoceros (Ceratotherium simum) 109
wings 13, 17, 93–4
 feathers 31–3
wire 85
wishbone (furcula) 94, 119, 121

zygomatic arch 121

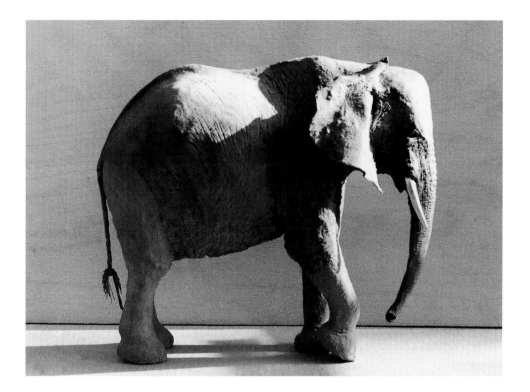

TITLES AVAILABLE FROM
GMC Publications
BOOKS

WOODCARVING

The Art of the Woodcarver	GMC Publications
Carving Architectural Detail in Wood: The Classical Tradition	Frederick Wilbur
Carving Birds & Beasts	GMC Publications
Carving Nature: Wildlife Studies in Wood	Frank Fox-Wilson
Carving Realistic Birds	David Tippey
Decorative Woodcarving	Jeremy Williams
Elements of Woodcarving	Chris Pye
Essential Tips for Woodcarvers	GMC Publications
Essential Woodcarving Techniques	Dick Onians
Further Useful Tips for Woodcarvers	GMC Publications
Lettercarving in Wood: A Practical Course	Chris Pye
Making & Using Working Drawings for Realistic Model Animals	Basil F. Fordham
Power Tools for Woodcarving	David Tippey
Practical Tips for Turners & Carvers	GMC Publications
Relief Carving in Wood: A Practical Introduction	Chris Pye
Understanding Woodcarving	GMC Publications
Understanding Woodcarving in the Round	GMC Publications
Useful Techniques for Woodcarvers	GMC Publications
Wildfowl Carving – Volume 1	Jim Pearce
Wildfowl Carving – Volume 2	Jim Pearce
Woodcarving: A Complete Course	Ron Butterfield
Woodcarving: A Foundation Course	Zoë Gertner
Woodcarving for Beginners	GMC Publications
Woodcarving Tools & Equipment Test Reports	GMC Publications
Woodcarving Tools, Materials & Equipment	Chris Pye

WOODTURNING

Adventures in Woodturning	David Springett
Bert Marsh: Woodturner	Bert Marsh
Bowl Turning Techniques Masterclass	Tony Boase
Colouring Techniques for Woodturners	Jan Sanders
The Craftsman Woodturner	Peter Child
Decorative Techniques for Woodturners	Hilary Bowen
Fun at the Lathe	R.C. Bell
Further Useful Tips for Woodturners	GMC Publications
Illustrated Woodturning Techniques	John Hunnex
Intermediate Woodturning Projects	GMC Publications
Keith Rowley's Woodturning Projects	Keith Rowley
Practical Tips for Turners & Carvers	GMC Publications
Turning Green Wood	Michael O'Donnell
Turning Miniatures in Wood	John Sainsbury
Turning Pens and Pencils	Kip Christensen & Rex Burningham
Understanding Woodturning	Ann & Bob Phillips
Useful Techniques for Woodturners	GMC Publications
Useful Woodturning Projects	GMC Publications
Woodturning: Bowls, Platters, Hollow Forms, Vases, Vessels, Bottles, Flasks, Tankards, Plates	GMC Publications
Woodturning: A Foundation Course (New Edition)	Keith Rowley
Woodturning: A Fresh Approach	Robert Chapman
Woodturning: An Individual Approach	Dave Regester
Woodturning: A Source Book of Shapes	John Hunnex
Woodturning Jewellery	Hilary Bowen
Woodturning Masterclass	Tony Boase
Woodturning Techniques	GMC Publications
Woodturning Tools & Equipment Test Reports	GMC Publications
Woodturning Wizardry	David Springett

WOODWORKING

Bird Boxes and Feeders for the Garden	Dave Mackenzie
Complete Woodfinishing	Ian Hosker
David Charlesworth's Furniture-Making Techniques	David Charlesworth
Furniture & Cabinetmaking Projects	GMC Publications
Furniture-Making Projects for the Wood Craftsman	GMC Publications
Furniture-Making Techniques for the Wood Craftsman	GMC Publications
Furniture Projects	Rod Wales
Furniture Restoration (Practical Crafts)	Kevin Jan Bonner
Furniture Restoration and Repair for Beginners	Kevin Jan Bonner
Furniture Restoration Workshop	Kevin Jan Bonner
Green Woodwork	Mike Abbott
Making & Modifying Woodworking Tools	Jim Kingshott
Making Chairs and Tables	GMC Publications
Making Classic English Furniture	Paul Richardson
Making Little Boxes from Wood	John Bennett
Making Shaker Furniture	Barry Jackson
Making Woodwork Aids and Devices	Robert Wearing
Minidrill: Fifteen Projects	John Everett
Pine Furniture Projects for the Home	Dave Mackenzie
Router Magic: Jigs, Fixtures and Tricks to Unleash your Router's Full Potential	Bill Hylton
Routing for Beginners	Anthony Bailey
Scrollsaw Pattern Book	John Everett
The Scrollsaw: Twenty Projects	John Everett
Sharpening: The Complete Guide	Jim Kingshott
Sharpening Pocket Reference Book	Jim Kingshott
Space-Saving Furniture Projects	Dave Mackenzie
Stickmaking: A Complete Course	Andrew Jones & Clive George
Stickmaking Handbook	Andrew Jones & Clive George
Test Reports: The Router and Furniture & Cabinetmaking	GMC Publications
Veneering: A Complete Course	Ian Hosker
Woodfinishing Handbook (Practical Crafts)	Ian Hosker
Woodworking with the Router: Professional Router Techniques any Woodworker can Use	Bill Hylton & Fred Matlack
The Workshop	Jim Kingshott

UPHOLSTERY

The Upholsterer's Pocket Reference Book	David James
Upholstery: A Complete Course (Revised Edition)	David James
Upholstery Restoration	David James
Upholstery Techniques & Projects	David James
Upholstery Tips and Hints	David James

TOYMAKING

Designing & Making Wooden Toys	Terry Kelly
Fun to Make Wooden Toys & Games	Jeff & Jennie Loader
Restoring Rocking Horses	Clive Green & Anthony Dew
Scrollsaw Toy Projects	Ivor Carlyle
Scrollsaw Toys for All Ages	Ivor Carlyle
Wooden Toy Projects	GMC Publications

DOLLS' HOUSES AND MINIATURES

Architecture for Dolls' Houses	Joyce Percival
A Beginners' Guide to the Dolls' House Hobby	Jean Nisbett
The Complete Dolls' House Book	Jean Nisbett
The Dolls' House 1/24 Scale: A Complete Introduction	Jean Nisbett
Dolls' House Accessories, Fixtures and Fittings	Andrea Barham
Dolls' House Bathrooms: Lots of Little Loos	Patricia King
Dolls' House Fireplaces and Stoves	Patricia King
Easy to Make Dolls' House Accessories	Andrea Barham
Heraldic Miniature Knights	Peter Greenhill
Make Your Own Dolls' House Furniture	Maurice Harper
Making Dolls' House Furniture	Patricia King
Making Georgian Dolls' Houses	Derek Rowbottom

Making Miniature Gardens — *Freida Gray*
Making Miniature Oriental Rugs & Carpets — *Meik & Ian McNaughton*
Making Period Dolls' House Accessories — *Andrea Barham*
Making 1/12 Scale Character Figures — *James Carrington*
Making Tudor Dolls' Houses — *Derek Rowbottom*
Making Victorian Dolls' House Furniture — *Patricia King*
Miniature Bobbin Lace — *Roz Snowden*
Miniature Embroidery for the Georgian Dolls' House — *Pamela Warner*
Miniature Embroidery for the Victorian Dolls' House — *Pamela Warner*
Miniature Needlepoint Carpets — *Janet Granger*
More Miniature Oriental Rugs & Carpets — *Meik & Ian McNaughton*
The Secrets of the Dolls' House Makers — *Jean Nisbett*

CRAFTS

American Patchwork Designs in Needlepoint — *Melanie Tacon*
A Beginners' Guide to Rubber Stamping — *Brenda Hunt*
Blackwork: A New Approach — *Brenda Day*
Celtic Cross Stitch Designs — *Carol Phillipson*
Celtic Knotwork Designs — *Sheila Sturrock*
Celtic Knotwork Handbook — *Sheila Sturrock*
Celtic Spirals and Other Designs — *Sheila Sturrock*
Collage from Seeds, Leaves and Flowers — *Joan Carver*
Complete Pyrography — *Stephen Poole*
Contemporary Smocking — *Dorothea Hall*
Creating Colour with Dylon — *Dylon International*
Creative Doughcraft — *Patricia Hughes*
Creative Embroidery Techniques
 Using Colour Through Gold — *Daphne J. Ashby & Jackie Woolsey*
The Creative Quilter: Techniques and Projects — *Pauline Brown*
Decorative Beaded Purses — *Enid Taylor*
Designing and Making Cards — *Glennis Gilruth*
Glass Painting — *Emma Sedman*
How to Arrange Flowers: A Japanese Approach
 to English Design — *Taeko Marvelly*
An Introduction to Crewel Embroidery — *Mave Glenny*
Making and Using Working Drawings for
 Realistic Model Animals — *Basil F. Fordham*
Making Character Bears — *Valerie Tyler*
Making Decorative Screens — *Amanda Howes*
Making Greetings Cards for Beginners — *Pat Sutherland*
Making Hand-Sewn Boxes: Techniques and Projects — *Jackie Woolsey*
Making Knitwear Fit — *Pat Ashforth & Steve Plummer*
Natural Ideas for Christmas:
 Fantastic Decorations to Make — *Josie Cameron-Ashcroft & Carol Cox*
Needlepoint: A Foundation Course — *Sandra Hardy*
Needlepoint 1/12 Scale: Design Collections
 for the Dolls' House — *Felicity Price*
Pyrography Designs — *Norma Gregory*
Pyrography Handbook (Practical Crafts) — *Stephen Poole*
Ribbons and Roses — *Lee Lockheed*
Rose Windows for Quilters — *Angela Besley*
Rubber Stamping with Other Crafts — *Lynne Garner*
Sponge Painting — *Ann Rooney*
Tassel Making for Beginners — *Enid Taylor*
Tatting Collage — *Lindsay Rogers*
Temari: A Traditional Japanese Embroidery Technique — *Margaret Ludlow*
Theatre Models in Paper and Card — *Robert Burgess*
Wool Embroidery and Design — *Lee Lockheed*

GARDENING

Auriculas for Everyone: How to Grow and
 Show Perfect Plants — *Mary Robinson*
Bird Boxes and Feeders for the Garden — *Dave Mackenzie*
The Birdwatcher's Garden — *Hazel & Pamela Johnson*
Companions to Clematis: Growing Clematis
 with Other Plants — *Marigold Badcock*
Creating Contrast with Dark Plants — *Freya Martin*
Gardening with Wild Plants — *Julian Slatcher*
Hardy Perennials: A Beginner's Guide — *Eric Sawford*
The Living Tropical Greenhouse: Creating a
 Haven for Butterflies — *John & Maureen Tampion*
Orchids are Easy: A Beginner's Guide to their
 Care and Cultivation — *Tom Gilland*
Plants that Span the Seasons — *Roger Wilson*

VIDEOS

Drop-in and Pinstuffed Seats — *David James*
Stuffover Upholstery — *David James*
Elliptical Turning — *David Springett*
Woodturning Wizardry — *David Springett*
Turning Between Centres: The Basics — *Dennis White*
Turning Bowls — *Dennis White*
Boxes, Goblets and Screw Threads — *Dennis White*
Novelties and Projects — *Dennis White*
Classic Profiles — *Dennis White*
Twists and Advanced Turning — *Dennis White*
Sharpening the Professional Way — *Jim Kingshott*
Sharpening Turning & Carving Tools — *Jim Kingshott*
Bowl Turning — *John Jordan*
Hollow Turning — *John Jordan*
Woodturning: A Foundation Course — *Keith Rowley*
Carving a Figure: The Female Form — *Ray Gonzalez*
The Router: A Beginner's Guide — *Alan Goodsell*
The Scroll Saw: A Beginner's Guide — *John Burke*

MAGAZINES

WOODTURNING ♦ WOODCARVING
FURNITURE & CABINETMAKING
THE ROUTER ♦ WOODWORKING
THE DOLLS' HOUSE MAGAZINE
WATER GARDENING
EXOTIC GARDENING
GARDEN CALENDAR
OUTDOOR PHOTOGRAPHY
BUSINESSMATTERS

The above represents a full list of all titles currently
published or scheduled to be published.
All are available direct from the Publishers or through
bookshops, newsagents and specialist retailers.
To place an order, or to obtain a complete catalogue, contact:

**GMC Publications,
Castle Place, 166 High Street, Lewes, East
Sussex BN7 1XU, United Kingdom
Tel: 01273 488005 Fax: 01273 478606
E-mail: pubs@thegmcgroup.com**

Orders by credit card are accepted